Symbolism in Christian Art

Symbolism in Christian Art

Edward
Hulme

Blandford Press
Poole · Dorset

First published in Great Britain
by **Blandford Press**, Link House, West Street, Poole, Dorset. BH15 1LL

ISBN 0 7137 2501 X

704.948
H 915 ay

First published MLCCCXCI

This Revised and illustrated edition MCMLXXVI

Copyright © F. E. Hulme

Dolphin Studio Production

Printed and bound in Great Britain
by Biddles of Guildford

Contents

"When the Morning Stars Sang Together" from The Book of Job 1825, No. 14 by William Blake. British Museum.

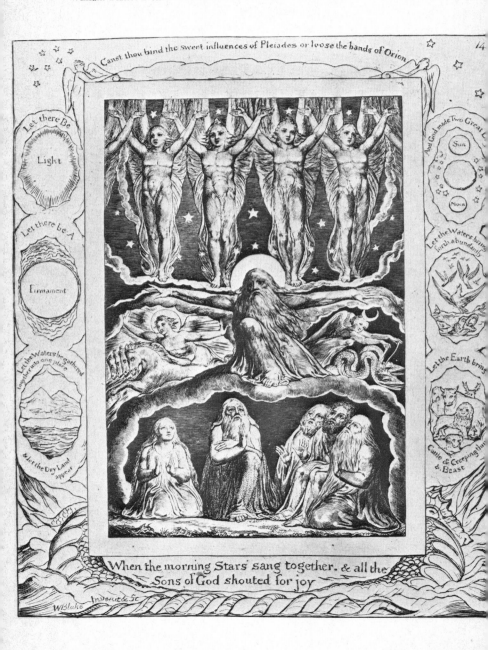

Chapter 1

A symbol is a form that in itself may be trivial, barbarous, or even repellent, but which nevertheless, from the association connected with it, is the sign of something higher than meets the outward eye. Symbolic forms can never again attain the importance they have done in the past. Their study is nevertheless deeply interesting; for, grotesque and quaint as they often are, we must remember that they were but the outer shell, and often beneath a rugged exterior bore a golden wealth of significance. To the artist and archaeologist such study is indispensable. The field of inquiry is so vast, both in space and time, that it is evident that an exhaustive treatment is impossible; we purpose then in the present pages to do little more than deal with the subject in its association with Christianity and its illustration in art.

Though the terms symbol, allegory, and type appear to be ordinarily regarded as interchangeable, there is a difference of meaning and application. Symbolism employs real objects such as the lamb, the cross, the crown, to illustrate the truth. It is a picture language. Allegory uses fictitious things and imaginary personages. Symbolism appeals to the mind through the eye, is more or less artistic and pictorial; while allegory is more especially literary, and the picturesque treatment of such works as the "Pilgrims Progress" or the " Holy War" affords us very excellent examples of its scope. A type is a something or somebody that prefigures some greater thing or person; thus the ark riding in safety amidst the waters of the deluge was a type of the Church of God. As the thing that originally prefigures also afterwards represents, many of these typical forms have been pressed into the service of symbolism.

The sculptured fonts or stained-glass windows in the churches of the Middle Ages were full of teaching to a congregation of whom the greater part could not read, to whom therefore one great avenue of knowledge was closed. The ignorant are especially impressed by pictorial teaching,

and grasp its meaning far more readily than they can follow a written description or a spoken discourse. Hence the clergy wisely supplemented their discourses with these appeals to the eye. But symbolism, though ordinarily a very effective way of imparting instruction, has at times been employed in an entirely opposite direction. Thus the priests of Egypt reserved to themselves an inner meaning to many of their rites; and thus too the early Christians employed symbols that, though full of significance to themselves, conveyed no meaning to the heathen around them. We too may at first see nothing but poverty of design and poorness of execution in these rude and strange imaginings; but when we recall how essential they once were as pledges and declarations of faith, they acquire a strong interest, and we see through and beyond the visible representation, and grasp something of the great ideas veiled in these simple and rude forms.

Clement of Alexandria suggested to the Christians of his day that, in place of the heathen subjects cut on stones and rings by the Roman lapidaries and metal workers, they should have such devices as a dove, symbolic of the Holy Spirit of God within them, the palm branch of victory, the anchor, emblematic of their hope, and other devices of like import. The strong expressions of Tertullian in his treatise, "De Idololatria," are directed against the pagan rites, and in his zeal against error he objects to all representations whatsoever, and stigmatises the art of the painter as an unlawful thing; though he, in spite of his anxiety to prevent any tampering with arts that had been perverted to the service of heathendom, made exception in favour of the devices suggested by Clement. The influences of the life around them did in fact considerably affect early Christian art. Christ Himself, the Good Shepherd, we shall see, was often represented as Orpheus; while St. Paul finds in the Isthmian Games apt illustration of the Christian race. St. John Damascenus, writing in the eighth century, strongly defends the introduction of

sculpture and painting as accessories to the teaching of the Church.

The great sources from whence our knowledge of Christian symbolism is derived are, from the third to the eighth centuries, the frescoes and sarcophagi in the catacombs, the mosaics in the Italian churches, and the vessels of glass or pottery found in tombs. Later on, for another three hundred years or so, we find a rich store of illustrations in the carved crosses or richly illuminated books of the Irish and Anglo-Saxon scribes; and, still later, the magnificent manuscripts of the Middle Ages, the profusion of sculpture, the glorious stained-glass windows, the pavements of figured tiles afford us numberless other examples.

Symbolic forms may be readily divided into three distinct classes. The first of these comprises those that still survive, and convey their meaning to us as clearly as they have done to preceding generations. The dove is a good illustration of these, and it will ordinarily be found that such symbols are based on some definite passage of the Bible. The second class comprises forms that for some reason or other have now wholly ceased to be employed, though their significance is still clearly understood. While a third and much smaller class includes forms that from their associations are clearly symbolic, but of which all clue to their meaning is lost. It is of course necessary to bring some little knowledge and experience to bear on the matter, as it does not certainly follow that a thing is meaningless because it is so to us. Many old legends and beliefs have now faded away; but no one to whom the legend of the phoenix is unknown, to whom the old belief in the pelican feeding its young with its own blood is unfamiliar, is in a position to express an opinion as to their introduction in old work. A knowledge of such superstitious beliefs, and with the various legends that are associated with the saints in the Church's calendar, is as needful to the due appreciation of early art or modern revivals of it as a knowledge

of Greek and Roman mythology is to those who would desire to intelligently appreciate the paintings on classic vases or the masterpieces of Greek sculpture.

The student must moreover be warned that the points of resemblance between the symbol and the thing symbolised must not be pushed too far, nor too rigid a parallelism exacted. Often therefore but one face of a many-sided truth can be given. Thus our Saviour may be represented as the Good Shepherd, the guardian of the flock, and the symbol is a just and beautiful one; but such a symbol gives no suggestion of the fact that he was also the Lamb without spot or blemish, or that hereafter He will be the Judge in that dread tribunal that closes the drama of this world's history. A symbol too, we must remember, may mean two entirely different and opposing things. Thus the lion may symbolise the evil spirit walking about as a lion to devour his prey, or the all-conquering Christ, the Lion of the tribe of Judah. Our Lord too compared the kingdom of heaven in one of His parables to leaven; yet elsewhere He spoke in an entirely different sense of the leaven of the Scribes and Pharisees.

While symbolic teaching is of great service, and a most valuable means of imparting truth, it can, like most other things, be carried to a point where it becomes forced and almost ridiculous. Hence the abuse has been made an argument against the use. Our Lord's teaching, while clear and distinct, was clothed almost invariably in parabolic, figurative, descriptive, allegorical, and symbolic form. Our duty to our neighbour was not coldly set forth in a harsh, unbending formula, a rigid and frigid command, but brought home to us in the parable of the traveller who so sorely needed and so readily obtained compassion; and every discourse was lighted up and brightened by some picturesque allusion, the pearl of great price, the lost and wandering sheep, the working leaven, the house founded upon a rock, the sower and the seed, the labourers in the vineyard, the unjust judge, the

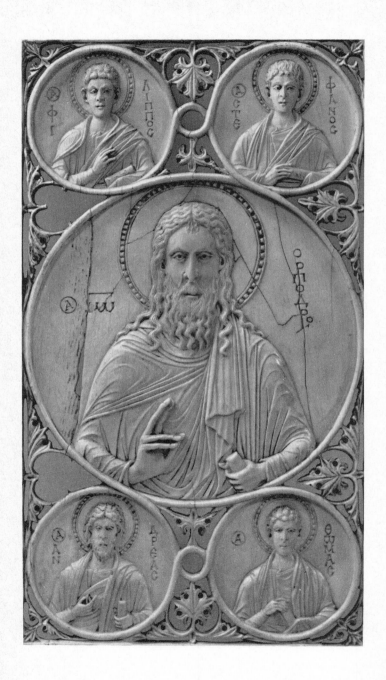

5

beautiful story of the prodigal son. The method of teaching thus inaugurated by the Founder of the Church may well be adopted by his Followers.

At the same time, as we have already indicated, this symbolic teaching has suffered at the hands of its too zealous friends. There is perhaps no better illustration of this than the "Rationale Divinorum Officiorum" of Durandus, a book on the symbolism of churches and church ornaments. Durandus was chaplain to Pope Clement IV., afterwards captain of the Papal forces, and finally, in the year 1286, became Bishop of Mene. The "Rationale" was the first book from the pen of an uninspired author ever printed. Though it passed through many editions, it is now of extreme rarity.

Durandus deals in his book with all the component parts and details of a church, and finds in each and all an inner meaning that, ingenious as it frequently is, is often sadly strained. We may give but one illustrative example of this, the bell, to most of us a useful but prosaic thing enough.

"Bells do signify preachers, who ought after the likeness of a bell to exhort the faithful; the which was typified in that the Lord commanded Moses to make a vestment for the high priest, having seventy-two bells, to sound when the high priest entered into the Holy of Holies. Also the cavity of the bell denoteth the mouth of the preacher, according to the saying of the apostle, 'I am become as sounding brass or a tinkling cymbal.' The hardness of the metal signifieth fortitude in the mind of the preacher; whence saith the Lord, 'Behold, I have made thy face strong against their faces.' The clapper or iron which, by striking on either side, maketh the sound, doth denote the tongue of the teacher, the which with the adornment of leaning doth cause both testaments to resound. The striking of the bell denoteth that the preacher ought first of all to strike at the vices in himself for correction, and then advance to blame those of others. The

link by which the clapper is joined or bound unto the bell is meditation. The wood of the frame upon which the bell hangeth doth signify the wood of our Lord's cross. The pegs by which the wooden frame is joined together are the oracles of the prophets. The iron cramps by which the bell is joined with the frame denote charity, by which the preacher being joined indissolubly unto the cross doth boast and say, 'God forbid that I should glory, save in the cross of our Lord Jesus Christ!' The hammer affixed to the frame by which the bell is struck signifieth the right mind of the preacher, by which he himself holding fast to the Divine commands doth by frequent striking inculcate the same on the ears of the faithful".

While pictorial and sculptured forms have their undoubted value as exponents of truth, we must not forget that there is a possiblity of such use degenerating into mere picture worship, as may be very evidently seen in the adoration paid by the Russian peasantry to their sacred pictures.

The use of symbol may be as well seen in the earliest art of which we have knowledge as in any later period, the sacred writing of the priests of Egypt being essentially of this nature. Amongst the Jews again symbolism was one of the most striking features; the Passover feast, the dismissal into the wilderness of the scapegoat, the Feast of Tabernacles, the sabbatic year, were all in the highest degree figurative, while the Song of Solomon, and many others of the Jewish writings are a mine of picturesque imagery. Canon Westcott, in his "Christus Consummator," points out clearly how the writer of the Epistle to the Hebrews "dwells with reverent memory on the significance of the ritual which he had known; and then he shows how to the Christian every symbol had become a truth, every shadow a reality." Writers have noticed especially in the Epistle to the Hebrews, the repeated employment of the word "true," showing over and over again that in the fulfilment we have the reality of which in the Jewish dispensation there was but

7

the shadow. The prohibition in the Jewish religion against the representation of the Deity or of any living thing to a great extent prevented the use of symbolic forms, a prohibition that we also find in full force amongst the followers of Muhammad. Where no such religious restriction is exercised, the love of symbolism has shown itself almost universally, from the cultured Greek, the learned priesthood of the valley of the Nile, or the followers of Hinduism, to the North American nomad Indians, or the dwellers in the mysterious cities of ancient Mexico and Peru. It is equally at home on a Japanese lacquer tray, in the carvings of a Celtic cross, the rich mosaic pavements of an old Roman villa, or in the wealth of sculpture of our grand cathedrals.

Having, we trust, demonstrated the importance of the study, we now indicate, in concluding our introductory remarks, the course we propose to pursue; for "whosoever shall address himself to write of Matters of Instruction, or of any other Argument of Importance, it behoveth that, before he enter therein, he should resolutely determine with himself in what Order he will handle the same, so shall he best accomplish that he hath undertaken, and inform the Understanding, and help the Memory of the Reader." Symbolism may manifest itself in several ways; for though our thoughts naturally turn in the first place to symbolism of form, there may be, equally, symbolism of language, of action, of number, or of colour. Having briefly dwelt upon these points, we propose to deal more especially with symbolic forms as we meet with them in art, in the works of the painter or the sculptor, the embroiderer or the glass painter, burnt into flooring tiles, woven into hangings, stamped upon coins, or whatever other possibilities of production yet remain unspecified.

The symbols associated collectively and individually with the three Persons of the Trinity will first engage our attention, then the cross and passion symbols associated with the earthly life and sacrifice of our Lord. These in turn will

suggest a consideration of the ordinary emblems of mortality. After this we may very naturally dwell for awhile on the representation in art of the human soul and of angels, good and bad, of heaven and hell, the apostles and saints of God, the dragon and the serpent, symbols of evil. We shall then proceed to refer to the emblems of authority, such as the crown, mitre, sceptre, orb, and staff. The various forms derived from the animal kingdom will be followed by those based on flowers. Various symbolic forms again are founded on the sun, the moon, and the starry host of heaven. Geometrical forms must not be overlooked; and the sea too will contribute its quota in such maritme forms as the ship, the trident, the shell, and the fish. Even stones have their associations; while we shall require to deal also with a large section of objects, such as instruments of martyrdom, the gridiron of St. Lawrence, or the wheel of St. Catherine, that almost defy classification in any formal way.

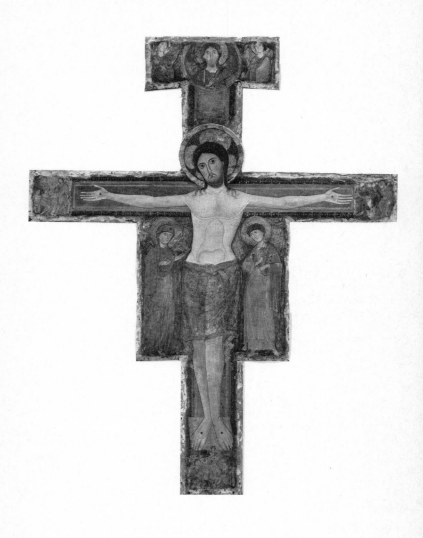

Crucifix. Tempera on panel. About 1200. Victoria and Albert Museum.

Chapter 2

Symbolism may be of language. This imagery of diction is especially characteristic of savage and semi-civilized peoples, though by no means confined to them. The oratory of the New Zealanders or of the North American Indians owes much of its force and beauty to this symbolism of language, and it is a very marked feature in the literature and daily speech of many of the Eastern races. Thus, amidst the decoration of the Alhambra, we find entwined a great variety of laudatory inscriptions, such as the following: "Thou hast risen in the horizon of empire like the sun in the vault of heaven, mercifully to dissipate the shadows of injustice and oppression. Thou hast secured even the tender branches from harm and the breath of the summer gale." Biblical examples may also very readily be found: "As the apple tree among the trees of the wood, so is my beloved. I sat down under his shadow with great delight, and his fruit was sweet to my taste." We may instance also the blessing given to Jacob, "With corn and wine have I sustained him": corn, the source of the staff of life, and wine to make glad the heart of man, being selected as symbolising the general material and temporal prosperity which the expression was meant to convey. The proverbs that are found in the literature and speech of almost all races of men are a further illustration of this delight in a picture-language.

Symbolism may be of action. It may be seen in the smoking of the pipe of peace and the burial of the war hatchet amongst the Sioux, in the passing round of the loving cup at the banquets of the city magnates. The rites of the Levitical priesthood afford many examples. The Arab custom of tasting salt with one's guest is a binding symbol of amity thereby established; and many other illustrations will readily occur to our readers.

Symbolism may be of number. Examples of this section, though frequently to be encountered, often escape notice, as they do not so clearly and immediately reveal their meaning as

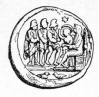

fig. 1

some other forms of symbolic treatment do. Threefold arrangements, such as a three-light window, a trefoil, or triangle, ordinarily symbolise the Trinity when found in Christian art. Pythagoras calls three the number of completion, expressive of beginning, middle, and end. The number was a favourite one in classic mythology, where we meet with the three-headed Cerberus, the three Fates, the three Furies, the three Graces, while the Muses are three times three in number. The wise men, or kings, or Magi, who followed the guiding star to Bethlehem were three in number, according to generally accepted tradition. In fig. 1, the reverse of an early medal, we have a representation of the visit of the Magi, three in number, to the infant Christ.

While we must be careful not to read meanings where they were never meant or intended, the number four will ordinarily in Christian art represent the evangelists; while six stands for the attributes of Deity,—power, majesty, wisdom, love, mercy, justice.

Seven has by old writers been called the number of perfection, and it is curious to notice how often this idea seems to be involved in its use. Thus to quote some few representative examples out of many: Balaam, as an effectual test of the will of God, built seven altars and prepared seven oxen and seven rams from sacrifice. Job, in referring to the effectual protection of Providence, says, "In seven troubles there shall no evil touch thee"; and again, "Wisdom hath hewn her seven pillars." Jacob, as a sign of perfect submission, bowed himself seven times before his brother. The sevenfold circuit of Jericho prior to its complete overthrow is another example. Naaman was commanded to bathe seven times in the Jordan as a prelude to his complete restoration to health. Samson for full security was bound with seven bands. The Jewish Church has seven great holy days in each year. The Romish Church has seven sacraments. On the first appointment of

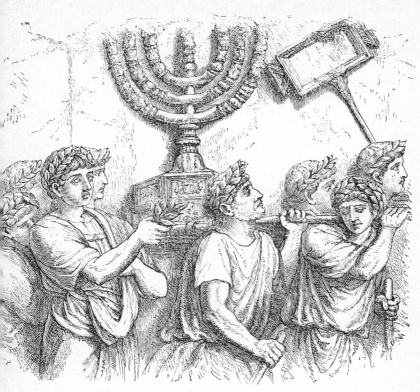

fig. 2

deacons in the early Christian Church seven men of honest report were to be chosen. "How oft shall my brother sin against me, and I forgive him?" The question suggested seven times as the limit of endurance of wrong. The golden candlestick of the Jewish temple was seven-branched. It is represented in fig. 2, a portion of one of the sculptured panels on the triumphal arch of Titus at Rome. The great apocalyptic angels are seven in number; and Ephesus, Smyrna, Pergamos, Thyatira, Sardis, Philadelphia, Laodocea were the seven Churches of Asia. In the same book we read of seven candlesticks, seven stars, seven trumpets, the seven spirits before the throne of God. Pharaoh in his dream saw seven oxen and seven ears of corn. On the seventh day of the seventh month a holy observance was ordained to the children of Israel, who feasted seven days

In the Talmud we read that over the throne of king Solomon hung a chandelier of gold with seven branches, and on these the names of the seven patriarchs, Adam, Noah, Shem, Abraham, Isaac, Jacob, and Job, were engraven. On the second row of the branches were engraved the names of the "seven pious ones of the world": Levi, Kehath, Amram, Moses, Aaron, Eldad and Medad.

13

and remained seven days in tents. The seventh year was to be observed as a Sabbath, and at the end of the seven times seven came the great year of Jubilee.

When we shall, later on, deal with the attributes of the Trinity, mention must be made of the sevenfold gifts of the Holy Spirit. At the creation of the world the seventh period marked its completion. Psalms vi., xxxii., xxxviii., li., cii., cxxx., cxliii., are those known as the seven penitential psalms from their especially contrite character. There are also seven deadly sins. The seven joys and the seven sorrows of the Virgin mother are frequently represented in the art of the Middle Ages. The first series comprises the Annunciation, the Visitation, the Nativity, the Adoration of the kings, the Presentation in the temple, the Finding of Christ among the doctors in the temple, the Assumption. The seven sorrows are the prophecy of Simeon, the flight into Egypt, Christ missed in the temple, the betrayal of her Son, the Crucifixion, the Deposition from the Cross, and the Ascension.

There were also seven great councils of the early Church; while in the Roman Catholic service of consecration of a church, the altar is sprinkled seven times in remembrance of the Lord's Passion and the seven outpourings of His sacred blood. "The first whereof was at circumcision; the second, in prayer in the garden; the third, at the scourging; the fourth, from the crown of thorns; the fifth, from the pierced hands; the sixth, when His feet were nailed to the cross; the seventh, when His side was wounded by the spear."

There are in addition the seven champions of Christendom; St. George of England, St. Andrew of Scotland,, St. David of Wales, St. Patrick of Ireland, St. James of Spain, St. Denys of France, and St. Anthony of Italy.

We read too of the seven wonders of the ancient world. As a matter of fact there were eight, but in any list there is an "or," and not an "and," where they are enumerated. This verbal

The first oecumenical synod at Nicaea, under Constantine the Great in the year 325, against the errors of Arius. The second at Constantinople, under Theodosius the Great in the year 381, against the heresy of Macedonius in denying the Divinity of the Holy Spirit. The third at Ephesus, under Theodosius in 431, against Nestorius. The fourth at Chalcedon, under Marcian in 451, against Eutyches and Dioscuros, who asserted that there was only one nature in Christ. The fifth at Constaninople under Justinian in 553, against Origen. The sixth at Constantinople also, under Constantine Pogonatus in 680, against Honorius, Sergius, and Pyrrhus; and the seventh at Nicaea, under Constantine and Irene in the year 787, against the Iconoclasts.

14

difference may seem trifling; but while the use of the latter word would make the total eight, the use of the former sacrifices one on the list to the desire to bring the total to the mystic number of perfection. We have also the seven wise men of Greece, while Shakespeare gives us the seven ages of man, from puling infancy to decrepit old age. The Hindus believe in seven mansions of all created spirits, the earth being the lowest of these, while the seventh and highest is the seat of Brahma. The Moslem pilgrimage is at last consummated when seven circuits have been made round the sacred stone at Mecca. The astronomers tell us of seven greater planets, the alchemists dealt with seven metals, and we all of us recognise seven days in each week. With our forefathers the period of apprenticeship was seven years, and Jacob for the love he bore to Rachel was willing, in the old world story, to serve Laban for as long. The lease of a house is often for seven, fourteen, or twenty-one years; and when we desire to give a rogue his deserts, he goes off to penal servitude for a like period. In the eyes of the law the stripling enters into manhood, with its contingent rights of sueing and being sued, paying his own debts, and serving on a jury, when three times seven years have gone over his head; while the tenth seven marks the natural period and duration of human life.

Eight is the number of regeneration, hence by far the greater number of the old fonts and baptistries are octagonal. Twelve, the number of the apostles, has naturally been a somewhat favourite number in art symbolism, being applied not merely in this more limited sense, but also in a more extended meaning, as representative of the Church generally. As an example of the mystical meanings often attached to numbers we may quote the words of St. Augustine where, after referring to the passage in St. Paul, "What, know ye not that the saints shall judge the world?" and explaining that the twelve thrones represent the twelve apostles, he goes on to say: "The parts of the world are four: the east, the

west, the north, and the south. From these four, saith the Lord in the gospel, shall the elect be gathered together. Called, and how? By the Trinity. Not called except by baptism in the name of the Father, and of the Son, and of the Holy Ghost; so four parts each called by the Three make twelve."

Nine as a number scarcely appears in Christian art, though Milton writes that the gates of Hell are thrice threefold, three of brass, three of iron, three of adamantine rock, and tells us that when the fallen angels were expelled from heaven "nine days they fell." A sense of completion has been associated with the number. There were nine Muses. In the "Lays of Ancient Rome," it will be remembered that Lars Porsenna swears by the nine gods; while in our own experience we still see leases granted for ninety-nine years. We have been taught that it takes nine tailors to make a man; that a cat's tenacity of life is equal to nine times that of other animals; that possession is nine points of the law; while we can pay the hero of the banquet no higher compliment than to toast him with three times three. The witches in "Macbeth" for the effectual working of the charm sing around the caldron—

"Thrice to thine and thrice to mine
And thrice again, to make up nine."

The ten petals of the passion flower represent the apostles in the mystical meanings that have been associated with the flower, since among the twelve one betrayed and one denied his Lord.

The number forty is expressive of a period of probation or trial. The Israelites wandered forty years in the wilderness, and forty years of bondage they also had to serve under the hard yoke of the Philistines. Moses was forty days on the mount of Sinai. Elijah was in hiding forty days. For forty days the deluge fell, and for yet

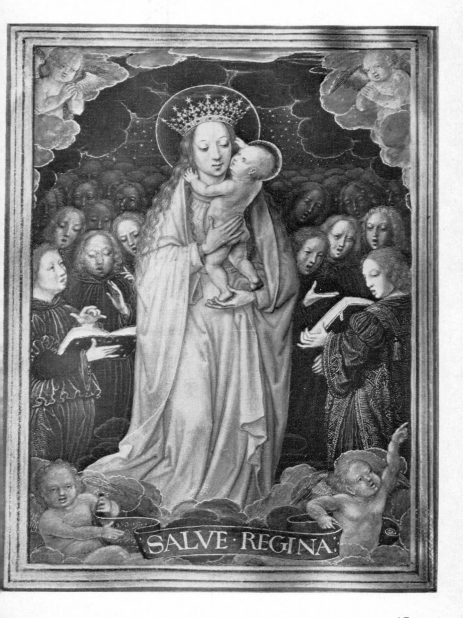

SALVE · REGINA ·

17

another forty days Noah was shut within the ark. The men of Nineveh had a like period of probation under the preaching of Jonah. The fasting of our Lord in the wilderness again was for forty days. Our readers will remember too that St. Swithin's Day is still anxiously looked for by many who believe that a very possible forty days of wet weather is in store for them; while many old legal observances were based on this number, such as the privilege of sanctuary, the duration of quarantine, and so forth.

We pass now to a consideration of the influence of colour, and of the meanings that have been assigned to the various tints employed.

White has ever been accepted as symbolic of innocence of soul, of purity of thought, of holiness of life. Hence the priests of the great divinity Osiris were robed in white, and thus too were the priests of Zeus. The ministers on the worship of Brahma, and the initiated in the Druidic rites, like the Vestal Virgins, wore robes of the same spotless hue. When the sins that are as scarlet shall have been made as the untrodden snow, that soul shall stand amidst the great army of the redeemed, clothed in stainless garb of white. Hence in the early ages of the Christian Church those admitted into its fellowship wore white garments. In 2 Chronicles v. 12 we read that the Levites at the dedication of Solomon's temple were "arrayed in white linen." At the transfiguration of Christ "His garment," St. Matthew tells us, "was white as the light," while the angel at the tomb of the Saviour was clothed in "raiment white as snow." The Apocalypse yields several illustrative texts of a like nature.

In the Pontifical of Bishop Clifford, Bishop of London from 1406 to 1426, we read, "Albus color inter omnes colores est prior purior, simplicior, et festivior." St. Jerome speaks of bishops, priests, and deacons being arrayed in white in his time, and the white surplice of the clergy is as marked a feature to the present day. It is used at all Feasts and at all seasons relating to the Lord that are not associated with

"He was transfigured before them. And His raiment became shining, exceeding white as snow; so as no fuller on earth can white them" (St. Mar Mark ix. 2, 3).

18

suffering; such as the Annunciation, Presentation in the temple, Epiphany, and Easter. It is also associated with the blessed Virgin and to those saints who were not also martyrs; used too at dedication and harvest festivals, at confirmations, and at weddings.

In the Middle Ages white was the general Lenten colour; not from its association however with the idea of rejoicing or of purity. Its use probably arose from the custom of covering the altars, reredoses etc., during Lent with white cloths, as signifying the absence or veiling of all colour; and thus regarded, its use during Lent is neither unseemly nor inconsistent. Later on the original meaning was not so strictly regarded, and instead of the plain linen covering, silk and other rich materials were introduced, and both vestment and altar covering became embroidered or painted with symbols of the Passion.

The old church inventories supply us with many excellent illustrations of this use. Thus, for example, at St. Cuthbert's, Wells, in the year 1393, we find in use " one white cloth for hanging in time of Lent." At St. Nicholas', Bristol, A.D. 1432, "viij clots of wt crucyfyx for leynt." At St. Margaret's, Southward, 1485, "iiij whyte frontelles with Red crosses for Lente seson"; and at Westminster Abbey in 1540, "a white clothe of sylk with a red crosse servying for Lent." The white hangings were exchanged for red during the last fortnight of Lent; while Good Friday varied from red, through purple and violet, to black.

Several portraits of Mary Queen of Scots are extant in which she is depicted as wearing white for mourning on account of the death of her first husband, Francis II. of France. The custom was by no means rare at that period. Elizabeth of England is recorded as wearing "Le Deuil blanc" for example, and several other instances could be cited. In China it is invariably the colour of mourning. At funerals the chief mourners wear robes of white, while friends don a sash of white in lieu of our crape trimming. The visiting cards

At the coronation of Charles I. the royal robes were of white satin. The previous sovereigns had always been attired in purple; but Charles being crowned on the Feast of the Purification, deliberately elected to be robed in white in honour of the feast day and "to declare the virgin purity with which he came to be espoused to his kingdom." This he did, notwithstanding a very threatening prophecy, popularly attributed to Merlin, of the disasters of all kinds that would attend the coming of a "White King" to the throne of England. Herbert records that at the king's funeral "the sky was serene and clear; but presently it began to snow, and fell so fast as by that time they came to the West end of the Royal Chapell the black velvet pall was all white (the colour of Innocency), being thick covered over with Snow. So went the White King to his grave."

used must be of white in place of the ordinary crimson. After a while salmon-coloured cards are substituted, then those of a deeper red, till ultimately the deep crimson cards are resumed. Any letter sent or received during this period of mourning must be upon white paper.

It has been held that the symbolic colours used in the Middle Ages in the services and adornment of the church were based on those used in the temple service in the vestments of the high priest and the hangings of the sanctuary under the Jewish dispensation, and that the liturgical colours of the mediaeval Church would naturally be allied to the Levitical; but the facts are altogether against this theory. In the early Christian Church the rites were celebrated in a vesture that only differed from that of every-day life from its greater costliness and richness of quality. Even as early as the tenth century certain colours were associated with particular days, and were ascribed with liturgical authority and significance. In the Greek Church, according to the "Enchologion" of Goar, published at Paris in the year 1647, only two colours were in use, purple for the Lenten and other fasting days, and white for all other occasions. Amongst the Armenians there are no special colours in use; while in the Churches of the West where such symbolic vestments are in service there is a great diversity of custom. Had the colours been handed down from the temple observances we should have found all Christian Churches probably equally ready to employ them,and there would have been no divergence in the use from the old standard.

It has been fancifully and poetically pointed out that if every virtue has its own colour, white, the colour of light, being produced by the blending of all the tints in the spectrum, may with peculiar appropriateness be employed as a symbol of the union of every virtue. Whatever poetic idea however we may read into old observance, we must carefully distinguish between historic fact and ingenious afterthought; and

there is no doubt that the grand discovery of Newton was not at the service of the mediaeval ecclesiastics.

The old writers on heraldry often delighted to throw a glamour of symbolism over their science; hence we find Guillim, for example, writing, "The colour White is resembled to the Light, and the Dignity thereof reckoned more worthy by how much the more the Light and the Day is of more Esteem than Darkness and the Night." The subject, from the heraldic point of view, may be very well studied in "La vraye et parfaite Science des Armoires," published at Dijon in the year 1660. Other curious old authorities on the symbolism of colours are Krausen's "Dissertatio de Colore Sacro, speciatim Vestibus Sacerdotalis," published at Wittemberg in 1707, and the book of Innocent III., entitled "De Sacro Altaris Mysterio." This is the pope, it will be remembered, that king John was so unfortunate as to differ in opinion from, and his book is the earliest on the subject, dating from the year 1198.

It is somewhat curious, symbolism of colours being once recognised in the Western Churches, to find such a divergence of custom, as it might naturally be supposed that some definite and binding ordinance on the point, some precise code of rules, would have been forthcoming. Directly however we look into the matter and refer to the "uses" of the various dioceses, we are struck with the difference in practice. Thus while white is held to be the appropriate colour for Trinity Sunday in Rome, Milan, Troyes, Sens, Auxerre, Rouen, and Lyons, we find green in use at Rheims and Exeter, yellow at Poictiers, blue at Toledo, violet at Soissons, red at Laon, Coutance, Wells, and Cologne. All these colours have their legitimate and appropriate meaning, white for instance, typifying the spotless dignity of the Godhead, while the violet, very sparingly found, characterizes the obscurity of the mystery of the Divine Trinity; but the divergence from uniformity is striking.

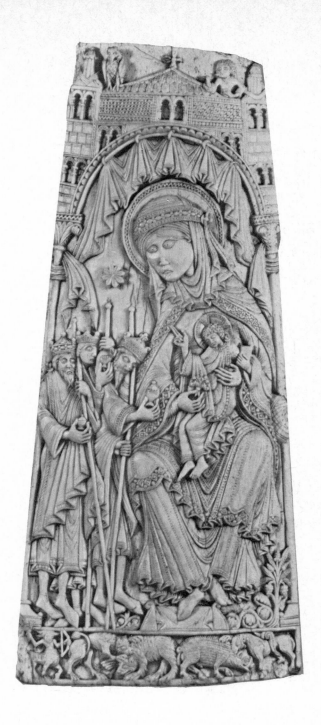

Yellow is comparatively but seldom met with.
It is a good example of the fact the student in
colour symbolism must by no means overlook,
that a colour may be employed either in a good
or a bad sense, and it is therefore often necessary
to judge from the surroundings before we are
able to assign a definite meaning to any colour.
In France, during the sixteenth century, the
doors of felons and traitors were painted yellow;
and in some countries the Jews were required to
wear yellow, because they denied the Messiah. It
is the colour of jealousy and treason, and Judas is
often represented in old glass painting in a yellow
robe. Where however it is represented by gold, or
is substitute for it, it signifies love, constancy,
dignity, wisdom; thus one of the early Fathers of
the Church was called Chrysostom, the golden
mouth, from his eloquence and wisdom. "This
colour in Arms is blazed by the name of Or,
which is as much as to say Aurum, which is Gold.
It doth lively represent that most excellent
Metal, the possession whereof enchanteth the
Heart of Fools, and the Colour whereof blindeth
the Eyes of the Wise. Such is the Worthiness of
this Colour, which doth resemble it, that none
ought to bear the same in arms but Emperors and
Kings, and such as be of the Blood Royal. And as
this Metal exceedeth all others in Value, Purity,
and Fineness, so ought the Bearer (as much as in
him lies) to endeavour to surpass all other in
Prowess and Virtue."

We are told by Verrius that Tarquinius Priscus
wore a tunic of gold, and we read too that
Agrippina, the wife of the emperor Claudius,
had a robe made entirely of woven gold. When
the tomb of the wife of the emperor Honorius
was opened in the year 1544 the golden tissue
that had enwrapped her was still intact, though
she was interred in the year 400; and when the
fowndations for St. Peter's at Rome were being
excavated, the workmen came upon the marble
sarcophagus of an illustrious Roman, Probus
Ancius, and his wife, each of whose bodies was
encircled in a robe woven of pure gold. Another

regal association, and one more familiar, will be found in the Field of the Cloth of Gold. Biblical illustrations of its use as a symbol of royalty and power are abundant, as for instance when king Belshazzar bestowed a chain of gold upon Daniel and made him third ruler in his kingdom, and when the king of Hamath sent an embassy to salute king David, and presented his brother ruler with vessels of gold.

Red, as applied to spiritual virtues, signifies an ardent love, a burning zeal for the faith; in mundane virtues, energy and courage; in an evil sense, cruelty and blood-guiltiness. It is used on the feasts of martyrs and at Whitsuntide. In the former case it speakes of the blood which was shed for Christ, and in the latter of the tongues of fire which descended upon the apostles. Hence, in the inventory of Westminster Abbey, of the year 1388, we find "albae rubeae pro Commemoratione Apostolorum," and in that drawn up about the year 1540 and "albe of sylk with parells of red nedyll work, etc., servyng for the chaunter at ye feast of Seynt Peter." In the pontifical of Bishop Clifford we find the various colours referred to, and the several occasions when they are to be used; and it is there stated, "Rubeus color igneus est et sanguineus: caritati Spiritus et effusioni sanguinis consimilis."

The Good Friday colours we have seen have varied from red through purple or violet to black, but the majority of the old inventories give red or purple. Thus, in the list of vestments made in the year 1432 at St. Nicholas', Bristol, we find "j fede chysypull for gode fryday." We find also in the inventory of Peterborough Abbey, A.D. 1539, "red albes for passion week."

In the catacombs of Rome many of the paintings are evidently portraits of the persons buried there. Of these, several very interesting examples may be seen in the National Gallery. They are ordinarily accompanied by paintings of scriptural subjects or by symbols indicative of the faith of the deceased, who is usually attired in a flowing dress closely resembling surplice and

stole. The surplice is either white, the symbol of the purified soul, or red, as washed in the blood of Christ; and the stole is the symbol of the yoke of Christ, borne over the shoulders.

According the Guillim, "heraldically red representeth fire, which is the chiefest, lightsomest, and cleareast of the Elements. This colour inciteth courage and magnamimity in persons that do grapple together in single or publick fight." We read that those that "strengthened their battels with Elephants, when they would provoke them to fight, produced before them resemblances of the martial colour, as the blood of Grapes and of Mulberries,"—an analagous proceeding apparently to waving a red flag at a bull. The colour has a curiously exciting effect on various animals. It is a sure provacative of the grotesque ire of the turkey-cock, and we remember an old man in the country who supplied adders' fat as a rustic remedy, who used to angle successfully for his game amongst the heath and furze with rod and line, having a piece of scarlet cloth attached.

This idea is clearly based on the thirty-fourth verse in the sixth chapter of the first book of Maccabees: "And to the end that they might provoke the elephants to fight, they showed them the blood of grapes and mulberries."

Whatever the ceremonial colour of the day may be, the Pope when he hears mass is vested in red, and at his death he is clothed in the same colour; while we need scarcely remind our readers that it is also the colour of the cardinal's robes and hat. Our familiar phrase, "a red letter day," a day of good fortune and happiness, refers to the old custom of printing the saints' days in red ink. On the other hand, the red flag is the symbol of insurrection and terrorism.

In China five symbolical colours are employed. "Red is appointed to fire, and corresponds with the south; black belongs to water, and corresponds with the north; green belongs to wood, and signifies the east; white to metal, and refers to the mist," says the commentator Li-ki. Yellow is apportioned to the earth. What led to this division of colours seems scarcely clear in some of the cases; but it is known to have been in force over a thousand years before the Christian era, so that it has at least antiquity in

There is considerable question amongst commentators as to what the biblical colours were, and we must not necessarily conclude that the scarlet of the Bible is the same thing as the scarlet of a Life Guard's tunic. The word rendered scarlet is in the original tola, *a word signifying a worm. Besides the dyes produced from the murex, a crimson or scarlet was in ancient times derived from an insect allied to the cochineal, and called by the Arabs the* kermes *(hence our modern word carmine); and it is highly probable that this would be the source of the "worm-dye." Our modern word vermillion carries the same significance, a colour derived from a worm, though the facts of the manufacture do not in this case bear out the name of the pigment.*

In "the good old times," before school boards and Civil Service examiners, spelling gave our ancestors but little anxiety. We find this word in the different inventories and documents of the Middle Ages appearing not only as above, but as chysypull, chesebyll, chesebull, chesable, chyssypull, etc., etc.

its favour. Red holds a conspicuous place in the Chinese marriage ceremony.

The term red is after all somewhat vague, and includes two colours so far distinct as scarlet and crimson. It is often difficult to determine what the ancient colours were, partly from our inability to decide what such terms as *purpureus, hyacinthus,* and *coccineus* conveyed to those who used them, and partly on account of the changeful effect of time on paintings, embroideries, and the like. It has been suggested that the ancients had either a very limited colour vocabulary or were absolutely less gifted with a sense of colour, or else we should scarcely find, as we do, one word, *purpureus,* doing duty as descriptive of the colour of the sea, of the sunrise, of the poppy flower, of the fruit of the fig, of the human hair, of blood, and many other things. It is also shown by Dr. Wickham Legg in his excellent work on " The History of the Liturgical Colours," that the same ignorance prevails as to the value of the mediaeval words rubeus, blodius, and others. It will be noted that St. Matthew says that the soldiers in mockery placed on Christ a scarlet robe, while St. John calls it purple.

Scarlet is ordinarily found in the Bible as a symbol and sign of honour and prosperity. It entered largely into the adornment of the tabernacle. The daughters of Israel are mentioned in 2 Samuel i. 24 as "clothed in scarlet, with other delights." The ideally good wife of the last chapter of Proverbs has her household "clothed with scarlet," and the merchandise of the great city mentioned in Revelation xviii. 12 included "gold and silver and precious stones, pearls, fine linen, purple, and silk, and scarlet."

In ecclesiastical and other decorative work we ordinarily meet with crimson as the red employed rather than scarlet, the latter being too crude and garish. Thus to give but one example out of many, we find in the inventories of Westminster "a cope, a chezabull, etc., of crymsyn serving for Palme Sonday."

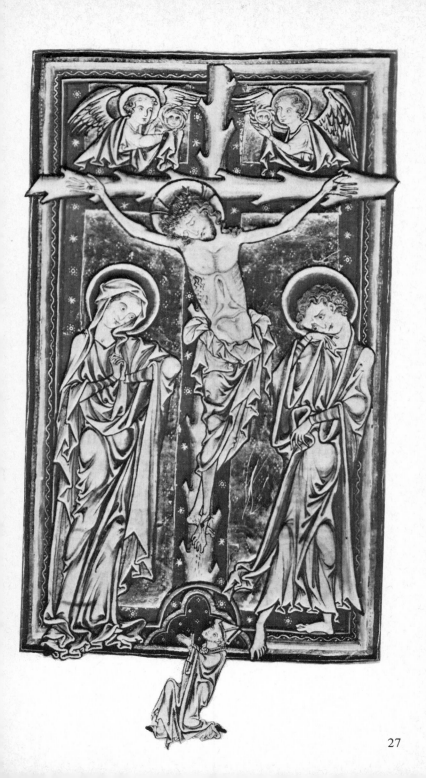

Green, the characteristic colour of the Spring-time, when all Nature appears to revive again, and in the bursting buds and blossoms gives rich promise of future fruitfulness, is naturally associated with hope. Hence, while the Easter ecclesiastical colour is almost everywhere white, as for example at Salisbury, Paris, Toledo, Cologne, and Milan, and Soissons Cathedral we find it replaced by green. "The Latins call it viridis," said an old author, "in regard of the strength, freshness, and liveliness thereof; and therefore it best resembleth youth, in that most vegetables so long as they flourish are beautiful with verdure. It is a colour most wholesome and pleasant to the eye." In the pontifical of Bishop Clifford, written in the fifteenth century, we read, "Virdis color vividus est et visu jocundus atque comfortaturus."

Amongst the ancient Britons a strict rule limited the colour of the official dress assigned to each of the ranks of the bardic order, spotless white, as we have seen, for the druid or priest; sky-blue for the bard or poet; and green, the verdant decking of wood and downland, for the teacher of the virtues of herbs and the mysteries of leech-craft.

Durandus associates with green the idea of contemplation, an interpretation that it may well bear, since the lover of nature is ever thoughtful; hence Wordsworth exclaims, *"To me the meanest flower that blows can give, Thoughts that do often lie too deep for tears."* Young affirms "the course of nature is the art of God." Chaucer calls Nature "the vicar of the Almightie Lord," while the Bible abounds in passages teaching the same truth. "All Thy works shall praise Thee, O God, and Thy saints shall bless Thee. Praise ye Him, sun and moon; praise Him, all ye stars of light, mountains and all hills, fruitful trees, and all cedars."

Green in mediaeval days was ordinarily associated with the Feast of the Trinity. Hence, in the instructions of Bishop Grandisson of Exeter, issued to his clergy about the year 1337, we find

the direction, "On the feast of Trinity, if they have beautiful green vestments with copes, tunicles, and dalmatics in a sufficient number for such a feast, they must be used: otherwise let wholly white or light vestments be assumed."

Shakespeare in "The Merchant of Venice," writes of "green-eyed jealousy," and again, in Othello: *"O beware, my lord, of jealousy; It is the green-eyed monster."* In many ways green was regarded in mediaeval folk-lore unfavourably, from its supposed association with the fairies, and from divers other superstitions that need not here be set forth, since our space can, we think, be better appropriated.

It is curious to find that in some of the Italian liturgical books green is given as an alternative for black in the office for the dead. It may be so found for example in the "Liber Sacerdotalis," printed at Venice in 1537, and in the "Liber Clericorum," A.D. 1550.

Blue, the colour of the clear sky, does not carry on its face so evident a meaning as the purity of spotless white, the burning ardour of glowing red; hence it has somewhat arbitrarily been taken to represent eternity, faith, fidelity, loyality, truth, spotless reputation. It was one of the Levitical colours, and many references to it will be found in Exodus, in the description of the tabernacle and of the priestly robes. In the book of Esther we read of Mordecai "in royal apparel of blue and white," but this probably should rather be rendered purple.

"Blew, which colour," says an old writer, "representeth the Aire amongst the elements, is of all the rest the greatest favourer of life, as the only nurse and maintainer of vitall spirits in any living creature. The cullor of blew is commonly taken from the cleere skye, which appeareth so after that the tempests be overblowne a prosperous successe and good fortune to the wearer in all his affayres."

The Earl of Surrey, in his "Complaint of a Dying Lover," associates the idea of loyalty and devotion with blue in the lines, *"By him I made*

Rubbing of sepulchral brass of Simon de Wensley, Rector, at Wensley, Yorks. Late 14th century.

Brass rubbing from the sepulchre of Sir Thomas Bullen, K.G. 1538.

his tomb, In token he was true, And as to him belonged well, I covered it with blue." Chaucer, again, in the "Court of Love," writes, *"Lo, yonder folke (quod she) that knele in blew, They wear the colourage, and ever shal, The signe they were, and ever will be true, Withouten change."* "True blue" is now generally associated politically with the Conservative party.

Other political colours are the orange of the Ulsterman, the green of the Irish Nationalist, the white of the Bourbon and the Stuart, the black of the House of Hanover, the red and white roses of Lancastrian and Yorkist, the violet of the Napoleons, and so forth.

Purple has always been associated with royal majesty, and accepted as the sign of imperial power. Thus in ancient Rome the toga of the emperor, or of conquerors on the day of their Triumph, was purple. The Babylonians and other Eastern heathen nations used to array their gods in purple robes. Homer intimates that garments of this colour were worn by princes alone, and a very early illustration of this royal use will be found in Judges viii. 26, where the kings of Midian, defeated by Gideon, are described as being clad in purple raiment. The pre-eminence still given to purple is no doubt a result of the old regal association. Probably the ancient preference arose when the relative superiority in beauty and brilliancy of purple to other colours was greater than at the present day, as the Tyrian dye prepared from shell-fish was highly esteemed, and the Phoenicians excelled all others in the manufacture of these pre-eminently beautiful garments.

Ecclesiastically purple and violet have borne an entirely different significance, being devoted, not to imperial pomp, but to penitence and fasting. "La couleur violette," says Malais, "représente l'obscurité, las tristesse, et la pénitence"; and amongst other items we find in the inventory, dated 1466, of a London church, "j purpyll chesebyll for gode fryday." Though white has ordinarily been used as the liturgical colour for

Illuminated bible in latin. Ninth
century. British Museum.

Epiphany, violet has occasionally in some "uses" been substituted, in allusion to that text in Isaiah where the Gentiles are walking in darkness until the Epiphany manifestation has shone upon their path: "Populus qui ambulabat in tenebris vidit lucem magnam." Still more rarely green has been employed the colour of hope, to symbolize the ingathering of the Gentiles that till then had been outside the fold.

Gray or ash-colour has sometimes been substituted for purple as the Lenten colour, and more especially on the Continent. Its use of course suggested by the ashes distributed on the first day of Lent. Claude Villette in his book "Les Raisons de l'Office et Ceremonies qui se font en l'Eglise," published in 1648, speaks of it as "couleur de terre, cendre, et pénitence." In the inventory of the church property of Exeter Cathedral, A.D. 1327, we meet with "una capa cinerei coloris pro Die Cinerium." Liturgically, gray, blue, and violet and even white, are treated as alternative and secondary colours to black.

Black, suggestive of the material darkness and gloom that follows the withdrawal of the cheering light of day, is meet symbol of the spiritual darkness of the soul un-illumined by the Sun of righteousness. We see therefore how appropriately the title "Prince of Darkness" is applied to the arch-tempter, the great enemy of the souls of men. It is the colour of mourning, of shame, and of despair—"black despair, the shadow of a starless night," and of *"all the grisly legions that troop Under the sooty flag of Acheron."* In the apse of one of the Greek churches is a fresco of the Last Supper. All the apostles have the nimbus; but while those of all the other apostles are bright in colour, that of poor lost Judas is black as the gloomy path of Erebus, the valley of the shadow of death that led to Hades.

Shelley.

Milton.

"Whatsoever Thing there is that hath in it either Light or Heat, or else a Life, either Animal or Vegetable, the Same being once extinct, the Thing itself becometh forthwith Black, which is

said to be the colour of Horror and Destruction; for which respect mourning Garments are made of that Colour that doth most significantly represent the Horror of Death and Corruption."

In Byzantium the emperor wore white on the death of a kinsman, as black garments were forbidden within the palace; and the same rule is, we are aware, rigidly enforced at the present day at the court of Morocco.

On the conquest of Jerusalem in 1099, the crusaders installed a patriarch over the church of the Holy Sepulchre and attendant Augustinians, and in their liturgical formulae we find the strange fact that all feasts of the Virgin were to be marked by black. "Omnes sollemnitates beate Marie cum pannis et vestibus nigris." In all other service books white is the invariable colour. It has been suggested that its use had reference to the passage in the Song of Solomon, "I am black, but comely"; but there seems no reason why on such ground the church at Jerusalem should make so marked a departure from universal custom. Can it possibly have been from a feeling that Jerusalem was the scene of the betrayal and crucifixion of the Divine Son, and that whatever homage might elsewhere be meetly paid to the virgin purity of Mary must at the scene of her bitter sorrows give place to the sadder memorial of heart-breaking anguish?

In the thirteenth century it was the custom on Christmas Eve to have a threefold vesting; first of black, to signify the time before the declaration of the law to Moses; on the removal of this, white, to indicate the days of prophecy; and then red, to symbolise the love and charity to mankind that the coming of the Christ brought into the world.

In an inventory of 1407 we find the item, "an hole vestiment of blac for masse of requiem"; while in another, dating from about 1540, we come across "a pair of curteynes black for dyrges."

Black was in the Middle Ages associated with witchcraft. It is naturally a type of darkness, and

therefore the transition to moral darkness and dealing with familiar spirits is readily made; hence such incantations and invocations of diabolic power were naturally known as the black art. Almost all allusions to the colour have a touch of the disquieting element in them. Thus a man who would fain get into a somewhat exclusive club fails to do so because he is black-balled; he loses his cash through black-mail if he is so unfortunate and weak as to yield to the menaces of a black-leg.

Leaf of an early Christian ivory diptych showing the Archangel Michael. Probably made at Constantinople early 6th century. British Museum.

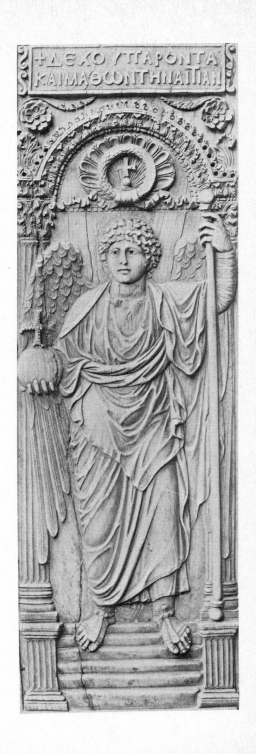

Chapter 3

Representations of the Trinity do not appear till somewhat late in the history of art. Figures or symbols of the Saviour may be met with at a very early period, as also the dove and other symbolic forms of the Holy Spirit; but for centuries no sculptor or painter ventured on any symbol of similitude of the first Person of the Trinity. Why this was the case we shall see later on, when we deal with the three Persons individually.

While we find amongst the Hindus a Trinity of Deities,—Brahma the great creator, who presides especially over the earth, Siva the destroyer, who reigns over fire, and Vishnu, whose empire is the water; and amongst the Greeks and Romans, Zeus or Jupiter reigning over earth and heaven, Poseidon or Neptune controlling the sea, and Aïdoneus or Pluto the governor of the shades of Hades;—the Triune God of Christendom is a Trinity of almighty Power, of boundless Love, of beneficent Wisdom.

Theophilus, bishop of Antioch, who flourished in the second century, was the first who used the word trinity to express the three sacred Persons in the Godhead, and the doctrine it expresses has been generally received amongst Christians. No reference will be found to it in the Old Testament, but in the New it is very explicitly set forth in the directions as to the rite of baptism in Matthew xxviii. 19, and in other passages.

In the National Gallery will be found a picture by Garofalo entitled, "The Vision of St. Augustin." Augustinus, bishop of Hippo, and one of the Doctors of the Church, relates that while engaged in a work on the Trinity, he had a vision in which he saw a child endeavouring with a ladle to empty the ocean into a hole which he had made in the sand; and upon the saint pointing out to him the uselessness of his toil, the child retorted by observing how infinitely more futile was the endeavour to explain what the Deity had left an inscrutable mystery.

Amongst later Italian painters the "Trinità," a conventional representation of the Godhead, was

a favourite subject. A very good typical example may be seen in the National Gallery, by Pesillino, in which we see Christ extended upon the cross while the Dove hovers above. The Father is seated, surrounded by cherubim and seraphim, and with outstretched hands beneath those of the Saviour sustains the weight of the cross. In other representations all three Persons are given in human form, the Father as an aged man, the Son and Spirit being younger looking; while in some few cases all three are as exactly alike, to carry out the idea of perfect equality, as the artist could make them. In such cases one extended cloak frequently enwraps all three figures, while one figure holds a globe, the emblem of dominion, the second the cross of sacrifice, while the third bears a roll or book, the attribute of wisdom. In the old church records we often find mention of representations of the Trinity, but unfortunately so briefly given, that we get no hint of the composition of the group. Thus in a parish book of St. Christopher's, London, dated 1488, we find "a chales with a patent of silver with a Trinite weyng xxi owncs," and "ij cloths stained white for thappostles altar, above with the Trinity and beneath with Our Lady," and yet again, "a Banner-Cloth with the Trynyte theryn." Illuminated manuscripts often supply illustrations, and in far better condition than the sculptures on fonts and elsewhere, that by stress of time and puritanical violence are so far disfigured as to make identification of subject often mere guesswork.

A picture of the Madonna and Holy Child by Domenico Veneziano, in the National Gallery, supplies us with another variation of treatment of the subject. In the "Trinità" we see suffering Christ; in other examples, as in some we have referred to, He appears with the other two Persons in strict equality, co-ruler with them of heaven and of earth; but in another class, of which this picture is a good example, Christ is the babe of Bethlehem standing on the Virgin mother's knee, or enfolded in her arms, while the

Dove hovers over the group, and, above all, the Father bends down from heaven with arms outstretched in love and protection. While there is often in such representations a treatment that gives us a sense of shock and irreverence, we must nevertheless bear in mind that in all such cases intention is everything, and the intention undoubtedly, whatever we may now think of its expression, was beyond question reverential, and must be jedged from that standpoint alone.

Three very different reasons influenced the artists of the early Christian period in their avoidance of any representation of the first Person in the Trinity—policy, reverence, and irreverence.

Jehovah, the eternal Father, "the Lord, strong and mighty, the Lord mighty in battle," He "who hath measured the waters in the hollow of His hand, and meted out heaven with the span," before whose almighty power Abraham and Job and all the sons of men are but as "dust and ashes," was in attributes too much like the Jupiter of the old religion to make it at all advisable to attempt a personification that would possibly remind the converts to the new faith of the great Olympic idol that they had so lately worshipped, while it was scarcely possible for even the most ignorant to confound the loving Redeemer, Christus Consolator, with any creation of pagan mythology. While the Word was made flesh and dwelt amongst the sons of men, the glory of God the Father has had no visible manifestation, for "no man hath seen God at any time." The glorified humanity of Christ was at least attemptable, but the ineffable majesty of "the King of Glory" was infinitely beyond all human imagination or the loftiest ideal: hence not policy alone, but a feeling of the deepest awe and reverence was a restraining influence. Later on, when the new religion had become more established, and a generation arose who had never bowed the knee before the shrine of Jove, the necessity for avoiding any representation that might suggest the old religion

became needless. It may at first sight appear that it is a dishonour to Jehovah to suggest a comparison with Jupiter; but we must bear in mind that while the actual difference is infinite, such men as Phidias and other great artists had invested the images of the gods of Greece and Rome with the highest and noblest art that the world has ever seen, forms that it was impossible, no matter how immeasurably grander the new theme, for the art of man to surpass. Later on this noble reverence was almost wholly lost, and what the early ages in awe and a sense of its utter futility did not dare to attempt became at length so materialized that we find the great God who dwelleth "in the light which no man can approach unto, whom no man hath seen, nor can see," represented in the pontifical robes and tiara, or bearing the orb and sceptre and the royal crown of an earthly ruler.

Not policy nor reverence alone were restraining causes. In the first century of the Christian era there arose many strange heresies; and one of these, the Gnostic, held that Jehovah was a stern, unpitying tyrant, condemning all for the sin of one, and indifferent to the sorrows of the creatures He had made. Hence they turned with aversion from the Jehovah of the Old Testament to the loving and merciful Saviour of the New, and refused to acknowledge His claim on their allegiance.

For many centuries the eye, hand, or arm of God emerging from the clouds that veiled the brightness of the Divine Majesty were the only symbols employed. At a later date the head or entire figure was shown, but with not nearly so grand and impressive an effect as that produced on the mind by the more reverential treatments of the subject. The frequent allusions in the Old Testament to the hand and the arm of the Lord as the instrument of His sovereign power, such as, "His right hand, and His holy arm hath gotten Him the victory"; or of His might in creation as "Thy hands have made me and fashioned me"; of His goodness to the creatures dependent on His

bounty, "Thou openest Thy hands, they are filled with good"; and of His justice, "the works of His hands are verity and judgment"—suffice to show how apposite such a symbol would be, and thus to clearly account for its frequent recurrence. Other texts, such as "His eyes are upon the ways of man, and He seeth all his goings," "The eyes of the Lord are upon the righteous," or, "The eyes of the Lord are in every place, beholding the evil and the good," justify and explain the use of the other early symbol of the God who is not only omnipotent, but omniscient.

The hand, as in fig. 3, at times sends down streams of light, and is often in the act of benediction. Our illustration is from a Greek miniature of the tenth century. The inscriptions show that the figures introduced are the prophet Isaiah and representations of Night and Aurora, these latter being suggested by the passage in Isaiah: "I am the Lord, and there is none else. I form the light and create darkness." The writings of Isaiah dwell in a marked degree on the coming kingdom of Messiah, and in the illustration before us darkness passes away before the coming dawn, the advent of the Sun of righteousness. It is a curious blending of Christian and pagan ideas and symbols. In the earliest —those in the catacombs and in the mosaics of the early Italian churches—the hand is without the surrounding nimbus that we, later on, often find added. The earliest known representation is from a tomb in the catacombs, dated 359, where Moses is represented as receiving the tables of the law from the Divine hand issuing from a cloud. An interesting example to Englishmen will be seen in the Bayeux tapestry, where the hand of God is represented over the Church of St. Peter. It may be seen also on the coins of some of our Saxon kings, in one case accompanied by the Alpha and Omega. Constantine II. struck a beautiful gold medallion at Byzantium, representing Constantine I. with his sons Constantine II. and Constans on either side,

In the Latin form of bendediction the thumb and first two fingers are extended, and the last two bent down. It symbolises the Trinity. In the Greek form of benediction the forefinger is extended to resemble the letter I, while the middle finger is bent into a C-like form. The thumb and third finger are crossed to make an X, and the little finger is bent into a C again, so that we get IC XC, the initial and final letters of the Greek name for Jesus Christ.

while a hand from heaven crowns him with a wreath. This was issued about the year 330. Eusebius speaks of the same monarch as gaining the victory over all his enemies, and enjoying the protection of the right hand of the King of kings. In fig. 4, the Divine hand issues from the clouds,

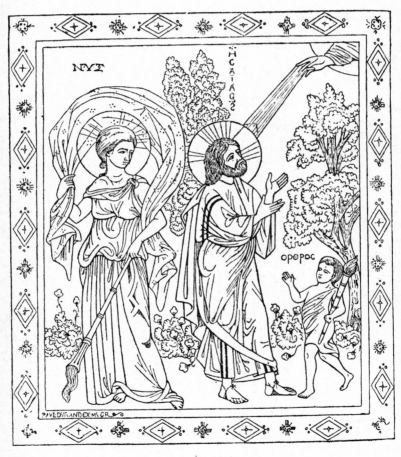

fig. 3

and delivers the righteous that trust in God from the perils of the world, for the souls of the righteous are in the hand of God, and no evil shall befall them: "In a picture by Verrocchio of the baptism of Christ in Jordan, the celestial Dove hovers over His head and above this again two outstretched hands are seen issuing from the sky in a position suggestive of protection and blessing. In a bas-relief by Luca della Robbia of the Virgin adoring the infant Christ, two arms issuing from above are about to place a crown upon her head. These are but illustrative examples of many others that might readily be brought forward. Even in an Egyptian papyrus in the British Museum, the god Horus, with widely outstretched arms, represents the vault of heaven extended in protection over the figures shielded from harm beneath. Many texts of the Bible refer to the arm of the Lord, and fully explain why such a symbol should so naturally and frequently recur.

As for example Job xl. 9; Ps. xliv. 3; Isa. xl. 11, li. 9, lii. 10; Jer. xxi. 5; Ezek. xx 33; Luke i. 51; Acts xiii. 17.

It was not until the twelfth century of the

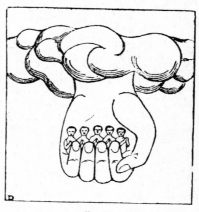

fig. 4

fig. 5

Christian era that this reverential treatment gave place to the head, and then the half, and finally the whole figure. In a fresco by Paolo Uccello, in St. Maria Novella, of Noah's sacrifice the patriarch and his family kneel around an altar, while overhead the rainbow spans the sky, and in the midst of it God, represented by a half figure, head downward, looks upon the little remnant of humanity, and gives the sign of benediction. A picture in the National Gallery, the Madonna in ecstasy, by Crevelli, shows the eternal Father bending over the Virgin; and in the famous and well known picture by Titian, at Venice, of the assumption of the Virgin, we get a very similar treatment, where the Father is floating in mid air, and surrounded by an attendant ring of cherubim.

On the walls of St. Francesco at Assisi, Giotto has painted various pictures illustrative of the life of St. Francis, and in one of these, again, the Father bends down, a half-length figure, from heaven, and blesses His followers; while, not to needlessly multiply examples, we may mention the Beautification of St. Ursula, by Vittore Carpaccio (fig. 5). In all such cases the eternal Father, God from everlasting to everlasting, "the Ancient of days," is represented as a venerable, graybearded old man.

The celestial surroundings and the majesty of the figure in all these examples have rendered it impossible to doubt the Person intended, mistaken and lacking in reverence as we may deem the representation to be. But in some examples the figure is so wholly at one with ordinary humanity, that the last shred of Divine dignity and of grandeur of conception is lacking. Thus amid the sculptures of the cathedral of Orvieto we come on two figures, one prostrate and sleeping, the other leaning over the first and making a puncture in his side. As the whole facade is covered with the Bible history from the creation of man to his redemption, we recognise that the particular group in question is a representation of the creation of Eve, and that the

"Or ever Thou hadst formed the earth and the world, even from everlasting to everlasting, Thou art God" (Ps. xc. 2). And thrice in Dan. vii., in vers. 9, 13, and 22, God is styled "the Ancient of days."

two very similar figures are really the Creator and Adam. In the celebrated gates of Ghiberti at Florence, we find in one of the panels a dignified but essentially human figure raising another from the ground—an incident that would not strike us any way exceptional, that might, for instance, stand for the pitying Samaritan raising the robbed and wounded traveller, but which all the surroundings indicate is meant for the creation by the Father of Adam from the dust of earth.

To the second Person of the Trinity art has ever rendered, and continues to render, highest homage. He has been figured at every era, and under great variety of form and symbol. We purpose here to deal with representations of Him in the form of humanity, but we shall find elsewhere that the lamb, the pelican, the fish, the vine, are all equally symbols of the Redeemer, while many other forms, such as the Passion symbols, the cross, the sacred monogram, the chalice, owe their existence and their meaning to their association with Him.

During the early ages of Christianity the Saviour was almost always represented as a young man, little more indeed than a youth, no matter what the incident might be; but about twelfth century. His age was represented as being in accordance with the period depicted. Thus we get the babe of Bethlehem, and the boy Christ in the midst of the doctors of the temple. During His public ministry we see Him in the prime of manhood, gravely gracious as He extends His hands in benediction, later on rising in glorious majesty from the tomb, and, finally, severe and unapproachable on the throne of judgment.

At the approach of the year 1000 of the Christian era, things political and social were greatly overcast, and it was a general belief that that date would mark the destruction of the world. Many charters about this time commence with the words, "As the world is now drawing to its close." The impression seems to have been founded on an expectation of the millennium. The earlier Christians had dwelt lovingly on the

miraculous and benevolent actions and the gentle utterances of the Christ; but these now gave place to a gloomy theology that entirely banished that most favourite image of the former centuries, the Good Shepherd, and dwelt upon every painful episode of the Passion, which, till then, had never been introduced in art or assigned a prominent place in theology. Hence too scenes of the last Judgment were depicted, and with every accessory of morbid horror; while the ideal Christ of the earlier days disappears, and the Man of sorrows, wounded, bleeding, takes His place in art and in the thoughts of men.

Besides the youthful, beardless Christ, the ideal adolescent of eighteen years or thereabouts, and the later type that Western Europe is now familiar with, and of which we may see countless mediaeval and modern examples in art, we get in the Greek Church, and in work done under the later Byzantine influence, yet a third type. The Latin Church has always held that, while Christ was Son of man, He was still Son of God, and that the sins He came to expiate, and all the sorrows and vices of humanity that He bore the burden of, were powerless to sully His glory and dignity; while the Greek Church, dwelling upon such a passage as that in the Epistle to the Philippians, where Christ was said to have made Himself of no reputation, and to have taken upon Himself the form of a servant, depicted Him as having, in the words of Isaiah, "no form nor comeliness, no beauty that we should desire Him." Hence these representations depict the Saviour, crushed, impoverished, beaten down beneath the load of human wretchedness. This is however to represent the Conqueror of death and sin, the Redeemer of mankind, as well-nigh vanquished in the strife, and is surely, theologically and artistically, a mistaken view and treatment.

Christ is the author of Christianity, the fountain from whence all its blessings flow, and from Him, most naturally, the new religion derived its title. Hence to Him all the devout

throughout the centuries have turned with profoundest gratitude and homage, and to Him art, and all else, should ever render highest honour.

In the incarnation of Christ was met and satisfied the yearning of mankind for some visible manifestation of God. Man is crushed and awed by the idea of the infinite, and the impossibility of realizing the incomprehensible God. Hence Job's cry was but the articulate utterance of the heart-ache of myriads: "Behold, I go forward, but He is not there; and backward, but I cannot perceive Him." These yearnings the noblest people of antiquity endeavoured to satisfy by statues of the gods that will ever remain incomparable in their beauty, while they were after all so unsatisfying that the final outcome was a statueless altar "to the unknown god." By the same indwelling instinct, the native of equatorial Africa carves the trunk of a tree, and decks it with opalescent shells, or adorns it with the gay plumage of rare birds; and it is to him an ideal of that higher Power which even he

Or, as it is still more strikingly put in its vagueness in the Revised Version, "To an unknown God."

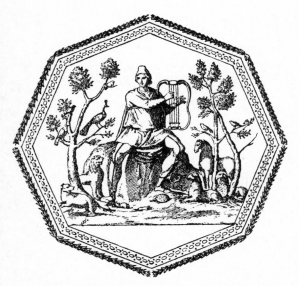

fig. 6

thus dimly recognises. Among the other and manifold benefits of the Incarnation is the satisfying of this craving. In this superhuman Humanity we recognise, not man alone, but the Divine.

In the earliest period of Christian art we not unfrequently, as in fig. 6, meet with representations of Christ as Orpheus. While evidently adopted from the heathen mythology, with which the early converts were so familiar, its application to Christianity was felt to be very legitimate. Orpheus seated with his lyre amongst the trees, and surrounded by the wild beasts that the sweetness of his music had tamed, might well be taken as an emblem of the attractive force of Christ. The symbol may be seen on early coinage and in the catacombs. In a chamber, for instance, in the catacombs of St. Calixtus, the central space immediately over the interment is taken up by a long, semi-circular painting of this subject; while on one side is the prophet Micah, on the other Moses striking the rock, and above it the Virgin mother and Holy Child.

The early Christians would be very familiar with the legend of Orpheus and the beasts, as it was a favourite subject of representation amongst the Romans. We need but refer, in illustration of this, to the mosaic pavements found at Horkstow and Winterton in Lincolnshire, and at Barton, near Cirencester.

In all these, the treatment of the subject is very similar. In the first of these, we have a series of ellipses, the centre one containing Orpheus; the next, rabbits, squirrels, weasels, and such like small creatures; the next, birds; and the outer and largest ring, the lion, elephant, bear, tiger, boar, etc. In the second we have Orpheus in a central octagon, and then eight outer spaces, with elephant, dog, fox, boar, stag, etc. In the third example, the inner circle has the figure of Orpheus the next has figures of birds, such as the duck, robin, peacock, and several others; while the outer circle is occupied by the elephant, horse, boar, lion, and other quadrupeds.

fig. 7

fig. 8

Christ as the Good Shepherd holds a very conspicuous position in early art, and soon entirely supplanted the Orpheus symbol. This treatment may be met with freely in the catacombs, on the walls, on the lamps found in the tombs, and in the mosaics of the oldest churches. Figs. 7 and 8 are from gems dating about the year 300 A.D., and giving us a good illustration of the treatment of the subject in early Christian art. It is very strange that this most expressive symbol died out completely before the tenth century, and is never met with again until the sixteenth century, and even then very sparingly, while it was never adopted in the Greek Church at all. The Saviour Himself most explicitly applied the title to Himself. "I am the Good Shepherd," and in the Epistle to the Hebrews (xiii. 20) He is again called "our Lord Jesus, that great Shepherd of the sheep." He is represented in art as tranquilly resting amongst the surrounding sheep, or as bearing one—the lost sheep of the parable—upon His shoulders. "The good shepherd layeth down his life for the sheep": hence the symbol testifies, not of protection and direction alone, but of devotion carried to the extreme of willing sacrifice.

The dramatic representations in the Middle Ages, of which the Oberammergau play is a survival, were of great educational value, as the graphic and dramatic arts appealed most forcibly to those who were unable to read for themselves; while the living actors gave reality to the personages painted in the cathedral windows, or sculptured round their doorways, and thus quickened the sculptor's and the painter's art. No doubt art gained much from the mysteries and plays of the time, which were pressed into the service of the Church; and the great truths of religion were offered on every hand to the eyes and ears of the people by carver, painter, musician, actor, and poet.

Gregory Nazianzen, desiring to banish profane plays from the theatre at Constantinople, prepared several sacred dramas to take their

place; and Chrysostom wrote a tragedy called "The Dying Christ," which was many times represented in the same city.

Christ as the infant was always, until the fourteenth century, depicted clothed, and it was only at the decadence of Christian art that He was represented as nearly or quite naked. Christ as the sufferer on the cross of shame is not found at all until the fifth century. Though the cross itself early appeared as a symbol of the crucifixion, it was nearly five hundred years after the event commemorated ere it became the crucifix. Until the eleventh century the body of Christ upon the cross is always clothed, as we see in fig. 9, wherein He is represented as the great High Priest. Afterwards, the breast is uncovered,

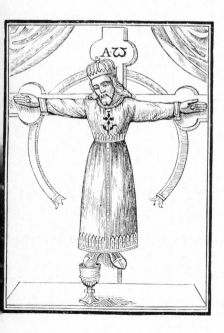

fig. 9

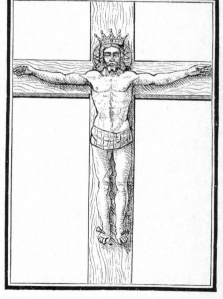

fig. 10

and the drapery becomes an apron descending from the waist to the knees, till in the fifteenth century it becomes the simple band, as shown in fig. 10, where nevertheless He wears the kingly crown upon His brow, and is shown with the rayed nimbus. The sun and moon, typical of nature, often appear in early work on either side of the cross. In the early centuries the serpent is placed beneath the foot of the cross, as a symbol of sin overthrown.

The Holy Spirit, the third Person of the Trinity, has from about the sixth century down to the present day been constantly symbolized by the dove. On this we shall dwell more at length later on, when considering the various animal forms that have been pressed into the service of symbolism. In the tenth century the custom arose of representing the Holy Spirit in human form; but after being very freely in use for nearly six hundred years, Pope Urban VIII (A.D. 1623) prohibited the practice as being contrary to the traditions of the Church and it was at once entirely abandoned, and the older symbol of the dove substituted in its place. When represented in human form, the distinguishing attribute of the Holy Spirit is the roll or book held in the hand the symbol of intelligence and wisdom.

Chapter 4

We propose now to consider the various forms assumed by the monogram and the nimbus: the first a symbol exclusively appertaining to Christ; the second a mark of holiness or of power of far wider application.

The earliest form of monogram is the symbol which is said to have appeared to Constantine, outshining the sun in its splendour, while a voice was heard to exclaim, "By this sign shalt thou conquer." Assigning any value we may to this legend, the fact at least remains that Constantine did receive some sudden shock to his old superstitions, and that, joining the Christian Church, he henceforth removed the old Roman eagle from the standards of the legions, placing in its stead the sacred monogram. There is no reason to suppose that this monogrammatic symbol was not in use amongst the Christians previously. What the monarch saw or fancied he saw was doubtless a form whose meaning he already knew; it would, in fact, from its abbreviated character, have been otherwise meaningless to him. The monogram is sometimes termed the *chrisma*, or, erroneously, the *labarum*. The labarum is the standard marked with the sacred device, and not the device itself. The labarum, see fig. 11. was adopted by the Emperor Constantine after his victory over Maxentius, duly described by Eusebius. The emperor also caused the sacred symbol to be represented on the shields of the soldiers. Julian the Apostate removed it, but it was again replaced by Jovian and his Christian successors, and was continued in use by all the later Byzantine rulers.

The monogram is formed of the first two letters of the Greek word for Christ, XPISTOS. X is equivalent to *ch,* and the P is the Greek *R.* This found on tombs of the martyrs and others of the reigns of Adrain and of Antonine, in the second century of the Christian era. After passing out of use for some centuries, it has been in these latter days somewhat revived. The X is sometimes turned, so as to make its arms come vertically and horizontally, instead of in the sloping

In the mosaics of the sixth century in the church of St. Vitale, at Ravenna, amongst the guards surrounding the Emperor Justinian a very good example of this may be seen, the field of the elliptical shield, some three feet by two, being entirely filled with the monogram.

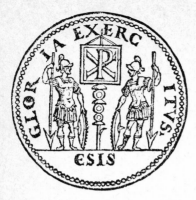

fig. 11

direction of the ordinary X: this arrangement gives the added symbolism derived from its resemblance to the cross. On the coins of Constantinus we get the Alpha and Omega, one on either side, the acknowledgment of the divinity of our Lord. "I am Alpha and Omega, the beginning and the ending, saith the Lord, which is, and which was, and which is to come, the Almighty." As Alpha, God is the beginning of all things at the creation in Genesis; as Omega in the apocalypse, He is the consummation of all things. Or, to quote the words of the Venerable Bede: "Ego sum A et Omega, initium et finis, dicit Dominus Deus. Initium, quem nullus praecedit; finis, cui nullus in regno succedit. Qui est, et qui erat, et qui venturus est, omnipotens." In fig. 12, a lamp of early Christian date and workmanship, we get the cross-like disposition of the letters, together with the Alpha and Omega; while fig. 13 is an instance of the more typical

fig. 12

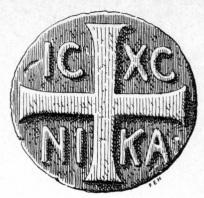

fig. 13 fig. 14

form of monogram. More rarely the P is turned
into the Latin R, implying *rex*, the kingship of
Christ. The monogram is sometimes found
inclosed in a circle, the symbol of eternity, or
standing upon a circle, symbol of the conquering
power of Christ over the world. At other times
we get the X alone or combined with the I, the
initial letter of Jesus, IHSOUS. When this latter
arrangement, the X and the I together, is placed
within the circle, it resembles a wheel with six
spokes. Often in the catacombs the tombs of
martyrs have the monogram surrounded by a
wreath, the symbol of victory through Christ.
Occasionally on lamps or gems we see the dove,
symbol of the Holy Spirit and of heavenly peace,
sitting upon it, or represented as descending
upon it. Early inscriptions, charters, and other
documents are often prefaced by the cross or the
monogram; one may see many excellent
examples of the latter in the British Museum, one
for example on a deed of Edgar, A.D. 961, and
another on a charter of Canute, dated 1031. The
familiar abbreviation of Xmas for Christmas, that
possibly some of our readers may have used
without consideration, is another illustration of
the X being equivalent to Christ.

In Greek art representations of the cross are
often accompanied, as we see in fig. 14, by the
inscription "IC XC NIKA," Jesus Christ the
conqueror; or in a still more abbreviated form XP
and NI on either side. The chrisma which was in
use during the whole of the Roman-Byzantine
period, fell into abeyance during the Dark Ages,
and re-appeared in the twelfth century. On a
coin of Constantius II., the emperor in full

*It is also in the
Orthodox Eastern
Church impressed on
the sacramental wafer.*

55

armour is represented as standing in a galley steered by Victory. In his right hand he bears the phoenix standing on a globe (for due significance of which see phoenix), and in his left the labarum emblazoned with the sacred monogram. On a coin of Gratian we see the emperor bearing the same standard of victory, the idea of triumph over his enemies being further enforced by the introduction of the kneeling captive at his feet. The sacred monogram was placed by Louis VI. of France upon his coins, and was maintained there by one sovereign after another until the Renaissance scattered all the more ancient traditions and revived classic forms.

The more familiar monogram based on the I.H.S. is ordinarily of later date then the XP, replacing it entirely from the beginning of the twelfth century. The earliest example known is on a gold coin of Basilius I., A.D. 867. This I.H.S. monogram is the abbreviated form of the word IHSOUS, the omission of the other letters being marked by the dash or bar, above the I.H.S. This dash was afterwards prolonged through the upward stroke of the H, and thus formed the cross. As the form of the Greek S differs from ours, being somewhat like a C, the monogram sometimes appears as I.H.C. These letters are often read as signifying "Iesus Hominum Salvator," Christ is the Saviour of men; and on their introduction into the Latin Church, this meaning was assigned to them. It is said that this reading was first suggested by Bernardine of Siena (1380-1441); but appropriate and beautiful as it certainly is, it is an after-thought. In the National Gallery may be seen a picture by Il Moretto of a group of saints, St. Bernardine, St. Jerome, St. Joseph, St. Francis, and others. St. Bernardine is holding up in his right hand a circle containing the I.H.S, and in his left hand is an open book with the words, "Pater, manifestavi nomen tuum hominibus," Father, I have set forth Thy name unto men. Modern examples, stamped on Prayer-Book covers, painted on glass, embroidered on

Alessandro Bonvicino, commonly called Il Moretto de Brescia. His pictures range in date from 1524 to 1556.

hangings, stamped on tiles, carved in the stone-work, may be met with in profusion everywhere.

We turn now our attention to the nimbus.

This form, which we naturally associate so entirely with the service of religion and of Christianity, is really pagan in its origin, and was a symbol originally of power rather than of holiness. Its origin dates back to an antiquity too remote for identification. It has been conjectured that it may probably have been in the first place suggested by the rays of the sun. In fig. 15, a coin of Rhodes, we see on the obverse the rayed head of Helios the sun god, the reverse being the rose, the device or badge of the city. Sun worship has amongst pagan peoples been a very prominent feature in almost all ages, and even when the time has arrived that they have ac-knowledged a higher power, the sun has often remained an emblem of the Divinity. Light has therefore been one of the attributes of the gods; hence Jupiter wields the lightning flash, Apollo is crowned with the glowing sunbeams, as in fig. 16, while to Diana is given the softer light and chastened beauty of the crescent moon. The

fig. 15

fig. 16

57

idols of China, of Burma, and of Hindustan are often represented with a nimbus as characteristic as any seen in the carvings or stained glass of a Gothic cathedral. The face of Moses reflected with dazzling brightness the Divine glory on his descent from Sinai, and a similar manifestation is claimed for Muhammad after the cleansing visit of the angel Gabriel.

After the death of Constantine his sons struck medals in his honour, in which he may be seen crowned with the nimbus,—a symbol not necessarily bestowed upon him on account of his embracing Christianity (though no doubt this fact had its influence), as we may also find on some of the coins of the earlier emperors, as Claudius and Trajan, a similar feature. It was, as we have already indicated, a symbol of dignity and power. So far was it from being at first accepted as a mark of sanctity, that in some early Byzantine works even Satan is represented as wearing the nimbus. In a thirteenth century MS. the Magi and king Herod are alike nimbed, and in one of the cathedral windows at Strassburg are fifteen kings, benefactors to the cathedral, and all are assigned a nimbus; these date about the eleventh or twelfth centuries. One of them is Charlemagne, the nimbus having inscribed within the circumference the words Karolus Magnus Rex. The double-headed eagle in the arms of imperial Germany is, as we may see in fig. 17, represented as being nimbed. In one of the mosaics in the church of Santa Sophia at Constantinople we see Christ sitting on a throne, and the emperor, richly attired, kneeling in submission and adoration at His feet. On either side of the throne are medallions of the Virgin and of the archangel Michael. Neither of these latter have the nimbus, while Christ, the King of kings, and Justinian, the earthly ruler, each have this symbol of sovereignty. On the other hand, Fra Angelico at a later period gives to the three Magi the crowns of earthly sovereignty, and reserves the heavenly glory for the holy maiden mother and the holy child.

It was a custom with the emperor Commodus to sprinkle gold dust over his hair, so that, while walking in the sunlight, his head might appear to shine with supernatural splendour!

fig. 17

Where a nimbus in Christian art is rayed, the rays spring from the centre of the circle, behind the head, and are generally very numerous; the individual rays, necessarily very narrow and linear, being just the opposite in this respect to the form seen on Greek and Roman coins. In these latter, the rays are few in number (often seven); and, while they, as a series, radiate from the head, they are individually broad at the base and running out to a sharp point. In the Christian form a circle is ordinarily shown as joining the extremities of the rays; while in classic examples it is more commonly shown as about half way up them. At other times, no less in Hindu than in Roman examples, the nimbus is composed of a series of pleats that give as a bounding edge a zigzag line or sawlike appearance. On the coins of Rhodes the head of the sun-god has, independently of it and of each other, a surrounding series of pear-like forms, fig. 15, which we may very naturally conclude to have been intended to represent flames.

The Christian nimbus is not met with on any monument prior to the sixth century, but during the next three centuries its use rapidly grew. Until the twelfth century the nimbus was luminous and transparent; but during the two following centuries it became an opaque disk. It then again became translucent, and was indicated only by the bounding circle, or by a series of fine rays without the circle at all. Still later on the circle is put into perspective and becomes an ellipse, more and more approaching, where the figures have their heads in profile, a straight line. All early nimbi were circular; the triangular form does not appear till the eleventh century; and the square nimbus, as characteristic of a living person, does not come into use until the ninth century. The first nimbus forms were assigned to God; later on the angels, His ministers, receive them; and only by slow degrees did the apostles, saints, and martyrs become thus adorned with the seal of holiness.

As the writers on heraldry in the mediaeval

period assigned arms to the earlier kings, to Edward the Confessor and others who had the misfortune to be dead and buried hundreds of years before the birth of "the noble science," and even devised coats of arms for Gideon and Joshua and other valiant heroes of the Old Testament records, so the religious painters of the Middle Ages gave to the pre-Christian saints like honour with their successors. This was more especially the case in the East. Moses is always represented with a curious form of nimbus composed of two rays, or two groups of rays, only. In sculpture these become exceedingly like horns. An old theory, more or less satisfactory, held that God did not reveal Himself to him in all His glory, and that He only delivered to him such portion of the Divine law as was especially applicable to the Jews; and that as the advent of Christ, though foretold, was not accomplished, the nimbus of Moses only bears testimony to the other two Persons in the Godhead. This, we would venture to say, is a particularly lame theory, though we give it as one that has been gravely advanced, and we cannot supplant it by a better. In the fresco by Signorelli, the "History of Moses," in the Sistine Chapel, the great leader is twice introduced in the one picture, and each time with the characteristic nimbus, two groups of three rays each. The colossal statue of Moses by Michael Angelo on the monument of Julius II. has the curious horn-like forms to which we have referred. As a final example, out of many that might be adduced, of the bestowal of the nimbus on the saints of the old dispensation we may refer to the wall paintings of Benozzo Gozzoli (1424-1455) in the Campo Santo at Pisa. They represent the stories of the Old Testament, beginning with Noah and ending with Joseph, and are full of patriarchal simplicity, pastoral beauty, and incomparable *naivete*. One of these is a vintage scene, wherein Noah figures twice in the composition as superintending the ingathering of the grapes; and in each case he is depicted with the nimbus.

Allegorical and ideal figures are also at times assigned a nimbus; such impersonations, for instance, as Faith, Hope, Charity, Prudence, Justice, and Fortitude. In the works of the Italian painters such abstractions often have a nimbus of hexagonal form, as in fig. 18 a head from the "St. Francis Wedded to Poverty" of Giotto. The picture is in the lower church of St. Franceso at Assissi. Poverty is no mere abstraction, but is represented by a comely female figure, though clothed in somewhat patched and torn apparel. Our illustration is the head of Poverty. The Saviour Himself celebrates the nuptial rite. Those imaginary personages to whom the teaching of the Master has given semblance of life, such as the wise virgins of the parable, are also represented often in old pictures and carvings with this attribute of holiness. On the coins of Faustina, the peacock, symbol of the glorified soul, has its head encircled with the nimbus; and on the coins of the Antonines, the phoenix, the symbol of immortality, is also thus distinguished. The four evangelists when in human form are of course so honoured; but even when represented by their attributes, the angel, the lion, the ox, and the eagle, the heads of these creatures are almost invariably encircled by the nimbus.

fig. 18

Where the hand of God is seen proceeding from the clouds, it is ordinarily surrounded by the nimbus. This is often of three rays, indicative of the presence and sympathy of the Trinity in whatever the work may be that has drawn forth this symbol of the presence of God.

The idea of the nimbus as a symbol of saintliness being once conceded, it might be thought that little or no practical difficulty would arise in assigning it; yet in practice curious deviations are found from what might be imagined a simple procedure. For instance, in a picture of the Holy Family by Andrea del Sarto in the National Gallery we notice that, while the Virgin and Elizabeth each have a golden nimbus of similar character, St. John and the infant Christ have

none at all. In a picture by Francia of the Virgin and the dead Christ, the Saviour, the Virgin mother, and two attendant angels, we note that all have exactly similar nimbi; while in another picture, the procession to Calvary, by Ghirlandaio, Christ, the Virgin, St. Veronica, St. John, and other saints, again all have nimbi of identical character. We see the same thing again in a beautiful bas-relief by Luca della Robbia of the Virgin mother in adoration of the Divine Infant where the Christ, the mother, and two attendant cherubs form the group. The dignity and greater technical difficulty of the sculptor's art doubtless go far to justify this simplicity of treatment; but as the painter could so readily enrich and vary his forms, it seems strange that the greater or less dignity and importance of the persons in such groups as we have indicated should not have been noted and duly honoured by more or less enrichment of the nimbus in each case assigned.

We occasionally find the square nimbus, though only in Italian work. It is placed either with upright sides and horizontal top edge, or else turned diamond-wise; and this alternative in the method of its arrangement makes all the difference in its application and meaning. The latter position is exclusively bestowed on the first Person of the Trinity, and it is ordinarily given concave sides. In the "Disputa" of Raphael, the Divine nimbus has straight sides instead of concave; but it is placed, as is almost invariably the case, lozenge or diamond-wise. Even here however we meet with an exception or two; thus in the mosaic in the church of San Giovanni in Laterano the square nimbus of God has upright sides, but it is surrounded by a circle, emblem of eternity. Much curious symbolism was associated by the Neo-platonists and Pythagoreans and the Middle Age astrologers with the square, though it would be foreign to our present purpose to dwell upon it here.

When the nimbus is a square having upright sides, it always implies that the person so marked

was still living at the time. It may be freely found in Italian work, and a good early example may be noted in the Victoria & Albert Museum in a portion of an eighth century mosaic from Ravenna. It may be seen too very well in the nimbus surrounding the head of Pope Leo III., and in that of the emperor Charles the Great in the mosaics of the Lateran church. A mosaic in the church of St. Cecilia in Rome is another good example, as it represents Pope Pascal similarly distinguished. He holds in his arms a model of this church, as it was erected through his instructions and assistance. The mosaic dates from the year 820. The same pope, with similar nimbus, will be met with again in the churches of Sta Maria della Navicula and Sta Pressede. Both are in Rome, and the mosaics date respectively 815 and 818. Durandus says that "when any living prelate or saint is pourtrayed, the glory is not fashioned in the shape of a shield, but four-square, that he may be shown to flourish in the four cardinal virtues."

Occasionally this rectangular nimbus, instead of being flat, is made with its two upright sides curling inwards, as though the man were emerging from within a big roll of paper. At other times we find a straight, upright back, and then the two sides thrown forward at a sharp angle, suggesting the idea of a small folding screen behind the head.

In the fifteenth century the nimbus in the form of an equilateral triangle appears. It is reserved for the first Person of the Trinity ordinarily, though we occasionally find the dove, the emblem of the Holy Spirit, with a similar nimbus. As emblematic of the Trinity, it would manifestly be equally properly applied to any one of the three Persons, though ordinarily the second Person has the circular nimbus, and a cross inscribed within it. In some cases beams of light radiate beyond the triangle, their extremities forming an exterior circle. In the sixteenth century, figures of the eternal Father no longer appear, but His name in Hebrew characters is

fig. 19

sometimes placed within an equilateral triangle, and often the whole surrounded by a circular halo or radiation, as we may see in fig. 19.

The nimbus is often represented as a solid circular dish behind the head of the person so distinguished; so solid, in fact, that in many of the early pictures where many saints are represented the nimbi overlap almost like tiles on a roof, and allow only very small portions of the heads of those in the rear to be visible at all. In the beautiful picture of the Annunciation by Fra Angelico (fig. 20), the nimbus in each case, that of the Virgin Mary and of the angelic visitant, is of this solid type. "The righteous live for evermore; their reward is also with the Lord, and the care of them is with the Most High. Therefore shall they receive a glorious kingdom, and a beautiful crown from the Lord's hand: for with His right hand shall He cover them, and with His arm shall He protect them." Durandus says that

Wisdom of Solomon v. 15, 16.

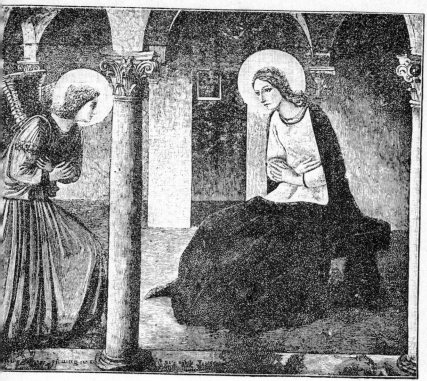

fig. 20

the crown of the righteous "is made in the
fashion of a round shield," because the saints
enjoy the Divine protection. Whence they sing
with joy. "Lord, Thou hast crowned us with the
shield of Thy favour." The solid nimbus is a
necessity, of course, in sculpture, but in painting
also it is often represented with most evident
thickness and opacity. In a couple of heads of
saints in the National Gallery by Domenico
Veneziano the nimbi are of solid gold; but while
the direction of the light in the pictures throws
them mostly into shade, their margins are
defined by a broad edge of brilliant light; while
in a picture by Cossa, also in the National Gallery,
of St. Vincentius Ferrer, the solid plate of gold
has its thickness emphasized by a broad line of
vermilion. In a picture by Zoppo, in the same
gallery, of Christ being placed in the tomb, Christ
and two saints have all similar nimbi, that,
instead of being absolutely opaque, are like discs

of glass through which the sky can be seen, but having a very definite and thick edge.

An added dignity was speedily given to these solid nimbi by a very considerable enrichment of the surface, by painting, by puncturing patterns on the golden ground, by embossing, or by the addition of jewels and pearls. In Fra Angelico's picture of the Adoration of the Magi, Christ, the Virgin, and St. Joseph all have similar red nimbi, thickly covered with radiating and radiant golden lines. In a picture of the procession to Calvary by Ugolino de Siena in the National Gallery, both the nimbi and the background are gold, so the former have to be brought out by means of incised lines and punctures. These are arranged in quatrefoils and other geometrical forms. Fra Filippo Lippi, in the same gallery, affords several good illustrations of this method of treatment; but the richest examples will be found in Orcagna's grand picture of the Coronation of the Virgin, where a wonderful variety of geometric and floral enrichments will be found.

During the fourteenth century a custom arose of placing the name of the wearer within the edge of the nimbus. This lasted for some two hundred years, and may be seen alike in Greek, Italian, and German art, except that in Greek examples, instead of the name they almost invariably give the monogram of the person or some other abbreviation of the full name, or even only its initial letter. Some very good examples of these inscribed nimbi may be seen in the National Gallery. Thus in the Marriage of St. Catherine, by San Severino, in the nimbus of Christ are the words "Sum Lux"; in that of the Virgin, "Ave, gratia plena Domi"; while in the golden glory of St. Catherine is the inscription, "Santa Ktrina de Sena." While it may be objected by the hypercritical that the first two of these examples are not names at all, they fairly come within the scope of our remarks, as they are fully equal to them as a means of identification of those to whom they refer.

Two Catherines figure in art and legend: the St. Catherine of Alexandria, whose symbol, the spiked wheel of martyrdom, makes her always readily recognised in the numerous pictures where she appears; and the St. Catherine of Siena of the present picture.

In Benozzo Gozzoli's picture of the Virgin and Child, surrounded by angels and saints, the various nimbi are circular plates of gold, and in every case the name of the wearer is painted in black upon it. In Ludovico da Parma's picture of St. Hugh, a Bishop of Grenoble in the twelfth century, the nimbus is inscribed S.VGO; while, to quote but one other example, the Ecce Homo of Niccolo Alunno, in the glory around the head of the Saviour are the letters YHS.XPS.NAZ., Jesus Christ of Nazareth, and beyond these the inscription, "In nomine Jeu omne genu flect celestium, terrestrium, et inferno." The text in the Vulgate runs as follows: "In nomine Jesu omne genu flectatur, caelestium, terrestrium, et infernorum," At the name of Jesus every knee should bow, of things in heaven, and things in earth, and things under the earth.

We may frequently find the cross within the nimbus, and it is generally supposed that the Person so distinguished is necessarily the second Person of the Trinity. Thus Durandus writes: "But the crown of Christ is represented under the figure of a cross, and is thereby distinguished from that of the saints; because by the Banner of His cross He gained for Himself the glorification of our Humanity, and for us freedom from our Captivity." The cruciform nimbus is not however exclusively confined to Christ, though it is entirely devoted to Deity. In the "Biblia Sacra" we see, for instance, an illustration of the creation of Adam. All three Persons of the Trinity are present, and all have cruciferous nimbi. In a "Coronation of the Virgin" by Borgognone the diadem is placed upon her head by her Divine Son, the Holy Spirit in the form of the dove hovers over them, while standing behind with extended arms is the eternal Father. In this picture it is the first Person of the Trinity that has a cruciferous nimbus, while Christ has a plain one. In fig. 56 all three Persons of the Trinity are seen with the crossed nimbus. In the Greek Church, on the three visible arms of the cross we find the Omicron, the Omega, and the Nu

In all references to this subject we find the expression "cruciform nimbus." It is not a particularly happy idea, as it suggests the notion that the nimbus itself is in the form of a cross, instead of containing the cross. Cruciferous would be preferable.

Nevertheless, in the picture of the Virgin, St. Jerome, and St. Dominick, by Filippino Lippi, in the National Gallery, the nimbus of St. Jerome is distinctly cruciferous. It is the one exception, so far as we know, to the otherwise invariable rule.

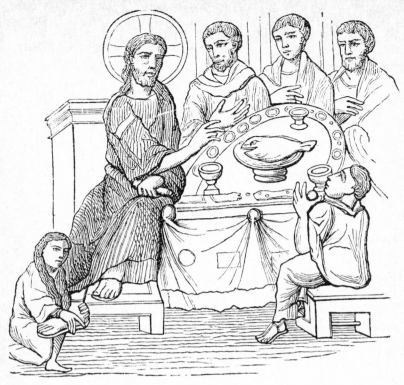

fig. 21

*"I AM THAT I AM"
(Exod. iii. 14). "The
Lord is King for ever
and ever" (Ps. x. 16).*

respectively, signifying I AM; while in the Latin
Church we occasionally find the letters R.E.X in
token of the sovereignty of God.

It is nevertheless true that the cruciferous
nimbus is especially devoted to Christ; examples
where He is without it, or where others are with
it, being comparatively few and far between.
Hundreds of examples are so readily to be found
in mediaeval and modern work, that it is almost
needless to give illustrations of a fact so patent.

In fig. 21 the Master is at once distinguished
from the disciples by its presence. The
illustration is from a MS. of the ninth century. It
is interesting too from its adherence to the
archaic principle, so distinctly seen in much
early work, of making the more important
figures larger than the others. Thus Christ is the
largest of all, the disciples somewhat smaller, the

fig. 22

churlish Pharisee much more insignificant, and least of all the repentant outcast. The whole story, see Luke vii. 36 *et seq.*, is admirably rendered. Fig. 22 is of much earlier date; it is the obverse of the medal of which we have seen the reverse in fig. 1. It will be noted that the legend "Emmanuel" is in characters partly Greek and partly Latin.

The artists of olden time were quite capable of drawing an equilateral triangle in a circle, or of dividing a disk into three equal parts by divergent rays from its centre. A theory has nevertheless been advanced that oftentimes the mediaeval painters did not in their apparently cruciferous nimbi intend to refer to the cross at all, but that the three rays that are ordinarily visible were symbolic of the Trinity. In most cases the head or beard would prevent the fourth ray of the cross being seen, even if it were there; but undoubtedly in some cases, where the position of the head would render it visible, it is nevertheless omitted. While we cannot dismiss the matter by assuming that the artist carelessly overlooked the necessity in such cases of indicating the much or little of the fourth arm that became visible, it certainly seems curious that, if a suggestion of the Trinity were intended, the three arms should not be placed at the divergent angles that geometrical construction calls for in the equal division of a circle into three parts. Theologically and symbolically the idea of perfect equality is not adequately expressed by a construction that divides a circle into two quarters and one half.

Sometimes rays of equal dimensions spread equally, so that the bounding line would be a circle; but at other times the rays from the crown of the head and from the temples are more pronounced, while the intermediate rays fall gradually away. In this case the bounding line used would be a lozenge with concave sides. At other times the circle is entirely absent, and we get only these three clusters of rays; or the circle is present, and while the majority of the rays stop at its circumference, these three groups

stretch beyond it. These clustering rays from their position naturally suggest the cross form again, and are no doubt often distinctly intended to do so.

In Fra Angelico's interesting picture of "Christ surrounded by Angels," some of the figures, instead of nimbi, have rays of light of varying length, a very early example of the absence of the bounding circle. In later work, instead of the nimbus, we get a halo of light; as for example in the "Christus Consolator" of Ary Scheffer, or the faint gleam around the head of Christ in the "Flight into Egypt" of Rubens. The illuminant power of the nimbus, an idea full of poetry and admirably expressive of the "Light of the world" is beautifully introduced in Correggio's "Adoration of the Shepherds" at Dresden, and in the works of Raphael and others, where the nimbus is an actual source of light in the composition.

In late work the nimbus, if shown at all, becomes a mere golden line, as in fig. 23, and instead of being a flat circular form becomes amenable to the laws of perspective, and more or less elliptical, as influenced by the position of the head, until in the case of a directly side view of the head it becomes almost or quite a straight iine. The "Christian Martyr" of Delaroche (fig. 24) affords us a good example of this later treatment. In the "Holy Family" by Andrea del Sarto in the National Gallery, the Virgin so nearly faces us that the golden line of the glory is almost circular; while Elizabeth being almost in profile, shows in her nimbus the close approximation to the simple straight line. In a picture in the National Gallery by Cosimo Tura of the "Madonna and Child Enthroned," Christ, the Virgin, and two angels have nimbi that are just indicated by the elliptical lines, while four other angels have nimbi as solid as dinner plates.

In the sixteenth century the nimbus disappears, though in these later days of art revival and study of ancient work it is occasionally introduced, and especially in designs for church glass. In Holbein's

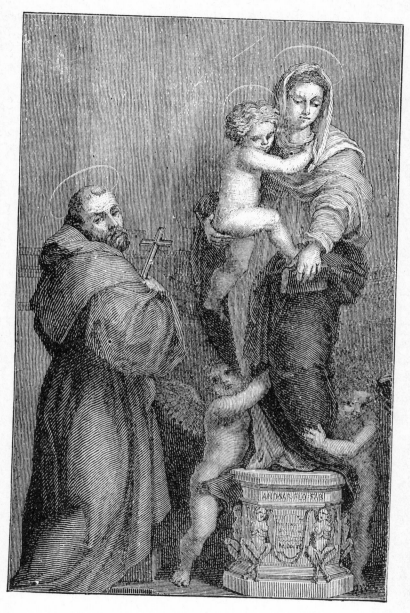

fig. 23

fig. 24

beautiful picture of the Madonna and Child, the
Virgin stands in a niche that has its upper portion
fashioned in the form of a shell, that gives a
radiation of line strongly suggestive, and no
doubt intentionally so, of the nimbus.

The nimbus adorns the head, while the aureole
surrounds the whole figure. The aureole appears
in art later than the nimbus and disappears
before it; and even when it was a fully recognised
feature, it was a much rarer form. In the fifteenth
and sixteenth centuries the nimbus, as we have
noted, often lost the hard bounding line seen in
earlier work; and in like manner the aureole
became a golden halo at this period, a glory of
simple or of flame-like rays, or in some instances
alternately one and the other.

The aureole is especially devoted to the Deity,
though we also find it associated with the Virgin
mother when she carries the Holy Child in her
arms; or at her assumption, when borne by angels
to heaven; or at the last judgment, when she
intercedes for the lost and fallen; or when repre-
sented as in the apocalyptic vision—"a woman
clothed with the sun, and the moon under her
feet, and upon her head a crown of twelve stars."

Abundant passages in the Scriptures suggest the

idea of the radiance of the Divine glory. Thus at Sinai we read, "the sight of the glory of the Lord was like devouring fire." At the dedication of the Temple "the glory of the Lord filled the house." At the Transfiguration the face of Christ, St. Matthew tells us, "did shine as the sun, and His raiment was white as the light"; while St. Mark says that "His raiment became shining, exceeding white as snow, so as no fuller on earth can whiten them." St. John in his glorious vision saw the Christ with eyes as flame of fire, with feet as if in glowing furnace, with countenance as the sun shining in His strength.

The aureole is often, when in the form of a pointed ellipse, called the "vesica piscis." We may see it in fig. 25, the screen of Hereford Cathedral, where the central figure is thus surrounded. It is also sometimes termed the "Divine oval," or the "mystical almond." The generic name aureole is however preferable, as it includes all the other forms. Sometimes when the figure is represented as sitting, the aureole takes the form of a circle or a quatrefoil; or instead of being a geometric figure at all, it may be a mass of aerial vapour bounded by a waved and irregular line, or a glowing nebulous splendour fading imperceptibly away. In fig. 26, the Annunciation, by Fra Angelico, the Father and the Holy Spirit have both nimbus and aureole.

Very good examples of the ichthus or vesica piscis may be seen in the picture of the Virgin and Child by Margaritone in the National Gallery, and in the picture by Emmanuel, in the same collection, of St. Cosmas and Damianus. It was more especially in use in the Graeco-Byzantine school, to which the two painters just referred to belonged; but we also find it in works of the later Italian school, as in the "Sts. Anthony and George" of Pisano, or the "Beato Ferretti" of Carlo Crivelli, both also in the National Collection. The Flemish painters, who comparatively rarely introduce the nimbus, equally seldom employ the vesica, though it may occasionally be seen.

fig. 25

We frequently, as in fig. 26, find both nimbus and aureole employed; thus in the "Speculum Humanae Salvationis" we may see a figure of Christ surrounded by the elliptical aureole and the head crowned with the cruciferous nimbus. In the "Trinita" of Pesellino, in the National Gallery, the figure of the crucified Christ has again both nimbus and aureole. In the "Ascension" in the "Benedictionale" of Ethelwold, the risen Lord is crowned with cruciferous nimbus again, and enveloped in the radiant aureole. In the frescoes of Francesco da Volterra in the Campo Santa at Pisa, illustrating the history of Job, the eternal Father is more than once represented with both these accessories and symbols of power and glory. In the fresco of the last judgment at Pisa, Christ and the Virgin are side by side, and surrounded by equal and similar aureoles.

While in the work of the architect, sculptor, and metal worker the aureole, as in the screen at

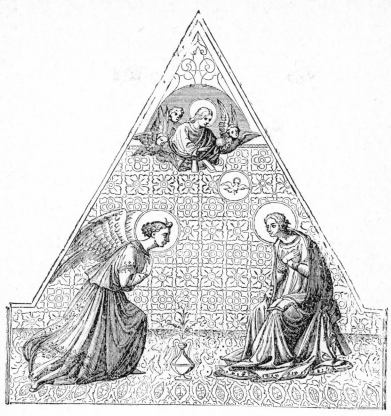

fig. 26

Hereford Cathedral, is necessarily bounded by
definite lines, a characteristic also of the earlier
paintings, it is often in later work an indefinite
flood of golden glory, a luminous nebula. In a
curious old mosaic at Rome, God interposes it as
a solid shield to protect Moses and Aaron from
the violence threatened by Korah and his
company. In late art, as in fig. 5, adoring cherubs
often form an encircling aureole. We may see a
good example of this in a picture in the National
Gallery of the Madonna and Child by an
unknown painter of the Umbrian school. In the
Madonna di Foligno of Raphael the seated Virgin
and Child are placed within a circular aureole

beyond the circumference of which are clustering cherubim; while in his Madonna di S. Sisto the stiffness of the line is wholly absent, and the glorious central group is surrounded by these radiant forms. In the "Assumption of the Virgin," one of Murillo's most celebrated works in the Louvre, a step further is reached; all suggestion of an aureole has vanished, though the Virgin has a glory of golden rays around her head, and the attendant cherubim float in happy freedom around the glorified Virgin. In the early legends and apocryphal gospels, such as the "Gospel of the Infancy," we find many suggestions that doubtless influenced the painters of a later age. Thus we read that the cave of the Nativity "was filled with light more beautiful than the glittering of lamps, brighter than the light of the sun. When the blessed Mary had entered it, it became all light with brightness." "Quando Christus natus est corpus ejus resplenduit ut sol quando oritur."

Chapter 5

The cross, erewhile, like the gallows or the guillotine the symbol of the doom of the male-factor, has by the sacrifice of Calvary become the symbol of sublime abnegation, of Divine pity for the lost and sorrowing sons of men. Hence for evermore it is no longer the badge of shame, but the emblem of triumph and eternal hope, and what to the Roman of old was a sign of infamy has by its association with the Saviour of mankind become the symbol of victory. It flitters on the crown of the monarch (fig. 27), while the crosses of St. George, St. Andrew, and St. Patrick form our national ensign. It crowns alike the loftiest spires of Christendom and the lowliest parish churches. It marks the resting-place of the departed who have died in faith in its efficacy; and it is the sign in baptism of their admission to the kingdom of the Crucified. Hence the cross has become one of the most familiar of symbols throughout the whole range of Christian art.

fig. 27

The **T** or Tau cross (fig. 28) is sometimes termed the anticipatory or type cross, the cross of the Old Testament. It was the symbol of eternal life with the ancient Egyptians, and as such was borne by Thoth. On an Egyptian mummy wrapping we have seen the dead man painted lying on a couch, while above him a winged figure hovers, bearing in one hand the hieroglyphic symbol for Breath, and in the other the Tau, or *crux ansata*, as it is sometimes termed, the hieroglyphic for Life. On a wall-painting may be seen the monarch worshipping before Thoth, while the god pours over him from a vessel in his hand what at first sight appears to be a thin line or stream of water, but which is seen on closer investigation to be a series of these symbols, the gift, in answer to the prayers of the king, of eternal life. In fig. 29, also from an Egyptian source, we have a very similar rendering. The Greeks adopted it in a like sense, and the early Christians of Egypt at first used it instead of other forms of cross. In the early Christian sepulchres throughout Egypt and the great oasis numerous examples may yet be seen; and it has

fig. 28

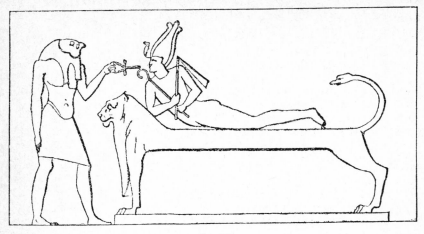

fig. 29

In Ezek. ix. 4-6, we read of a mark being set upon the foreheads of those that sigh for the abominations committed in the land, and of the instructions to the destroying angel: "Slay utterly old and young:but come not near any man upon whom is the mark." In an enamel of the thirteenth century, where this is represented, the faithful are marked with the Tau. In a sermon by Bishop Andrews on this text we read, "This reward is for those whose foreheads are marked with Tau."

been urged, with at least great probability, that this symbol of life was the form made by the children of Israel in blood upon their door-posts when the angel of death passed through the land of Egypt to smite the first-born of the nation; and it was, maybe, the form of cross on which the brazen serpent in the wilderness was raised. Many of the early basilicas were built on this as a groundplan, and the symbol is found in the catacombs of Rome. Tertullian writes, "haec est litera Graecorum **T**, nostra autem **T**, species crucis."

The Tau cross is the especial emblem of St. Anthony, and on the institution in 1352, by Albert II. of Bavaria, of the order of the Knights of St. Anthony, the members of the order wore a golden collar made in the form of a hermit's girdle, and suspended from it a stick cut like a crutch, the Tau cross of the Saint.

Though St. Paul, Justin Martyr, Tertullian, Chrysostom, and other Fathers of the early Church made many triumphant references to the cross, it was not till the fifth century that it began to appear in art, the monogram of Christ having till that time been exclusively used. The first occurrence is in a mosaic at Ravenna, and the date is about 440.

When the lower portion of the upright piece is longer than the rest as in fig. 30, it is termed the Latin cross; when all four arms are equal, as in

fig. 30

fig. 31, it is the Greek cross. At first both forms were used indiscrimatingly in each Church, and each form may be found in the catacombs. The church of the Holy Apostles at Constantinople was cruciform in ground-plan, the nave being somewhat longer than the upper part; for, as Procopius very explicitly states, "the western nave is longer than the choir by all the extent necessary to constitute a cross of crucifixion or Latin cross." The Latin cross suggests the actual form, while the Greek cross is idealized; the Romans being an essentially matter of fact people, and the Greeks equally essentially an artistic and poetic race.

fig. 31

The Latin cross is also termed the cross of Calvary, or the Passion cross. The cross of the Resurrection is often placed in the hands of the risen Christ. It is ornate in character, and ordinarily bears a banner attached. The cross is sometimes represented as made of branches, in reference to such passage as that in the Acts of the Apostles, where Peter declares, "The God of our fathers raised up Jesus, whom ye slew and hanged on a tree"; and elsewhere, "Who His own self bare our sins in His own body on the tree." Sometimes instead of rugged branches the cross is idealized, and represented as bearing leaves and fruit.

fig. 32

On the cross of Calvary was nailed a scroll bearing an inscription, and, suggested by this, the Latin cross has occasionally, as in fig. 32, a double cross piece. This is the cross of Lorraine and of the Knights Hospitallers. It is a form constantly seen in Greek and Byzantine art, and dates from a very early period. The pope has borne before him a triple cross, cardinals and archbishops have the double form, and the single cross is devoted to the bishops.

In the "Descent from the Cross," by Quentin Matsys, the central cross is of the Latin form, while those on either side are of the Tau type. In the "Crucifixion," by Antonello da Messina, in the museum at Antwerp, Christ has a well formed cross, while the malefactors on either

fig. 33

fig. 34

fig. 35

fig. 36

fig. 37

side are bound on rough trees that are not at all cruciform in character.

When the basilica form was gradually abandoned, there was a general adoption of the Latin cross in the West, and of the Greek cross in the East, as the ground-plan. The Church of the Holy Sepulchre was made circular, a natural arrangement in that particular instance, as the traditional site of the actual sepulchre of our Lord thus became the central point; and all other circular churches in Europe were suggested by this, and had in themselves but little appropriateness of form. The Latin cross may be very well seen in the ground-plans of the cathedrals of Santiago di Compostella, in Spain; of Siena and Florence, in Italy; of Cologne, in Germany; of Elgin, in Scotland; of Lincoln, Rochester, Salisbury, and many other cathedrals and churches, both in the United Kingdom and abroad.

In the early churches a cross was frequently inlaid in the design of the pavement, part of it running into the chancel, the arms passing down the centre of each transept, and the rest along the middle of the nave; but a solemn anathema was pronounced at the second Ecumenical Council on those who should tread the sacred symbol under foot, and the custom of placing the cross where it could be thus trampled on at once ceased.

In many churches a slight deviation in the chancel from the line of direction of the nave may be found. It is very clearly marked in the cathedrals of York and Lichfield, and in many large parish churches. It symbolises the inclination of the Saviour's head upon the cross. While generally to the south, it is not unfrequently toward the north, no rule of practice having been laid down in favour of either.

Not a few churches are dedicated to the cross. The cathedral of Orleans is that of the Sainte Croix, while at Florence we find the Santa Croce. Other instances are St. Cross at Winchester and the Scottish Holyrood.

Unless distinctly stated to the contrary, the various crosses of heraldry have arms of equal length. The shape of the shield would naturally render this the more convenient form, and as by far the greater number of these devices originated with the wars of the cross, the crusaders in their eastward wanderings would naturally come under Greek influence. Engrafted upon the original Greek cross, the heralds have produced great variation of detail. Examples of ten of these are given in figs. 33-42. Dame Juliana Berners, at a time when blazonry was comparatively simple, declares in her "Boke of St. Albans" that "crossis innumerabull are borne dayli"; while Legh, another old writer, affirms, "You bring in so many crosses, and of so sundry fashions, that you make me in a maner werye of them." Berry's "Encyclopaedia Heraldica" enumerates and figures 385 varieties, but many of these are seldom employed.

fig. 38

On early deeds and charters we often find the subject matter prefaced with a cross as a pledge that its contents are just and true, or in other cases having a dedicatory or invocatory meaning.

We now turn to dedication or consecration crosses. Those who are at all interested in the subject will doubtless have observed crosses carved or painted on the walls of various old churches. These are known as dedication crosses, and they were placed at the various spots touched by the bishop while performing the ceremony of consecration. Very few dedicatory crosses of the Norman period are now extant, though they may be seen in the churches at Wiston, Ditteridge, Barfreston, and some few other places; but many crosses of later date and of varied and elegant design may be found.

fig. 39

fig. 40

In a consecration service of the eleventh century we find that an important part of the ceremony was the anointing of the walls with oil of chrism at various points in the building, and it was the custom to mark the places beforehand with the cross. A manuscript of the sixteenth century in the British Museum shows us the

fig. 41

fig. 42

81

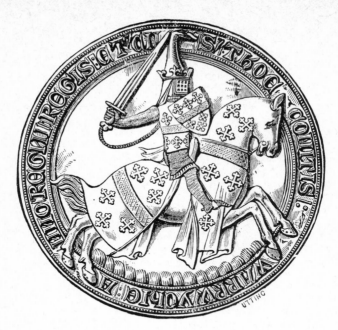

fig. 43

bishop in the act of anointing one of these crosses. Injudicious restoration and wall-scraping have unfortunately destroyed many of these interesting relics of the past. Ordinarily three were placed on the north, south, east, and west walls respectively, both inside the building and out, thus making a total of twenty-four. The following extract from the old writer Durandus explains their significance and use. It will be seen that he refers to twelve instead of twenty-four, as his description clearly refers to the interior of the church alone. "Next when the Altar hath been anointed with chrism, the twelve crosses painted on the walls of the church are also anointed. The crosses themselves be painted, first, as a terror to evil spirtis, that they, having been driven from thence, may be terrified when they see the Sign of the Cross, and may not presume to enter there again; secondly as a mark of triumph, for crosses be the Banners of Christ, the Signs of His triumph. Crosses therefore are with reason painted there, that it may be made manifest that that place hath been subdued to the dominion of Christ. For even

in the pomp of an earthly Sovereign it is custom-
ary when any city hath been yielded for the
imperial Standard to be set up in it. The twelve
lights placed before these crosses signify the
twelve apostles who have illumined the whole
world by the Faith of the Crucified, and whose
teaching hath dispelled the darkness. Wherefore
the crosses on the four wall of the Church are
lighted up and anointed with chrism, because the
apostles preaching the mystery of the Cross have
by the Faith of Christ illumined the four quarters
of the earth with knowledge, have lighted them
up unto love, have anointed them unto purity of
conscience, which is signified by the oil, and
unto the Savour of a good reputation, which is
signified by the balsam."

Old legends tell us that after the expulsion from
Eden Adam begged for a seed of the tree of life.
The request was granted, we are told, though this
involves a direct contradiction of the Biblical
narrative. The tree that sprang from this seed was
held in great honour, and its wood was preserved
in Solomon's temple; but the queen of Sheba,
apparently wiser for once than the great king,
told him that He who should hereafter one day
be slain upon that tree would by His death cause
the destruction of Jerusalem. Solomon therefore,
missing the obvious idea of having it burnt to
ashes, had it removed and deeply buried in the
earth. The Pool of Siloam sprang from it, and
owed its healing virtues to it; but when the hour
of the crucifixion drew nigh, the trunk floated to
the surface, and as it seemed a useful piece of
timber, it was drawn out of the water, and was
presently used for the cross!

According to Sir John Maundeville, who
travelled much over Europe and the Holy Land,
and wrote his experiences in the year 1371, the
cross of our Lord was made of four kinds of
trees. The piece that went upright from the earth
to the head was of cypress, and the cross-piece
was of palm; the stock that stood in the ground,
to which the upright was fastened, was of cedar,
while the tablet bearing the inscription was of

*Behold, the man is
become as one of Us,
to know good and evil:
and now, lest he put
forth his hand, and
take also of the tree
of life, and eat, and
live for ever: there-
fore the Lord God
sent him forth from
the Garden of Eden.
.And He placed at
the east of the garden
cherubims, and a
flaming sword,....to
keep the way of the
tree of life" (Gen. iii.
22-24).*

olive. The reason he gives is that the Jews were of so vindictive a mind that they determined that the victim of their hatred should hang upon the cross for ever, therefore they chose cedar for the foot, because of its lasting qualities; the cypress was selected from its pleasant fragrance, as a corrective of the results of dissolution; the palm was chosen because it is an emblem of victory, in sign of their triumph; while the tablet was of olive, the emblem of peace, because they held that Christ had made discord and brought trouble to the nation, and that His death would restore to them political and religious concord.

If we are to credit tradition, Isaac, in carrying the wood for his sacrifice, held it in the form of a cross upon his shoulders, and therefore the angel was sent to rescue him from death; while the widow of Sarepta, in carrying home her two sticks, had them cross-wise, and thus received the blessing of the prophet, the restoration of her son to life, and an inexhaustible supply of oil and meal; stories which, despite their morbid and extravagant character, and their wild impossibility, are at least a testimony to the honour and virtues ascribed to the cross.

According to the old writers, the cross was found, deeply buried in the ground, at Jerusalem, some three hundred years after the crucifixion, or, to be as absolutely precise as the legend, on May 3rd, A.D. 328. Hence this date was commemorated as the "Invention of the Cross." The word, of course, comes from the Latin *invenio*, to come upon or discover, though most of our readers doubtless will be fully prepared to accept the word in its more familiar sense, and regard the whole tale as very much indeed of an invention. The discovery was made by St. Helena. All three crosses were found, but that of our Lord was at once discriminated from those of the thieves who were crucified with Him, because a woman who was grievously sick was immediately restored to health on touching it, while a dead body laid upon it returned to life! The custom of crossing one's self was first practiced by the

Christians about A.D. 110, thereby to distinguish themselves from the pagans around, and as a sign of recognition amongst themselves.

The crucifix is the most materialized of the symbols of the cross, and often develops into a mere representation of acute physical suffering, that, whatever aid to faith it may be to some who gaze upon it, is dishonouring to the Saviour in its repulsive dwelling upon one side alone, and that the least, of His great sacrifice. The agony of the cross was not the smart of bodily pain, but the burden of the sins of the whole race of mankind.

fig. 44

The cross of St. Andrew, as in fig. 44, the badge of the Order of the Thistle; is shaped like the letter **X**, though it was not till the fifteenth century that it was so represented. One may just notice in passing the grotesque contrast between the suffering saint of God, the lowly follower of the Prince of peace, and the aggressive and self-asserting motto that surrounds the whole.

Early tradition affirms that St. Andrew was crucified on a cross of the ordinary form, but with his body extended horizontally. Like St. Peter, he deemed it far too great an honour to be crucified as was his Lord; and he therefore gained from his persecutors the concession of being fixed sideways, while St. Peter was crucified head downwards. We may see this very well in fig. 45, "The Crucifixion of St. Peter," by Guido Reni, in the Vatican. Tradition has it that this form of cross appeared in the sky to Achaius, king of the Scots, the night before a great battle with Athelstane, and being victorious, he went barefoot to the church of St. Andrew, and vowed to adopt his cross as the national device. In Scottish heraldry St. Andrew's cross as we may see in the Union Jack, is argent of a field azure.

The crucifixion of St. Peter has been a somewhat favourite subject with painters. A very good example may be seen in the church of the Carmine at Florence, by Filippino Lippi, and another by Guido Reni, in the Vatican

Very early examples of the cross form, as in

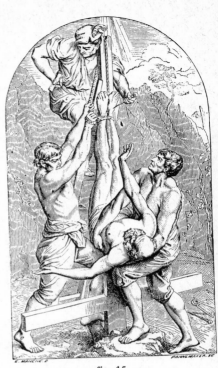

fig. 45

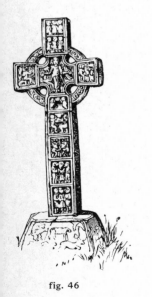

fig. 46

figs. 46, 47, may be seen in the sculptured Celtic crosses of Great Britain and Ireland. They are ordinarily found thickly covered with interlacing; but when figure subjects are introduced the scenes and incidents are generally those of the Bible. The cross at Clonmacnois, in Ireland, is called the Cross of the Scriptures, in an entry in the annals of Tigernach, dated 1060. The monuments themselves are more or less cruciform, and the cross also often enters as a detail into the ornament. Fig. 48 is the ancient Danish jewel known as the Dagmar Cross.

Besides the cross we meet also with other forms that are known as the Passion symbols. These are chiefly found in the wood-carving and stained glass of the fifteenth century, though even as early as the tenth century they may occasionally be seen. Such early examples are however distinctly exceptional. Like many other things,

they were held, with more or less of reason, to be of superstitious tendency; and at the time of the Reformation and again during the Commonwealth a very clean sweep indeed was made of all such objects, so that only comparatively few examples now remain.

Such symbols include the ladder, the dice, seamless robe, the cock, spear, sword, the thirty pieces of silver, pincers, hammer, pillar, scourge, reed and sponge, the nails, and crown of thorns. Good examples may be seen at Bishop Lydiard church in Somersetshire, Swaffham church in Norfolk, Mildenhall in Wiltshire, Horsham church in Sussex, and elsewhere. They are but rarely found on seals; but they occur on that of the Guild of Corpus Christi at Oxford, and on that of the Friars Minors at Cambridge. They are sometimes surrounded with the legend, "Vulnera quinque Dei sint medicina mihi."

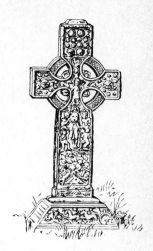

fig. 47

On an Italian picture frame containing a representation of the scourging of our Lord we notice the introduction of the following symbols: two staves and the sword of St. Peter, torch and lantern, bag of money, faggots for making the fire at which St. Peter stood and warmed himself, the crowing cock, the pillar of scourging, two scourges, a chain for binding the hands to the pillar, the seamless coat, the purple robe, the reed-sceptre and thorny crown, the basin and ewer used by Pilate, the cross, the cup of wine mingled with myrrh, the dice, the three nails, hammer, pincers, ladder, sponge, lance, winding sheet, spices in a vase, the chalice, and rope and chain for the deposition of the body from the cross.

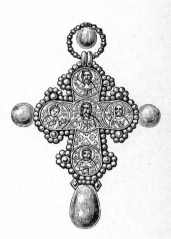

fig. 48

Pope Innocent VI. (1352-1362) affirmed in a decree that "the lance and nails and other instruments of the Passion are everywhere to be held in reverence of all Christ's faithful people," and he instituted in their honour a religious festival, the Feast of the Lance and Nails.

The finest existing series in England is on the bosses of the vaulting in the choir of Winchester Cathedral, a roof erected by Bishop Fox in the

fig. 49

early part in the early part of the sixteenth
century; and a very good foreign example will be
found on the bridge of St. Angelo at Rome,
where the colossal statues of angels bear the
various instruments of the Passion. These
symbols were often introduced on the vestments
and hangings thus in one of the old church inven-
tories that supply us with so much that is
interesting and valuable, we find the item "ij
steyned clothes for above and beneathe w the
tokenis of the passyon in tyme of lent w ij
curtyns accordyng to ye same"; and many other
references of like nature might be added. In the
picture of St. Dominic, by Zoppo, in the National
Gallery, we may see Christ in glory surrounded
by angels, each bearing one of the Passion
symbols.

The chalice (fig. 49) and the crown of thorns
(fig. 50) are frequently introduced to the
exclusion of all the other Passion symbols, the
latter especially being freely employed. In the
picture by De Bles in the National Gallery,
entitled "Mount Calvary," we see three angels
receiving in chalices the sacred streams flowing
from the wounded body of the Saviour.

fig. 50

The crown of thorns, though essentially connected with the sufferings of our Lord, is also an attribute of St. Francis of Assisi, St. Catherine of Siena, and one or two other less well-known saints. It was a favourite subject for legend in mediaeval times that certain men and women of peculiar holiness, desirous to share the sufferings of Christ, were so highly favoured of heaven as to be permitted to bear in their own bodies the *stigmata*, the signs of the sufferings of their crucified Lord, some bearing all the marks and others one or more of them. Thus several bore the scar of the spear wound in their sides, others the lacerations of the thorny crown, and others again the marks in the palms of their hands or on their feet the nail prints. The stigmatization of St. Francis by the angel as he kneels in rapture on the ground is a favourite subject with the older painters: such marks, whoever may be the saint bearing them, are ordinarily surrounded by a halo of golden rays.

The *corona radiata* is a representation or suggestion of the golden rays of Helios, a symbol of divine effulgence and of the favour of the gods, that on the deification of the emperor took the

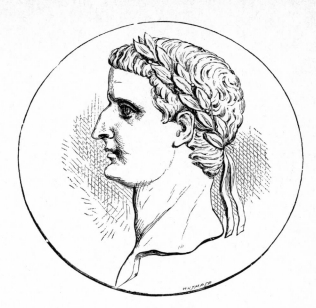

fig. 51

place in later Rome of the earlier laurel-wreath of mundane glory. An example of this latter may be seen in fig. 51, the laureated head of Tiberius. It has been suggested that the crown of thorns was a mockery of the radiate diadem assumed by the Roman emperors when they arrogated to themselves both divine and human kingship. While doubtless an instrument of physical suffering, it was probably intended, like the purple robe, rather as an instrument of moral suffering in scornful derision of the kingly claim, and brutal parody of the imperial insignia. The first representation, so far as is at present known, of Christ crowned with thorns will be found in the catacomb of Praetextatus in Rome, where the spiked and thorny wreath encircling the head of the Saviour has distinctly given to it the radiate character of the classic and imperial nimbus-like diadem.

In the frontispiece of the "Eikon Basilike," A.D. 1648, we see the king, Charles I., taking in his hand a crown of thorns, inscribed "Gratia." At his feet is the royal crown of England, marked "Vanitas," while in the air above is a

starry crown marked "Gloria." Beyond we have a landscape, in which a palm tree bears a conspicuous position in the foreground, while several other emblems are introduced that we need not here dwell upon. Beneath is the "Explanation of the Embleme," in two columns, one being in Latin and the other in English. The portion that at present concerns us runs as follows: *"That sp'endid but yet toilsom Crown Regardlessly I trample down. With joie I take this Crown of thorn, Though sharp, yet easy to be born. That heavenlie Crown already mine, I view with eies of Faith divine. I slight vain things and do embrace Glorie, the just reward of grace."*

We now proceed to consider the various symbols of mortality.

At the Reformation a clean sweep was made of all pictures suggestive of the old creed. In the third year of the reign of Edward VI. and injunction was issued ordering all pictures in churches not hitherto disturbed to be either destroyed if movable or defaced if fixed; and it became penal, by fine or imprisonment, to possess, even privately, pictures of this forbidden nature. In 1558, after the accession of Elizabeth, the law was made still more stringent, and the various church officers were required to certify their obedience to the law; thus at Thorpe, in Lincolnshire, for instance, to give but one example out of many, we find the following entry: "Item, we had noe Roode nor other Imageis but that were painted on the wall, and thei we defaced and put oute." The coats of whitewash being altogether too frigid-looking, and moreover presenting a tempting surface for renewed decoration, it became necessary to see what could be substituted for the obliterated work, that should have teaching value, without being illegal, and we find that figures of Time and Death were largely introduced.

The lapse of years, the damp that is often a conspicuous feature in old churches, and more especially "restoration," as it is termed, have played havoc with these ancient wall paintings;

but in an old poem by Cowper, entitled "An Elegy wrote in a Country Church," we get many interesting details as to the furniture and arrangements of a village church. We quote three of the stanzas that bear on our subject. *"Tho' Painting her Italian Pencil here Has never dip'd, yet on that Western Wall Two formidable Powers allied appear, Which shew Man's Rise, his Progress, and his Fall. To ev'ry Act of Duty to persuade, On these two Forms the Preacher turns his Looks, Points to thy Seythe, O Time, or Death, thy Spade, And makes mere painted Stones affecting Books. When from God's Word he proves that Time shall cease, And Death must to Eternity consign, He to the Hour-Glass points, and cries: 'Heaven's Peace To gain, this Hour alone is truly thine!'"*

Time is ordinarily represented as an old man, naked or but slightly clothed, and quite bald, with the exception of a single lock of hair on the forehead. In "King John" Shakespeare calls him "that bald sexton, Time"; and we are all familiar with the occasional necessity of "taking Time by the forelock." In his hand he holds a scythe, or in one hand a scythe and in the other an hour-glass. In an engraving by Bernard, executed in 1560, Time has scythe and crutches, and in some few cases he is represented as winged. *"Gather ye rosebuds while ye may, Old Time is still a-flying."*—HERRICK.

Though in later days Time and Death have been associated together, and the symbols they bear freely interchanged, in earlier days they were never represented as necessary companions. Time was associated with ideas of growth and life, rather than with destruction and decay. Time in the Greek Church was young and unbearded, while Death was a noble and angelic form, as in the Campo Santo at Pisa, and it was centuries before it changed to the ghastly skeleton that it afterwards became.

In the later figures of Death the skeleton forms are often horribly badly drawn, the bones incorrect in form, the articulations with no vestige

of anatomical accuracy. So grotesquely horrible indeed are the forms, that it has even been suggested that in many cases the bad drawing was not the result of ignorance, but of a deliberate intention to make the forms more repulsive.

In figs. 52, 53, 54, we have good illustrations of this mediaeval treatment of the subject. Such drawings, illustrating the all-conquering power of Death, are very commonly to be met with. We give but three of these: the warrior with uplifted sword, himself succumbing to the fate that many others have suffered at his hands; the student poring over his books, mocked by the gift of the Elixir Vitae at the hands of Death; and the wealthy dame, who awakens suddenly to the fact that her life of ease and dignity is over, and that her next step is the edge of the grave.

The Dance of Death was a favourite mediaeval subject. Well-known examples may be seen at Basel, Lucerne, and elsewhere. In these we often see the scythe and hourglass attributed to Death. In Holbein's Dance of Death more than half of the skeleton figures have one or other or both of these emblems assigned to them; and we may see the scythe again in the work of Orcagna, in Titian's "Triumph of Death," and in many illustrations in the old MSS. Figures of Death as a skeleton are frequently introduced in the sepulchral brasses of the sixteenth and seventeenth centuries; and on the older gravestones in many churchyards one finds a free use made of skulls, cross-bones, and other such-like emblems of mortality. Much of the religious writing of that period busied itself in representing the weakness, sinfulness, and misery of man, and men were goaded heavenwards by fiery denunciations and glowing descriptions of the torments of the unregenerate. Even the gentle Jeremy Taylor made the key-note of his "Holy Dying," "He that would die well must always look for Death, every day knocking at the gates of the grave"; and the cross-bones on the tombstones are but one indication the more of the prevalent tone of mind.

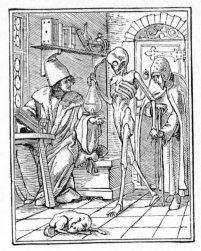

fig. 52 fig. 53

On many of the rings and other personal
adornment of this period these emblems of
mortality are freely introduced. The watch of
Mary Queen of Scots, for example, was in the
form of a skull. On the forehead was a small
figure of Death standing between a palace and a
cottage, and around it the passage from Horace,
"Palida Mors aequo pulsat pede pauperum
tabernas regumque turres."

On a mediaeval trencher, with device of a skull,
we find the lines: *"Content y felfe w thyn eftat:
And fende no poore wight from y gatt: For why
this councell I y geue: To learne to die and die
to lyue";* and in another example, with the same
emblem of mortality, the inscription: *"Truste
not this worlde thou wooeful wighte: But lett
thy ende be in thy fighte."*

It was customary in the Middle Ages to provide
richly decorated palls to be used at the burial of
members of various guilds, and some of these still
survive the ravages of Time. In one of these the
general black surface is crossed by broad bands
of white, and on these are embroidered skulls
holding thigh bones in their mouths, scapulae,
ossa innominata, and other portions of the
skeleton. Rings too were commonly, when of a
memorial character, made in the form of a

fig. 54

skeleton, or a skull was placed where we should ordinarily look for the stone or other adornment. Luther used to wear a gold ring with a small death's head in enamel, and the inscription "Mori saepe cogita." This ring is still preserved at Dresden. It will be remembered too that in "Love's Labour Lost" Biron compares the face of Holofernes to "a Death's face in a ring."

We remember seeing in the "God's acre" at Basel a striking commentary on the truth of the stanza in the noble "Elegy" of Gray: *"The boast of heraldry, the pomp of power, And all that beauty, all that wealth e'er gave, Await alike the inevitable hour: The paths of glory lead but to the grave."*

On one of the tombstones the armorial bearings of the person interred were all duly set forth in their heraldic significance, but behind the shield was carved the figure of Death, and his bony hands seized the shield with all its testimony of earthly rank and dignity, and had torn it apart from top to bottom. "Sic transit gloria mundi." The idea appeared to us a very striking one, as we came suddenly upon it in the solitude of this home of the dead. That the high-born relatives of the deceased should thus admit the solemn truth for him and for them was perhaps

still more striking, as poor humanity ordinarily clings to the last to all such distinctions, as we may so abundantly see in *"The marble tombs that rise on high, Whose dead in vaulted arches lie, Whose pillows swell with sculptured stones, Arms, angels, epitaphs, and bones: These, all the poor remains of state, Adorn the rich, or praise the great."*

PARNELL: "Night Piece on Death."

Cowley in a well-known passage, tells us how "beauty, and strength, and wit, and wealth, and power," all flourish and joy in their awhile, but the end is the same after all: for— *"Alas! Death mows down all with an impartial hand"*—as the reaper with his swinging scythe and steady, onward step brings to one common fall the useless and noxious weeds, the gay and brilliant blossoms, and the ripe heads of nodding corn.

Other familiar symbols of death are the broken column, and the urn. Both were introduced at the period of the Renaissance, when anything of classic association was welcomed; the urn of course referred to the Roman custom of preserving the ashes after cremation.

St. Jerome and Mary Magdalene are ordinarily represented as having a skull in their hands or in close proximity to them; while St. Eutropius has his cleft with a sword. St. Francis of Sales and St. Catherine of Siena are often represented as bearing their hearts in their hands: and we may in like manner find SS. Winifred, Valeria, and Regula, Dionysius, Proculus, and Piat carrying their heads about with them. The famous healing spring or holy well in Wales is said to mark the spot where St. Winifred's head fell on her decapitation.

The dust and ashes of the penitent are equally symbols of death. *"Can honour's voice provoke the silent dust, Or flattery soothe the dull, cold ear of death?"* The frequent Biblical use of the idea amply justifies the association. When man, made in the image of God, fell from his high estate, he learned the sad and solemn truth, "dust thou art, and unto dust shalt thou return."

Job in his misery exclaims, "Thou hast made me as the clay: wilt Thou bring me into dust again?" and elsewhere, "Now shall I sleep in the dust: and thou shalt seek me in the morning, but I shall not be"; while the writer of Ecclesiastes, dwelling on the vanity of all earthly things, sums up, "then shall the dust return to the earth": for, as he elsewhere writes, "All are of the dust, and all turn to dust again." The psalmist sings, "All that go down into the dust shall bow before Him," for death is but the threshold of immortality: "Mors janua vitae." Therefore Isaiah writes, "Awake and sing, ye that dwell in the dust: for the earth shall yield her dead"—the glimmering light of the dawn that bursts into the full glory of the triumphant words of the New Testament: "Now is Christ risen from the dead, and become the firstfruits of them that slept. For since by man came death, by man came also the resurrection of the dead. . . . For this corruptible must put on incorruption, and this mortal must put on immortality." In this radiant vision of coming bliss the Master's gracious welcome is all in all; and in the light of that greeting skulls and cross-bones, scythes and urns, fade away for ever and ever.

Tinted drawing of the Virgin and Child
by Matthew Paris (d. 1259) with the
author in prayer.

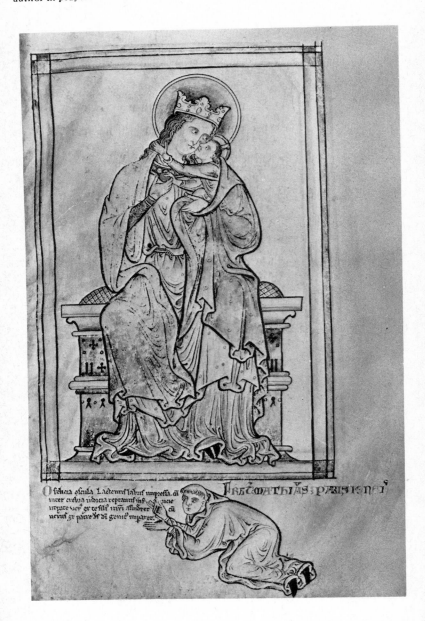

Chapter 6

The soul of man is usually symbolically depicted as a little child coming out of the mouth of the dying person, and good and bad angels are generally present to receive it, and to contest its possession. It is sometimes naked, at other times clothed and robed. Naked, for naked came man into the world, and stripped of all must he return to Mother Earth; "for when he dieth he shall carry nothing away." When the soul is clothed, it typifies the robe of Christ's righteousness. "Clothed upon," as St. Paul has it, "that mortality might be swallowed up of life." Sometimes both soul and body, the ascending spirit and the dying saint, are represented with the nimbus; while in other examples the soul issues as a little black imp or fiend. *Ps. xlix. 17; Eccles. v. 15; 1 Tim. vi. 7*

In the Campo Santo at Pisa will be found a wonderful series of paintings, that up till the last few years have been assigned to Orcagna, though it is impossible that the ascription is in fault. Whoever the artist may have been, he was a man of great artistic power and of vivid imagination. In the "Triumph of Death," gay and festive groups of ladies and cavaliers sit beneath the orange trees and amuse themselves with songs and music, while Death approaches with rapid flight and menacing scythe. At his feet are already a great host of the departed, some wearing the kingly crown or the coronet of the princess, some the robes and hat of the cardinal, or the panoply of steel of the knight. The souls of these, as they rise, fold their hands in parayer, or shrink back in horror as they see the fiends awaiting them. On the one hand, bright angels ascend to heaven with the souls of some, while others are dragged to a fiery mountain crater, and flung headlong into the raging flames. In another portion of the picture a crowd of beggars, the maimed, the blind, and the halt, with outstretched arms call upon Death to end their sorrows; but their appeal goes unheeded.

In another of these wonderful pictures, "The Last Judgment," the trumpet sounds, and the dead emerge from the earth, clad in the appropriate dress of their former condition; and on

their rising the angels divide them into two great companies, the redeemed and the lost.

We remember to have seen an example in Byzantine art where the soul issues as a serpent from the mouth of the dying man. It is sometimes also represented as a bird. In one of the ancient Egyptian funeral tablets in the British Museum, the spirit of a man is represented as a bird having a human head; it is being fed with divine food by the goddess Neith out of the sacred tree in which she stands. Elsewhere on a mummy-wrapping we find the dead man pictured, swathed for his burial, while above the lifeless body hovers his soul in form of a bird (see fig. 55) having human head and hands. It bears in one hand the hieroglyphic for breath, and in the other the Tau, the hieroglyphic for life. On another mummy case a man is depicted as suddenly falling dead to the ground, while above him stands another erect and with outstretched arms. The mortal man is painted red; the spiritual man, his risen soul, is blue, the colour of the sky. In this example, the two figures are the same size, it is the same being, in spite of the change that has come over him; but in Christian art examples of this identity of size are very rarely encountered, the bold figure of the Saviour in his discourse to Nicodemus, "ye must be born again," naturally suggesting the infant form.

The weighing of the souls in the balance by the

The Egyptian symbol for breath is the sail of a vessel: a happy and expressive idea, as the sail is inert and useless till quickened by the breath of the wind, but springs beneath its influence into movement and service.

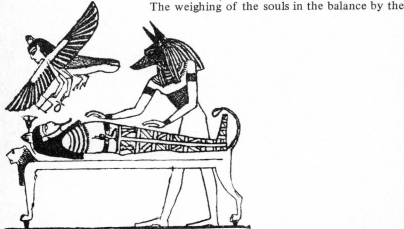

fig. 55

archangel Michael is a favourite mediaeval subject, and was often depicted on the walls of the churches as a sermon and a warning. Very frequently evil spirits cling to the scale, and endeavour by their weight to depress it in their favour. The Egyptians entertained the belief that the actions of the departed were solemnly weighed before Osiris, and the final condition of the soul determined by the preponderance of the good or the evil. The Babylonians probably held a similar belief, so that the mysterious writing on the wall during the impious feast of Belshazzar would appear to them the presage not only of national, but of eternal loss. "God hath numbered thy kingdom, and finished it. Thou art weighed in the balances, and found wanting." With that awful verdict against him, "in that night was Belshazzar the king slain," slain by his country's foes, while he was yet under the ban of the Divine displeasure, and in all that made for righteousness found wanting.

"On the point of separation of the soul from the body, the good and bad angels come, and the merits and demerits of the man are weighed. The good angel alleges and recites the man's good works, the bad angel calling to memory all the evil ones. And if indeed the bad preponderate, so that he departed in mortal sin, immediately the soul is delivered to the tormentors."—St. GREGORY, A.D. 604.

The souls of men are weighed too before Brahma in Hindu art, and by the Muhammadans the archangel Gabriel is called the "soul-weigher."

The butterfly as a symbol of the soul is but rarely seen in early work; for though the Greek word for the butterfly and the spirit of life is the same—*psyche*—yet, owing to the imperfect idea of all pre-Christian races as to the immortality of the soul, much of the force of the symbol was in early days lost. Even in later times, owing to the want of study of the lower forms of nature, the analogy between the spirit of life and the butterfly—first appearing as a creeping, toiling caterpillar, and then, its span of existence apparently over, burying itself in the earth a seemingly lifeless chrysalis, yet finally at the appointed season the perfect creature soaring above its tomb into the sunlight,—was not perceived. *"Yet wert thou once a worm, a thing that crept On the bare earth, then wrought a tomb, and slept. And such is man! soon from his cell of clay To burst a seraph in the blaze of day."*

Opposite: Terracotta Virgin and Child.
Florentine (?) first half of the 15th
century. Victoria and Albert Museum.

In some few Greek examples the butterfly is
represented hovering over the dead, and in
comparatively modern work it may not
uncommonly be found among us. We have
already referred to the *Gottesaker* at Basel as
supplying a striking piece of symbolic teaching;
and we remember to have there seen also,
sculptured on one of the gravestones, the
shrouded chrysalis and above it the soaring
butterfly.

As a symbol of the ascension of Christ, Elijah
borne to heaven in the chariot of fire occurs
often in early work. Many examples may be seen
on the tombs of the martyrs of the early
Christian Church.

The torch of life, though originally a pagan
conception, is occasionally introduced into
Christian art, and naturally, is more especially
found where the work is Renaissance in treat-
ment, and therefore influenced by the old classic
ideas and forms.

Angels, the ministers and messengers of God,
are abundantly met with in ancient, mediaeval,
and modern art, either in attendance upon the
first Person of the Trinity, or the Saviour, or
ministering to the needs of the saints. Often they
are hymning the praises of God or playing on
musical instruments. In the National Gallery, for
instance, in the picture by Filippo Lippi of the
"Madonna and Holy Child" attendant angels are
playing on the lute and the violin; and in old
churches we often find paintings or carvings of
the heavenly host with various instruments of
music, as though taking part in the devotions of
earth. In Fra Angelico's beautiful picture in the
National Gallery of the risen Lord surrounded by
angels and saints, the devotion of service of the
angels forms by far the greater portion of the
picture. As Dr. Alexander in his book, "The
Divinity of our Lord," excellently observes:
"Christianity is not a temporary influence, to be
absorbed into pure theism. The religion of
heaven, like that of earth, is Christianity." A
statement confirmed in the woundrous vision

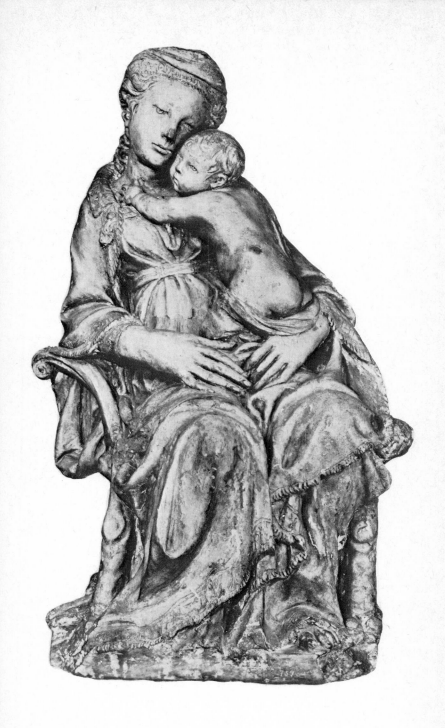

vouchsafed to the worn exile of Patmos: "I heard the voice of many angels round about the throne: and the number of them was ten thousand times ten thousand, and thousands of thousands; saying with a loud voice, Worthy is the Lamb that was slain to receive power, and riches, and wisdom, and strength, and honour, and glory, and blessing." And then the grand confirmatory cry in unison of all creation, of "every creature which is in heaven, and on the earth, and under the earth, and such as are in the sea," bursts with one accord into the thrilling anthem of devotion, "Blessing, and honour, and glory, and power, be unto Him that sitteth upon the throne, and unto the Lamb for ever and ever."

Of the ministry of angels to the saints we find abundant examples in art and legend. Thus to quote but a few: by angelic protection St. Hugh is defended from the lightning, while an angel holds the plough for St. Isidore during his devotions; an angel makes clothing for St. Homobonus, while another sings to St. Nicholas of Tolentinum, and yet another celestial visitor brings store of heavenly food to St. Congall.

We ordinarily associate the idea of white raiment with the angels; but the early painters did not by any means confine themselves to this, as we may readily see in any collection of the works of the old masters. They are often represented as having a bright flame of fire, two or three inches high, rising from just above the forehead. This may be very well seen in a decorative panel in the National Gallery by Aretino, and in several other pictures in the collection. They are almost invariably winged, ordinarily with two wings, but sometimes with six; these are expressive of swiftness and alacrity of service. Sometimes they are standing upon flaming and winged wheels, forms suggested by the mystical vision of Ezekiel. At times they are without bodies: incorporeal intelligences.

Ezek. i., also iii. 13 and the greater part of x.

The orders of angels, as represented in art, would appear to have been suggested by a treatise, "De Hierarchia Caelesti." St. Thomas

Aquinas gives them as follows: "Seraphin, Cherubim, Throni, Dominationes, Virtutes, Potestates, Principatus, Archangeli, Angeli."
"But over the hye desse in pryncypall place Where the sayd thre Kynges sat crowned all The best hallynge hanged as reason was. Whereon were wrought the ix orders angellicall, Dyvyded in thre ierarchyses, not cessynge to call Sanctus, sanctus, sanctus, blessyd be the Trynite, Dominus Deus Sabaoth, thre persons in one Deyte."

In the Greek Church, St. John the Baptist, while clad in garment of camel hair, is winged, since that Church translates literally the text, "Behold, I will send My messenger (angel), and he shall prepare the way before Me." He often has two heads, one in the ordinary position, and a second, also his own, borne in his hand in a basin! Christ too, as the bearer of reconciliation between God and man, is called in the Greek Church "the Angel of the Mighty Will," resulting in a wonderful creation of Greek art, which in the symbolism of the West has no parallel.

Mal. iii. 1; Matt. xi. 10; Mark i. 2; Luke vii. 27.

No subject perhaps has been more frequently painted than the Annunciation. The celestial messenger is the great archangel Gabriel, who stands in the immediate presence of God. The only other archangel mentioned in the canonical books of the Bible is Michael (Jude 9); but in the Book of Enoch we read of the four great archangels, Michael, Uriel, Raphael, and Gabriel, while in Tobit xii. 15 reference is made to "the seven holy angels, which present the prayers of the saints, and which go in and out before the glory of the Holy One," The speaker being Raphael. Seven, as we have already seen, has been accepted as the number symbolic of perfection and completion; and thus both in artistic and literary work, the great "angels of the presence" are ordinarily seven in number. To give but one illustration, when Milton introduces, in "Paradise Lost," the archangel Uriel, it is as *"one of the seven Who in God's presence, nearest to His throne, Stand ready at command."*

Luke i. 19, 26; see also Dan. viii. 16 and ix. 21.

For the first four centuries we do not find in the catacombs or elsewhere any representation of the devil, except as the serpent, the tempter of Eve. Later on the fallen angels and their leader have ordinarily been depicted with every accessory of grotesque horror. The Satan of Milton is a grand conception; but at the other end of the scale we may place the Satan of the "Ingoldsby Legends," a Pan-like creature with hoofs and horns and tail; and it is in some such guise as the latter that he generally figures in the art of the Middle Ages. In the illustration of a fourteenth century missal before us, the mouth has great protruding tusks that curl upward nearly to the eyes; the ears are long and pointed. At the shoulders and the thighs are other heads, from the mouths of which issue the arms and legs of the figure, the arms terminating in bears' claws, the legs in eagles' talons; the body, open at the waist, exposes a nest of serpents darting forth and hissing in fury, while the rest of the figure is covered with large scales. He is often represented also with wide-spreading draconic pinions.

The gargoyles on old churches often represent evil spirits. They are supposed to be flying from the sacred building, and great faith was held in the church bells as a protection against evil. "The reason for consecrating and ringing bells," says a mediaeval writer, "is this: that by their sound the faithful may be mutually cheered on towards their reward; that the devotion of faith may be increased in them; that their fruits of the field, their minds, and their bodies may be defended; that the hostile legions and all the snares of the enemy may be repulsed; that the rattling hail, the whirlwinds, and the violence of tempests and lightning may be restrained; the deadly thunders and blasts of wind held off; the Spirits of the storm, and the Powers of the air, overthrown."

The Tempter is represented as being driven away by the sign of the cross made by St. Hilarion; as chained by St. Norbert; as driven off by a large stone by St. Oswald; as seized with hot pincers by St. Dunstan; as trampled under foot

by SS. Theodore, Cyriacus, and Euphrasia; as cast by SS. Zeno, Hermes, and Hidulphus out of one possessed. The histories of the saints, and the pictorial representations in old work of their lives, would yield numerous other illustrations of the assaults of Satan and his defeats.

While sometimes represented as of colossal proportions, the evil spirit is more commonly given the stature of a man, and occasionally is found much more diminutive. Thus in some old manuscripts he is represented as tempting David and other good men in the form of a little black figure sitting upon their shoulders and whispering suggestions of evil in their ears; and often in representations of Christ casting out devils, the evil spirit issues in diminutive form from the mouth of the demoniac.

The Greek Hades, the Scandinavian Hella, originally the unseen world, has gradually become, in popular idea, the place of torment, the kingdom of Satan. As merely the invisible state, it is referred to in Matthew xi. 23, xvi. 18; Acts ii. 27, 31; Revelation i. 18; and several other passages. As the place of punishment it is referred to in Matthew v. 22, x. 28, xviii. 9; Mark ix. 43; Luke xii. 5; James iii. 6; and elsewhere. In the original these two quite distinct meanings are represented by two entirely different words.

Hell is generally, with the mediaeval painters and sculptors, the yawning mouth of a huge monster, breathing smoke and flames (as in fig. 56), or a large caldron set on flames, into either of which attendant spirits hurl their victims; and often, with a grim touch of humour and bitterness of satire we find some of these with kingly crowns, or wearing the cowl of the monk or the mitre of the bishop. It is curious to note that when the Spaniards entered the City of Mexico, they found that the doorway of the temple of the god of the air was made like the mouth of a serpent or dragon, painted to quote one of the their chronicles, "with foule and devilish gestures, with great gums and teeth wrought, which was a thing to feare those who should enter in thereat,

fig. 56

and especially the Christians, unto whom it represented very hell, with that ugly face and those monstrous teeth."

Representations of the kingdom of Satan are very numerous in the Middle Ages, though in earlier work there is no suggestion either of hell or of evil spirits. These mediaeval wall paintings in the churches probably suggested to Spenser the lines, — *"He shewed him painted in a table plaine, The damnèd ghosts that doe in torments waile, And thousand feends that doe them endless paine With fire and brimstone, which for ever shall remaine."*

It will be remembered how Dante's fellow citizens regarded him, such was the power of his poetry, with awe, as the man who had "seen hell."

fig. 57

The Renaissance idea of hell may be very well seen in the "Last Judgment" of Michael Angelo, where Charon is landing the lost souls on the farther side of the Styx, near to the mouth of a dismal cavern, clearing his boat of its unwilling passengers by the vigorour swinging of his oar.

In the Rabbinical book, "Bab. Berachôth," we are told that, if we could but discern the evil hosts around us, no one could withstand the shock; for every man has ten thousand at his right hand, and one thousand at his left. Wier, in his book, "De Praestigiis Daemonum," is content with a total altogether of lost spirits of 7,405,926.

Satan is most commonly symbolised as the dragon or as the serpent: the serpent representing the evil spirit as the wily tempter that first betrays to sin, the dragon as the devouring monster that remorselessly consumes those that have become its victims. "When lust hath conceived, it bringeth forth sin; and sin, when it is finished, bringeth forth death."

James i. 15.

The dragon and the dragon-slayer (fig. 57) appear in many creeds and form the subject of countless legends. While the story of the conflict varies with race and country, the legends of classic days, such as that of Perseus and Andromeda, the still older struggles carved on

109

the slabs of Persepolis and Nineveh, the stories narrated around the camp fires to the awed rings of Eastern nomads, or listened to with glistening eyes or rapt attention in the nurseries of England, the great mass of legend that in the Middle Ages clustered around the names of God's faithful saints, the local traditions of every land, all point to the fatal presence of some evil principle, and record the ultimate triumph of good. Beneath the mass of everchanging fable we find at length the one foundation to all, the deadly strife between two great antagonistic principles.

The evil spirit is described in the Book of the Revelation as "that great dragon." The conflict between St. Michael and the dragon is a favourite subject in art. We may see it, for instance, in Fra Carnovale's picture in the National Gallery; while the combat of our own national saint with the monster may be seen in the same collection in the works of Memling, Tintoretto, Pisanello, and Domenichino, and in old church carvings: as for example, at Pitsford in Northamptonshire, at Moreton Valence and at Ruarden, Gloucestershire, Brinsop, Herefordshire, and Fordington in Dorsetshire; in a brass at Elsyng church, Norfolk, and in considerable profusion on tiles, stained glass, and so forth.

Besides the religious and artistic association of the dragon with St. Michael and St. George, we find St. John of Rheims and St. Cyriacus represented in art with a dragon held enchained. SS. Longinus and Servatius also have one at their sides. St. Theodore is accompanied by a dragon having three heads, while St. Germanus of Auxerre has one with seven heads. St. Margaret is represented thrusting a staff into the jaws of a dragon at her feet, while St. Romain has the monster bound with his girdle and captive at his feet. As we have not sufficient space, or possibly sufficient inclination to give at full length the various legends, we are content to give but one as an illustration of all.

St. Romain was a bishop, and it is said that in his time a frightful winged dragon devastated the

neighbourhood of Rouen, and indulged, after the approved fashion of such monsters, in sundry feasts on human beings, etc. St. Romain determined to rid the country of this scourge, and after many snares and traps had been set and laid in vain, he resolved to go in person to the forest-haunt of the monster, taking with him two companions to assist him in the chivalric deed. As they drew near the spot, one of his colleagues fled at the sight of the dragon; but the other, taking the girdle of the holy man, approached the monster. At the sight of the girdle it became "as gentle as a lamb," and submitted to be bound therewith, and was thus conducted to the prelate, who caused it to be taken into the market-place at Rouen and publicly burnt. Its ashes were then thrown into the river Seine. One cannot help feeling on reading the story, that while the bishop gets most of the credit, his companion took most of the risk.

Another subject in which the dragon is represented is in connection with St. John, in allusion to some poison which was once given to him to drink, but from which he took no hurt, as, on placing the cup to his lips, the poison rose out of the vessel in the visible form of a dragon.

The Biblical account of the temptation and fall of Eve naturally makes the serpent a peculiarly appropriate symbol of Satan. As early as the eighth century it was supposed that the serpent that beguiled Eve had the face and head of a woman,—"A cherub's face, a reptile all the rest"; and we therefore often find it so represented in art. In a picture, for instance, by Ercole di Giulio Grandi, in the National Gallery, the tempter has a woman's head and bust, and long flowing hair, though the form is otherwise serpentine; the head of the monster and of Eve are on a level, and face to face. We see this again in "the Fall" by Filippino Lippi, in the church of St. M. del Carmine at Florence; though here the human face is so small, and the writhing, serpentine convolutions so evident, that the woman's face, instead of being an attraction and a snare, is but

"Albertus saith that the hair of a woman, taken at some seasons and laid in the ground will become venomous serpents. Which some have supposed to befall that Sex because of the ancient familiarity it had at first with that accursed Serpent."—GUILLIM.

111

fig. 58

an added horror. We see the human head again in the work of Pietro d'Orvieto in the Campo Santo at Pisa, and in may early illuminated manuscripts Fig. 58, a sufficiently ghastly example, though the ugliness is probably less intentional than indicative of want of artistic skill, is from the "Ortus Sanitatis," a Latin herbal printed first in the year 1491. From a praiseworthy desire to make his book as comprehensive as possible, the author starts from the Garden of Eden, and gives us this illustration, the *arbor vitae*, the tree of life, with its golden fruit and beguiling tempter in the midst. The arms of the Fruiterers' Company are a tree having a serpent coiled round it and on either side Adam and Eve.

In one of these old manuscripts we meet with the passage, "Quoddam ergo genus serpentis sibi dyabolus eligebat, qui cum erectus gradiebatur et caput virgineum habebat." It is known from very similar passages in the "Historia Scholastica" and elsewhere, that this belief was held at least as early as the eighth century: we have therefore both pictorial and literary proof of the antiquity of the idea. Even Michael Angelo, one of the later and greater men, an artist capable of the grandest idealizations, still conforms to the old treatment in his representation in the Sistine Chapel of the Fall of Man, though his feeling for beauty and his art-power enabled him to combine the human and the serpentine more pleasingly than in the work of the earlier men. while the betraying spirit is still beguiling Eve, the angel of the drawn sword hovers above ready to drive out of the Garden of Eden the guilty progenitors of our fallen race, a grand and suggestive addition to the work, and emblematic of the swift punishment that followed upon the fall.

On a medal struck in 1605 to commemorate the discovery of the Gunpowder Plot, we see on the obverse a snake gliding amongst lilies and roses, while on the reverse is the name of Jehovah set amidst a glory of rays.

On a Greek vase in the British Museum we have the daughters of Hesperus gathering the golden

apples, while a serpent coiled round the tree appears to be guarding them, thus strikingly suggesting some far away echo amidst pagan fancies of the Bible story. The serpent is often represented as winged; but winged or wingless, footed or purely serpentine, with one head or a dozen, with false woman face or stony ophidian glare, it coils round the tree of life, full of malignant subtlety and evil power, the sad symbol of enmity to good and God. *"Some flow'rets of Eden ye still inherit, But the trail of the serpent is over them all."*

MOORE, "Paradise and the Peri."

The winged serpent was probably suggested by the passage in Isaiah that refers to the "fiery flying serpent," and the additional attribute of swiftness would be accepted and welcomed as one feature the more of terror, an added horror bestowed on the loathsome crawling reptile, as a further means of compassing the destruction of its victims. The winged serpent is represented in the Egyptian wall-paintings · many centuries before its appearance in Christian art.

In the Book of the Revelation Satan is "the dragon, that old serpent, called the Devil, which deceiveth the whole world." Various texts refer to the subtlety of the serpent, to its deadly poison, to its dangerous lurking in the dust; and only twice do we find anything commendatory: in the first instance, when the brazen serpent gave life to those who looked upon it, and was thus made the type of the great Saviour of mankind; and, secondly, when the righteous were instructed to combine the wisdom of the serpent with the harmlessness of the dove. Even here the commendatory application is of the most oblique kind. The notion of the wisdom of the serpent probably sprang originally from the opening verse of the third chapter in Genesis: "Now the serpent was more subtle than any beast of the field which the Lord God had made." As the outcome of this was in the case of the serpent a malignant cunning, it can scarcely be made a legitimate basis for the higher idea we associate with wisdom.

As a talisman against evil and sickness we find

the serpent the companion of the physician, the magician, the soothsayer. It may be seen at the foot of the tripod at Delphi, or twined round the staff of Esculapius; while Cassandra, licked behind the ear by the serpent, became gifted with prophecy and foresaw all the evil that should befall Troy. Blind Plutus, after a serpent had licked his sightless eyes, saw clearly all the past, the present and the future; and strange powers of healing and of mysterious insight were ascribed to those who had come within the influence of the serpent's power and fascination.

In the Middle Ages men, for the possession of power, were held to have sold themselves to evil; and if a man were but a little wiser, a little sadder, a little more taciturn than his neighbours, he was held, like Dr. Faustus, to have invoked the enemy of mankind, and it was a moot point whether he should be viewed with awed respect as a magician, or burnt alive.

As the serpent refuses to hear the voice of the charmer, so the man of wisdom will imitate the prudence of the reptile, and refuse to listen to beguiling words that are full of future peril. Snakes are naturally attracted by sweet sounds, and the serpent charmers take advantage of the fact to capture them; a fact that was evidently well known in the days of the psalmist, who states that "the deaf adder stoppeth her ears, and will not heed the voice of the charmer, charm he never so wisely." The deafness, it will be noted, is no mere lack of the hearing faculty, but a deliberate turning away from peril. It was an old belief that when the asp heard the voice of the charmer it stopped its ears by burying one of them in the sand and coiling its folds over the other.

Marguerite de France, the daughter of Francis I., who was styled by her subjects the mother of her people, bore as her device an olive branch entwined with serpents, and the motto, "Rerum sapientia custos," signifying that all things should be guided and governed by wisdom.

The serpent has also been accepted as an

emblem of regeneration or immortality from the annual casting of its skin. As a symbol of eternity, the serpent may often be seen having its tail in its mouth, thus forming a complete circle, the accepted emblem of everlasting life.

Amongst various early sects the serpent was regarded not only as the symbol of wisdom, but also of goodness, and its form was largely employed in charms and amulets. It appears from St. Augustine that the Manichaeans used it as a direct type of Christ; but its employment was ordinarily antagonistic to Deity. Thus the Ophites, an offshoot of the Gnostics, and sharing with them their belief in the implacability of Jehovah, taught that God was jealous of man, and wished to prevent his acquiring more knowledge, but that the serpent came to teach man wisdom. The Ophites consequently adored the serpent,—a worship probably prompted and suggested by the reminiscences of the older faiths of Phoenicia and Egypt, where the serpent was revered as a beneficent being.

The Egyptian serpent of goodness, the cobra, is often represented with a human head. It stands erect upon its folds, while the serpent of evil creeps along the ground. It may be seen crowned with the diadem of the monarch, the double crown formed of the distinctive head coverings implying lordship over Upper and over Lower Egypt. The serpent of evil is very commonly met with in the Egyptian sculptures and wall paintings. In one example the goddess Isis is piercing it through the head; in another we see the advancing monster destroying mankind by the breath of its mouth.

Serpent worship is a widely spreading form of religion that we find in many lands and throughout centuries of time, the idea in most cases probably being not a recognition of beneficence, but rather a sense of the necessity of propitiating a potent evil power. The subject is a most interesting one, but its proper consideration would encroach upon our pages more than would be justly its due.

In the Hindu mythology we read that there was once a manifestation of the Deity who appeared on earth as counsellor, warrior, and teacher. "They who trust in me," cried Krishna, "know Brahma. I am the Victim, I am the Sacrifice, I am the Worship, I am the Road of the Good, the Creator, the Witness, the Asylum, and the Friend." This same being is the dragon-slayer of their creed, and none of the Indian sculptures are of greater interest and beauty than those of Krishna suffering, enveloped in the coils of a serpent that fastens its fangs into his heel, and Krishna triumphant, trampling under foot the crushed head of the monster. In this myth before the eyes of the teeming millions of India of a terrible yet vanquished power of evil, of a wounded yet conquering saviour, who proclaims himself the sacrifice, the way, the truth, and the life, we find a wonderful parallel with the Christ of God; while in fig. 59, a portion of a Hindu picture, we see a strange similarity to the multitudinous pictures of the Virgin and the holy Child found in Christian art.

fig. 59

The serpent is not much associated in art with the saints. St. Didymus is represented as treading one under foot, and we also find it in association with SS. Paternus, Pirminius, Thecla, and Phocas. Unfamiliar as these names may be, and generally unknown the legends that make the introduction of the serpent appropriate, the same difficulty scarcely arises in the case of St. Patrick, the patron saint of Ireland, the benefactor who once and for ever banished snakes and all such noxious creatures from the Emerald Isle, and who therefore, very justly, in recognition of his deed, bears the serpent as an attribute.

Ivory panel from an Early Christian casket with scenes from the Passion. About A.D. 400. British Museum.

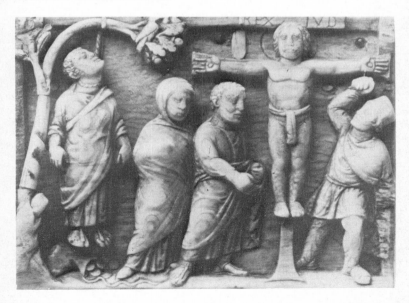

An early representation of the martyrdom of St. Thomas Becket, forming a full page miniature in a Latin Psalter, executed in England about 1200. British Museum.

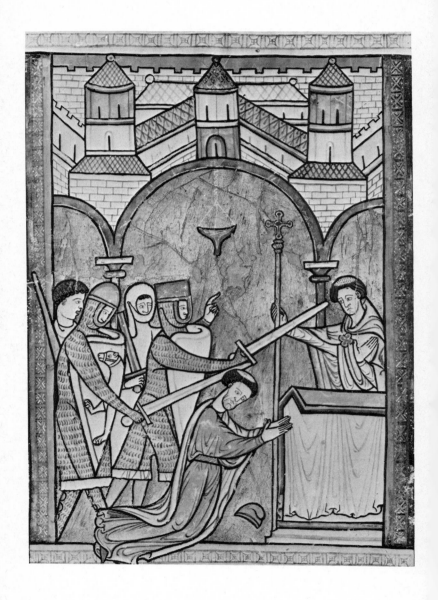

Chapter 7

We proceed now to some brief consideration of the faithful, the body of believers, the Church militant of God, and pass in review the glorious company of the apostles, the goodly fellowship of the prophets, the noble army of martyrs.

The Church as a whole we shall find is often represented either by a flock of sheep or of doves. The first symbol naturally follows from the Saviour of the world speaking of Himself as the Shepherd, and from His solemn charge to Peter, "Feed My sheep": while the dove, primarily an emblem of the Holy Spirit, is secondarily applied to all those upon whom He has breathed the breath of life eternal. Hence in the catacombs we often find representations of the Good Shepherd surrounded by His flock, and bearing a sheep in His arms, as in figs. 60, 61, 62, or at other times we see Christ as the Lamb of God, surrounded on either side by the sheep of His pasture. Fig. 63, an early Christian gem in the British Museum, shows us the soul resting in peace on Christ, the believer being symbolised by the dove with the olive branch, while the fish and the monogram are both emblems of the Saviour. The duplication seems at first needless; yet through it we get this double meaning, the sure rest for the wanderer on the Redeemer, and the steadfast gaze fixed on Christ. In fig. 64, a portion of one of the slabs in the catacombs of Rome, the single sheep with the palm branch aptly symbolises the victory over death of the member of the little flock thus commemorated.

In mediaeval work we not uncommonly find sculptured two female figures as symbols of the Jewish and the Christian Churches; but these are ordinarily found more freely in the continental cathedrals and churches than in England. The Church is represented as a woman, "the spouse of Christ," even in the earliest ages; but later on the second figure is added. The Jewish Church or synagogue is represented as blinded, a veil being over her eyes; in one hand she bears the tables of the law, in the other a drooping banner on a broken staff. The figure symbolizing the Christian

"I am the good shepherd: the good shepherd giveth his life for the sheep" (John x. 11). "Our Lord Jesus, that great Shepherd of the sheep" (Heb. xiii. 20).

fig. 60

"As a bride adorned for her husband" (Rev. xxi. 2). "As the bridegroom rejoiceth over the bride, so shall thy God rejoice over thee" (Isa. lxii. 5).

119

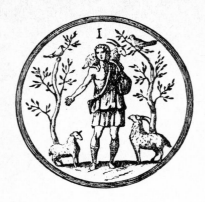

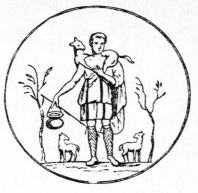

fig. 61 fig. 62

Church wears the crown, holds in one hand the
chalice, the pledge of communion with her Lord,
and in the other the once despised cross, the
symbol of her faith and power. Good examples
of these figures may be seen at Strassburg
cathedral. At Le Mans, in a painted window of
the twelfth century, the Church is depicted as
crowned by St. Peter, while the figure represen-
ting the synagogue falls fainting into the arms of
Aaron.

During the papacy of Leo the Great (A.D.
440—462) the wonderful mosaics in the church
of S. Paolo Fuori le Mura in Rome were
produced. Here we see the enthroned Christ,
above Him the four winged creatures symbolic of
the Evangelists, while on either side are the four
and twenty elders, those on the right being
bareheaded, and those on the left covered: the
one group signifying the prophets of the Old
Testament, who only saw the truth veiled; the
others, the apostles of the New Testament, who
beheld it face to face in all its fulness and beauty.
Thus in one united ascription of praise and
adoration to the Christ the great teachers of the
olden time and the evangelists of the new dis-
pensation join in one grand outburst of joy and
thanksgiving.

The Old Testament scenes are often represented,
not only from the historical, but from the
symbolical standpoint, not merely as depicting
the actual incident, but utilizing it to enforce

fig. 63

fig. 64

other and greater truths such as the Incarnation, the resurrection of the body, and the everlasting life of the soul. This kind of treatment is abundantly met with in the catacombs of Rome. The ark floating upon the stormy waters of the deluge becomes a type of the Church riding in safety amidst the strifes and turmoil of the world. Abraham's ·sacrifice of his son reflects the sacrifice on Calvary. Moses striking the life-giving stream of water from the rock in the arid desert, not obscurely points to Christ, the great spiritual Rock and the source of living water to the thirsty soul. Daniel in the den of lions suggest not merely God's protecting care over the faithful servant of God and the king, but becomes a type of victory over death. The ascent of Elijah prefigures the greater Ascension; and in the same way the prophet Jonah, the three faithful ones in the burning fiery furnace, the brazen serpent in the wilderness, and many other Old Testament histories and incidents, furnish the substratum upon which higher truths are built.

The following extracts from the "Biblia Pauperum" illustrate this teaching by type and symbol very clearly: "It may be read in the book of Numbers that in one night the rod of Aaron brought forth buds and blossoms, whereby is figured the Virgin Mary, who miraculously brought forth the ever-blessed Jesus Christ. It may be read in the first book of Kings that the queen of Sheba heard of the fame of Solomon,

121

and came into Jerusalem with great gifts in adoration for him; which queen was a Gentile, which will typify the Gentiles who came from afar to worship with gifts. We read in the book Genesis that when the Ishmaelites who had brought Joseph came into their own country, they sold him in Egypt; this boy Joseph is a type of Christ, who was sold by the impious Judas. We read in the book of Judges concerning Samson, that in the middle of the night he arose, and of his own might cast down the brazen gates of the city, and carried them away with him. Samson is a type of Christ, who, rising from the grave in the middle of the night, cast down the gates of the tomb, and left it in freedom and power. We read in the first book of Kings that when Bathsheba, the mother of Solomon, had entered in unto him in his palace, king Solomon commanded a throne to be placed for his mother next to his own throne. Bathsheba signifies the glorious Virgin, whose throne is placed next to the throne of the true Solomon, that is Jesus Christ."

As the old was made a type of the new, so the new was occasionally a reflex of the old. Thus in representations of the adoration of the Magi the travellers are almost always depicted as kings, as in fig.65, a picture by Fra Angelico, though there is nothing in the Bible record of the visit to justify the idea. It is based on that passage in the Psalms where we read, "The kings of Tarshish and of the isles shall bring presents: the kings of Sheba and Seba shall offer gifts: yea, all kings shall fall down before Him, all nations shall serve Him." Hence again in almost every representation of the Nativity the ox and the ass are introduced. This was not merely done from an idea that they formed very natural accessories in an event of which the scene was a stable, but quite definitely in illustration of the words of Isaiah, "The ox knoweth his owner, and the ass his master's crib; but Israel doth not know, My people doth not consider."

Where we sometimes find a difficulty in comprehending a subject, we must bear in mind that,

The scene of the Nativity is in the East always shown as a grotto or cave, while in Western Art it is depicted as a stable.

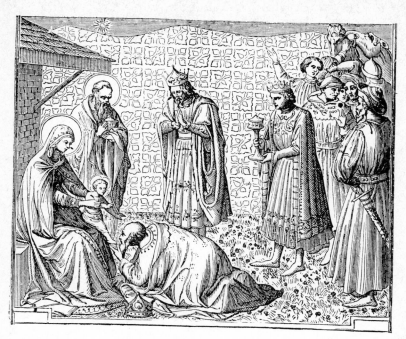

fig. 65

besides the canon of Scripture as now received,
the ancient writers, sculptors, and painters drew
their inspiration from various apocryphal sources;
such as the "Evangelium de Nativitate Mariae,"
the "Protevangelium Jacobi," the Speculum
Salvationis," the "Flos Sanctorum," the "Aurea
Legenda," and many other writings of the kind.
 During the Middle Ages, and especially where
the Renaissance influence is paramount, we oc-
casionally find the sibyls introduced. They were
held to be next in dignity to the prophets: the
function of the latter being to proclaim the
Messiah to the chosen people, of the former to
foretell His coming to the heathen world. Refer-
ences to the sibyls will be found amongst the
writers of Greece and Rome, amongst the Jews,
and in the writings of most of the Christian
Fathers. Plato speaks of one, Pliny of three,
Aelian of four, and Varro of ten. The Erythraean
sibyl is said, by Livy, to have offered to Tarquin
II. nine books containing the destinies of Rome,

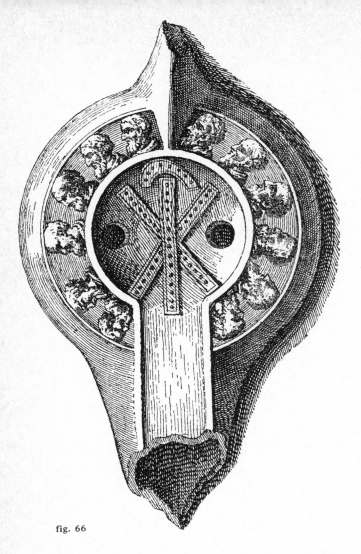

fig. 66

demanding for them three hundred pieces of gold. He declined the offer, whereupon the sibyl threw three of them into the fire, and asked the same price for the other six; this being still refused, she burned three more, and again demanded the same sum for those that remained, when Tarquin, conferring with the augurs, was advised to buy them. These books were destroyed at the burning of the Capitol, A.D. 670. In mediaeval times the traditions of the Church had assigned to each of the sibyls her distinctive prophecy and proper

emblem. Thus to the Libyan sibyl was assigned the statement, "The day shall come when men shall see the King of all living things," her emblem being a lighted torch. To the Persian sibyl was assigned the prophecy, "Satan shall be overcome by a true prophet" her attribute being a dragon. To the Delphic sibyl was imputed the prophecy, "The prophet born of virgin shall be crowned with thorns." These prophecies were manifestly merely monkish legend; but even so early as the second century certain writings were held in great honour amongst the pagans, and the pious fraud of interpolating passages bearing allusions to the Messiah was practised. These spurious predictions were held in veneration for centuries, and the sibyls were freely introduced into art, the best known examples being in the magnificent work of Michael Angelo in the Sistine Chapel at Rome. In Raphael's picture of the "Adoration of the Kings," in the Berlin Museum two sibyls are placed in the upper portion of the work, and two saints in the corresponding lower portion.

See Appendix A.

In religious art the patriarchs and other Old Testament worthies are distinguished by their special symbols. Thus Aaron bears a censer or rod, and is clothed in the vestments of the priesthood, while Abraham has in his hand the knife of sacrifice; Daniel is accompanied by a lion; Amos has the crook of the shepherd; Moses carries the tables of the law, and is crowned with a radiant glory; Noah bears the dove and olive-branch, or a small figure of the ark, in his hand; David has the harp, or sometimes the stone and sling; Elias a scroll or chariot; Jonah a big fish or a ship.

The apostles, as the forerunners and symbols of the whole Christian Church, are in the earliest work represented as sheep, six on either side of the central figure of the Shepherd or of the Divine Lamb. Later on they are shown, as in fig. 66, in human form, and then the need was soon felt of giving them distinctive symbols to aid in their identification. They first appear wearing the nimbus in the mosaics of the church of St. Maria,

The mosaics of the early churches supply us with most valuable materials. Had they been lost to us, there was nothing else that could have taken their place. The Christian mosaics date from the fourth century. The early pictures are very simple in character, and deal with the historical facts of the Old Testament, and such emblems as the vine, Orpheus, or the Good Shepherd. Later on we see the gradual development of various doctrines and the first indications of various errors that had crept into Church government or Christian belief.

Ravenna, dating from the year 553. It was the custom to bestow a certain personality upon each of the Apostles: thus St. Peter always had a short, rounded beard, while St. Andrew had a long, flowing one; St. Philip was of advanced age, St. John almost a youth. But it was no doubt soon found that it was impossible by such means to clearly distinguish from one another twelve or more distinct persons. Attributes or symbols were therefore assigned to them. St. Andrew bears the X shaped cross, the emblem of his crucifixion. St. Bartholomew was flayed alive, and therefore has in his hand a large knife. St. James the Elder carries the scallop shell, water-bottle, and staff of the pilgrim. St. James the Less has the fuller's pole, the instrument of his martyrdom. St. John bears in his hand a cup with a winged serpent emerging from it, in reference to the tradition that one of the priests of Diana challenged the apostle to drink a draught of poison; after St. John had made the sign of the cross over the cup, Satan, in the form of a dragon or serpent, rose from it and flew away. Judas, the traitor, bears the bag, since he was the treasurer of the band. St. Jude bears a big knotted club, the instrument of his death; and St. Matthew, for the same reason, a hatchet. St. Peter ordinarily carries a couple of keys, or at other times is accompanied by a cock; St. Simon a large saw, and St. Thomas a lance, in each case the instrument of martyrdom. St. Philip has a long staff or pillar, as he suffered death by being suspended from a lofty column; St. Matthias a battle-axe; St. Paul a sword, the instrument of his decapitation.

The Evangelists are abundantly introduced, and under very varying forms. Sometimes they are men with rolls or books in their hands, inscribed with their names; at other times we get the inscribed books or rolls alone. Most commonly the evangelistic symbols are the angel, the lion, the ox, and the eagle; and these also, as in fig. 67, are generally associated with the rolls. Sometimes the men are introduced with these four creatures

The number varies, since sometimes Judas is not introduced, while at others SS. Matthias, Barnabas, and Paul are included, though not in the original band of twelve.

126

fig. 67

by their sides, or at their feet, while in a few cases the forms are human, except that they have the heads of the angelic or animal type. In fig. 67, a piece of early carving from the church of Sta. Maria, Rome, instead of, as in fig. 48, having Christ surrounded by the evangelists, we have the hand in benediction, and around it the four evangelistic symbols, each bearing the roll in hand, paw, hoof, or claw. Fig. 68 is a much later piece of work, a portion of a picture by Van Eyck, representing St. Luke painting the portrait of the Virgin. Even though the treatment is purely pictorial and modern in character, we still see introduced in the background the symbolic ox bearing its scroll of writings. We may even occasionally find all four symbols combined into one, with the four distinctive heads, and supported on the foot of the angel, the paw of other examples again they are depicted as men holding urns, and pouring from them the living waters of the gospel, or at other times the four streams alone are seen issuing from Christ the rock.

As some of our readers may find a certain difficulty in remembering the appropriate symbol of each evangelist, they will find the following

fig. 68

It is curious too to notice that the four Egyptian gods of the dead that stand before the Judge have four different natures, though in this case they have the heads of the dog or jackal, ape, man, and eagle. These four, as we may see in funeral tablets in the British Museum and elsewhere, always appear at the trial of the dead man, and mediate to Osiris on his behalf. When the body was embalmed, various parts of the internal organs were placed within jars having lids surmounted with these heads.

mechanical aid to memory very serviceable: if the word ALOE be taken, it will be found to be composed of the initial letters of the four symbols, angel, lion, ox, eagle, and in their proper sequence for Matthew, Mark, Luke, and John. This key-word will at once give the symbol required.

These four figures, the man or angel, the lion, ox, and eagle, are in a marked degree common to almost all periods of art. Thus in Egypt we find the Sphinx human, eagle-headed, or leonine in character, while the ox is amply represented in the countless figures of the sacred Apis. In the Assyrian remains we are confronted by bulls or lions with human heads, or by figures in human form, but having the wings and heads of eagles. The four creatures seen in the wonderful vision of the prophet Ezekiel were of this nature; for he

128

expressly says in his description that they were similar to those he had seen while a captive by the river Chebar—a river of Assyria that runs into the Euphrates about two hundred miles north of Babylon—whither he and the great bulk of his nation were carried by the Assyrian king Shalmaneser, 721 years before the Christian era. The Assyrian sculptures therefore must have been familiar in appearance to him and to those to whom he was sent to prophesy.

The prophecy opens with the words, "Now it came to pass in the thirtieth year, in the fourth month, in the fifth day of the month, as I was among the captives by the river of Chebar, that the heavens were opened, and I saw visions of God." The whole of the first chapter is full of glowing imagery, and he reverts to it again in the tenth chapter; though we realize as we read it how utterly inadequate he must have felt all verbal description to be to express the glory of that vision of the opened heaven.

In the apocalyptic vision of another captive exile, St. John of Patmos, the mysterious creatures adoring ceaselessly before the throne re-appear to mortal eye. We read that the first creature was like a flying eagle. Probably it was upon these passages in the Old and New Testaments that the evangelistic symbols were based.

St. Jerome and St. Ambrose assert in their writings that these four creatures represent, through the evangelists, our Lord under four aspects. Wyckliffe, in his translation of the Old Testament, published in the year 1380, refers to the beliefs of both these older writers. His English is almost too quaint for direct quotation, but the substance of it is that Matthew is represented as a man or angel, inasmuch as he dwells in his gospel chiefly upon the manhood of Christ; Mark is shown as the lion, as he treats most fully of His rising again; Luke is represented as the ox, writing as he does more especially concerning the sacrifice and the priesthood; while John is the eagle, since he passes in his writings over many of the little details given by the other evangelists,

and dwells most lovingly on the sacrament and the higher mysteries. Another theory on which he touches differs slightly from this, as it sees in the life of our Saviour Himself four great incidents which the forms symbolize: the man, referring to His human birth; the sacrificial ox, to His death on the cross; the lion, to His resurrection; and the eagle, to His ascension into heaven.

Though art soon became an aid to faith, its previous association with heathenism made the early Christians shrink from its use, and the carvers of graven images were regarded as the servants of Satan, and forbidden the rite of baptism. This repudiation of art was however a matter of Church policy, and was in practice for only a limited time, the prohibition being removed as soon as the contest between the old beliefs and the new faith ended in the victory of the latter. Later on we find Gregory II. writing: "The sacred pictures elevate the feelings of men. Fathers and mothers lift up their children to view them. Youths and foreigners point with edification to the painted histories. All hearts raise themselves to God." There was nevertheless, as one may see at the present day in Russia, a tendency for this appreciation of picture and image to presently develop into worship and idolatry; and in the year 726 the emperor Leo III. published an edict condemnatory of the veneration and use of religious paintings and images. Hence arose the sect of the Iconoclasts or image-breakers, and this crusade was in active operation for over a century, and doubtless an enormous wealth of early art fell beneath the zeal of these enthusiasts. Later on in our own country, in the sixteenth and seventeenth centuries, inestimable treasures of mediaeval art were destroyed by men whose fanatical ardour was more characterized by a burning zeal than a just discretion.

The reckless and ignorant destruction of the manuscripts in the monastic establishments at their dissolution is a conspicuous illustration of this sadly misplaced energy. Bale, who was himself an advocate for the dissolution of the religious

houses, cannot help exclaiming: "Never had we bene offended for the losse of our lybrayes beyng so many in nombre and in so desolate places for the moste parte, yf the chief monuments and moste notable workes of our excellent wryters had bene reserved, yf there had bene in every shyre in Englande but one solemyne lybrary to the preservacyon of those noble workes, and preferrements of good learnynges in our posteryte it had bene yet somewhat. But to destroye all without consyderacyon is and wyll be unto Englande for ever a most horryble infamy amonge the grave senyours of other nations. A grete nombre of them wych purchased of those superstycyose mansyons reserved of those lybrarye bokes, some to serve their jaks, some to scoure theyr candelstyckes, and some to rubbe theyr bootes: some they solde to the grossers and sopesellers, and some they sent over see to the bokebynders, not in small nombre but at times whole shippes ful. I know a merchantman, whyche shall at thys tyme be nameless, that boughte the contents of two noble lybraryes for xl shyllyngs pryce, a shame it is to be spoken. Thys stuffe hathe he occupyed in the stide of greye paper for the space of more than these ten years, and yet hathe store ynough for as manye years to come. A prodygouse example is this, and to be abhorred of all men who love theyr natyon as they shoulde do."

Another good example of the destruction that went on all over the land may be gathered from the following extracts from the diary of William Dowsing, Parliamentary Visitor for the country of Suffolk, recording the smashing and breaking of the "superstitious pictures and ornaments of churches": "Sudbury, Suffolk, Peter's Parish, January 9th, 1643: We break down a picture of God the Father, two crucifixes, and pictures of Christ—about an hundred in all; and gave orders to take down a cross off the steeple, and divers angels—twenty, at least—on the roof of the church." "Clare, January 6th: We brake down one thousand pictures—superstitious. I brake

down 200—three of God the Father, and three of
Christ and the Holy Lamb, and three of the Holy
Ghost, like a dove with wings; and the twelve
Apostles were carved in wood on the top of the
roof, which we gave orders to take down, and
twenty cherubim to be taken down, and the sun
and moon in the east window, by the King's
Arms, to be taken down." "Bramford, February
1st: A cross to be taken off the steeple; we brake
down 841 superstitious pictures."

The church of St. Agnes, originally founded by
Constantine, and rebuilt by Pope Honorius (A.D.
626—638), is an example of how things were
tending, since not the Saviour as heretofore, but
St. Agnes is made the central figure in the great
mosaic; and though the previous representation
of various saints as accessories to the Saviour
could not suggest or provoke creature-worship,
the case was somewhat altered when the one
grand central figure that invited special attention
was that of a saint receiving such special honour,
and this feeling rapidly grew into invocation and
adoration.

In many of the old pictures a certain anachron-
ism would appear to be involved; but this is only
apparently so, as the groups of saints of various
periods assembled together are not intended to
represent historic fact, but have symbolic refer-
ence to the communion of the faithful in one
mystical body. Thus in a picture in the National
Gallery painted by Girolamo da Treviso as an
altar-piece for the Boccaferri Chapel in Bologna,
we have the Madonna and Child enthroned under
a canopy with SS. Joseph, James, and Paul, the
latter of whom is presenting the donor of the
picture to the infant Christ. In another picture in
the same collection, painted by Schiavone, of the
same subject, the attendant saints include SS.
Bernard, John the Baptist, Anthony of Padua,
Catherine, Cecilia, and Sebastian, an assemblage
that certainly never met together in this world.
Such gatherings represent a heavenly rather than
an earthly assembly. The pictures were ordinarily
altar-pieces, and each church or religious body

made its own selection of the saints to be represented quite independently of all considerations of geography or chronology. In Mantegna's "Madonna of Victory," in the Louvre, the infant Saviour is surrounded by two bishops, a cardinal, and a pope, all in gorgeous vestments; while in Van Eyck's "Adoration of the Lamb," three popes, two of them amicably singing from the same book, appear in the picture, a state of things that is materially though not spiritually, an impossibility and rank absurdity. Fig. 69, the "San Sebastiano" of Titian, is another characteristic example of this.

Besides the essential knowledge of the symbols attributed to each saint before identification is often possible, we require to know something of the various art traditions. Thus, for example, St. John is represented in Western art as the young man that he was at the death of the Saviour; while the Greek Church paints him as a venerable, gray-bearded old man, writing the Apocalypse some sixty years after the death of his Lord.

Amongst the noble army of martyrs there is no more favourite and common subject in art than St. Sebastian. He is always represented as divested of his clothing, tied to a tree, and pierced by arrows. In the National Gallery we have several examples: one by L'Ortolano, the figures life-size, where he is accompanied by St. Rock and St. Demetrius; and another by Pollajuolo, where the saint is seen in the middle of the picture, bound to a tree, and already pierced with arrows. In the foreground are four of his executioners, two of them in the act of discharging their weapons, and the other two charging their cross-bows: here again the figures are almost life size. A very beautiful example, the work of Bazzi (Il Sodoma) in the Uffizi Gallery, Florence, shows the martyr bound and pierced, while an angel descends from heaven to crown the suffering saint with the diadem of victory. In the "Madonna and Saints" of Giovanni Bellini, in the Academy at Venice, St. Sebastian occupies a prominent position. When the subject may be considered as painted

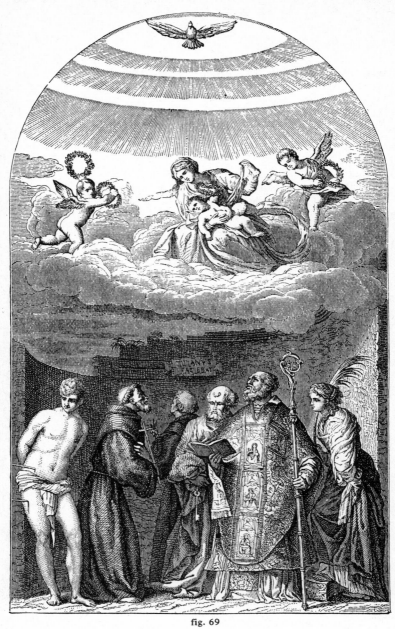

fig. 69

from the historical point of view, the treatment generally leaves nothing to be desired; but in a group of saints, including possibly a cardinal or other gorgeously robed ecclesiastic, the appearance of St. Sebastian, attired with a mere strip of cloth around the loins, and three-foot arrows sticking out all round him, is at first sight quaint. We may without breach of charity assume that doubtless one reason why this saint so often appears in art is that draughtsmen of the nude figure find in his sufferings an excellent opportunity of exhibiting their skill and anatomical knowledge.

Another very popular saint in art is St. Christopher. He may be seen in the picture of Joachim de Patinir in the National Gallery, and he is also on one of the panels on the tomb of Henry VII., at Westminster Abbey. He may always be recognised from his bearing on his shoulders a little child, and he often also has the bough of a tree in his hand. The little child is the Saviour of the world; the saint's name signifies the Christ-bearer. It would be manifestly impossible to give at length the legends associated with the various saints, but that of St. Christopher is so interesting that we may place it at the end of our book, for reference.

St. Cecilia, a Roman lady who suffered martyrdom in the third century, was said to have been the inventor of the organ. She may therefore be recognised in art from the organ or other musical instrument that is represented with her. She is the patroness of musicians. In the fine "St. Cecilia," by Raphael (a portion of which is given in the frontispiece), the saint gazes in rhapsody into the heavens, where an angelic choir is singing. She holds in her hands an organ, and at her feet are scattered various other musical instruments. In the picture by Domenichino in the Louvre, she is depicted as playing the violoncello, an attendant angel standing by and aiding the performance by holding out the music-book.

St. Lawrence the Deacon was broiled to death A.D. 258, and is therefore recognisable by the

fig. 70

great iron framework or gridiron that he holds at his side. He may be so seen in a Memling in the National Gallery. In the basilica of Galla Placidia at Ravenna, we may see him in a mosaic, standing before the heated gridiron, holding a copy of the gospels in his hand, to symbolize his office of deacon, and a cross, the cross of martyrdom. In the fourth bay of the north aisle in Henry the Seventh's Chapel, Westminster, St. Lawrence, clothed in dalmatic as a deacon, is sculptured amongst the many other interesting figures of saints that may there be found. He reads from a book which is supported on a gridiron.

SS. Catherine, Euphemia, and Quintin all have a wheel as a symbol; but the first-named of these is by far the most popular, and is almost always the one represented. She was a virgin of royal birth at Alexandria, and publicly confessed the Christian faith at a feast to the gods; for which confession she was put to death. The sentence of the emperor was that she was to be crushed and torn by toothed wheels; but the apparatus was broken by angelic agency, if we may credit the legend, and she was therefore beheaded. In a fine picture by Raphael in the National Gallery she is looking upward with an expression of resignation, and leaning with her left arm on the spiked wheel, the intended instrument of her death. Another good example in the same collection is by Pinturicchio, where the saint stands erect, with the crown of a princess upon her head, the nimbus of the saint also, a sword erect in her right hand, and the wheel behind her. Representations of her recur constantly in mediaeval work. Of these fig. 70 may be taken as a good illustration. In some examples, the wheel is much larger, and more of the matter of fact character seen in fig. 71. The wheel borne by the saint in fig. 70 is but a graceful symbol of the actual instrument martyrdom, while the sword is of much more realistic type. The illustration is from a German source.

Other favourite female saints are SS. Veronica and Agatha. The legend of the former is given by

fig. 71

John Damascenus, in "De Fide Orthodoxa." We are told that Berenice, the woman who had an issue of blood for twelve years, and who was healed of her plague by her faith in the great Physician, encountered our Lord on His journey to Calvary, and in loving pity gave him her kerchief to wipe His bleeding brows. When he gave it back to her it bore the impress of His features, and became the Vera Icon, the miraculous portrait, and she was ever afterwards called St. Veronica. In the National Gallery we may see, in a picture by William of Cologne, the saint holding before her the *sudarium* or white cloth containing the sacred portrait. St. Agatha is indicated in art by her symbol, the pincers, her breast having been lacerated by those instruments before she was put to death. She may be seen accompanied by this symbol in Sebastian del Piombo's picture representing her; a picture called by Vasari "divine." It is one of the works in the National Gallery.

The pincers are also associated with SS. Apollonia, Macra, Lucy, Pelagius, and Dunstan. With the first of these a tooth is always held in the pincers, as Apollonia, like the mediaeval Jews and many other unfortunates, had to submit to a severe experience of involuntary dentistry as an inducement to abandon her way of viewing matters. St. Lucy is the patron saint of the blind. A heathen ruler praised the beauty of her eyes, and desired to marry her; so she tore them out with pincers and sent them to him, with the message, "Having these, let me now live to God." Heaven, we are told, restored her sight; but the rejected wooer accused her to the authorities of holding the Christian faith, and she was put to death. Her attributes in art are the palm branch of the martyr, and the more distinctive symbol of a platter having two eyes in it. The pincers of St. Pelagius are always depicted as being red hot; but St. Dunstan, who also has them as an attribute, and in like manner represented as of a glowing red, was more fortunate in his association with them. The former saint had them

This poetical fable is of great antiquity, and re-appears under many modifications. This miraculous kerchief or veil was said to have healed Abgarus at the hands of St. Thaddeus, and it was also, we are told, carried to Rome for the healing of the emperor Tiberius. According to other versions of the legend, Abgarus, in his zeal to know something of Christ, sent his own painter to Jerusalem to take the portrait of the Saviour; but the Divine face far outshone the feeble powers of the artist. The Christ, ever kindly and full of consideration, pressed a handkerchief over his countenance, and sent it to Abgarus, stamped with the glorious image, the Vera Icon, of his Divine features.

137

applied to himself, while the latter applied them to some one else, which makes, practically, a very considerable difference. The old legend tells us that while St. Dunstan, who was a great handicraftsman in metals, was working in his cell, the devil in disguise came to his window and chatted with him. The saint soon detected from the tone of the conversation the person he had to deal with, and picking up a pair of red-hot pincers seized the tempter by the nose, and only let go on faithful promise of no further molestation. His statue may be seen in Henry the Seventh's Chapel, and elsewhere, with the cope and crozier of the bishop, and in his left hand a formidable pair of tongs or pincers.

It is impossible to dwell on the legends that explain the attributes borne by the various saints. We must therefore perforce be content with little more, or in most cases nothing more, than just mentioning them. The prominent display of a cloak probably refers to an act of charity especially associated with St. Martin; but if spread out on the ground before the figure represented, that figure will be St. Alban. St. Hyacinth floats out to sea upon his, while St. Raymond uses his cloak as a sail.

A lamp in the hand will probably betoken St. Hiltrudis or St. Nilus, while in a general sense the lamp implies truth and righteousness, and the illumination of the Holy Spirit: "Let your light so shine before men, that they may see your good works, and glorify your Father which is in heaven." The lamps of the early Christians are found in abundance in the catacombs and other cemeteries. They were accustomed to place them with the dead, and from the fourth century lamps were often kept burning before the tombs of the revered departed. They supply numerous and excellent examples of symbolic design. Christ as the good shepherd, the fish, lamb, monogram, cross, palm tree, ark, dove, and many other devices of like nature, are found upon them.

Where we find a saint carrying a lantern which a

See Appendix C.

fiend is trying to extinguish, we are in the presence of St. Hugh. The torch is more especially a heathen symbol, and is often associated with Aurora, while the reversed torch signifies that the light of life has departed. It is seen in Christian art as a symbol of some few saints, and generally, as in the case of SS. Dorothy and Dioscurus, as an instrument of pain and death.

We not unfrequently find statues and pictures of saints represented as holding books in their hands: these are divines and Fathers of the Church, whose writings have contributed to the building up and defence of the faith. St. Jerome, for example is ordinarily thus represented. At other times we may find the individual carrying the small model of a church in his hand, thus marking him as the founder of the building, or in some other way betokening his connexion with it. In Orcagna's picture in the National Gallery of the "Coronation of the Virgin," we find amongst the various saints depicted a figure of St. Peter. He is supporting on his knees a model of the church of San Pietro Maggiore in Florence, not, of course, because he founded it, but because it is dedicated to him; and it was for the altarpiece of this church that the picture was originally painted, and the ecclesiastical authorities naturally wished it to be understood by all who saw the picture that the great apostle had them under his especial care. In the public library at Boulogne is a manuscript copy of the Psalter that contains on its fly-leaf the symbolic description of a church. Though it soon runs into extravagance, and gives a forced meaning to everything, the beginning struck us as being excellent: "Fundamentum est Fides, Altitudo ejus est Spes, Latitudo ejus est Caritas, Longitudo est Perseverantia." In Crivelli's picture in the National Gallery of the Annunciation, beside the angel is kneeling St. Emidius, the patron-saint of Ascoli, and in his hand he holds a model of that town.

St. Luke is claimed as the patron saint both of the artists and of the physicians; but it is naturally in the former relationship that he appears

in art. The doctors may be as fully convinced of their claim; but while their lack of artistic skill prevents their representing the saint as healing, the practical art power of the painters enables them to represent him as one of themselves. Many old pictures still extant have at one time or another been ascribed to St. Luke. Metaphrastus mentions his skill as an artist, and John of Damascus refers in his writings to his portrait of the Virgin. Hence besides his best known symbol of the ox, the paraphernalia of the painter may often be found bestowed upon him.

The bag of money that generally indicates Judas is also sometimes bestowed as a symbol on St. Matthew, in allusion to his occupation before he became one of the chosen band of apostles. St. Mary Magdalene bears the jar and box of ointment, as also do SS. Cosmas and Damian; while St. Wilgeforte, besides her flowing tresses of hair, has a long beard. She may be seen thus represented in Henry the Seventh's Chapel at Westminster, in the ninth bay on the south side, in company with SS. Dorothy, Barbara, and Mary Magdalene. Her beard was bestowed upon her, we are told, in answer to her prayers, in order that she might escape matrimony. As it might therefore reasonably be supposed that she would sympathise with others who were of like feeling, she was the patron saint of all ladies who desired to get rid of their lovers or husbands, and was popularly therefore called St. Uncumber in England, Oncombre in Flanders, Kummernicht in Germany, and Liberata in France.

The great apostle St. Peter is sometimes represented with a single key, but more often with two, one of silver and the other of gold. The symbol is in obvious allusion to the text, "I will give unto thee the keys of the kingdom of heaven" (St. Matt. xvi. 19). In Perugini's fresco in the Sistine Chapel of Christ's charge to Peter, the Saviour hands the apostle two large keys; and we see this again in Raphael's cartoon of the subject. They are naturally a favourite charge in ecclesiastical heraldry. They may be seen, for instance,

fig. 72

alone or in conjunction with other charges, in the arms of the dioceses of York, Ripon, Exeter (fig. 72), Gloucester, Peterborough (fig. 73), and St. Asaph; in each case two keys being introduced, and crossing each other like the strokes of the letter X. At Winchester the two keys are both sloping in the same direction, but are crossed by a sword, the symbol of St. Paul, in the opposite direction. In the arms of Truro (fig. 74), we get key and sword again. The arms of the cathedral church of St. Paul are very appopriately two crossed swords, as we may see in fig. 75, and we get the sword again at St. Alban's, but this time as the symbol of the death of the great proto-martyr of Britain.

fig. 73

St. Adrian was put to death by having his limbs and head chopped off on a smith's anvil; his attributes therefore are an anvil and an axe or sword. St. Adalbert is pierced with a lance. SS. Aurea, Christina, Callixtus, Quirinus have a mill-stone round their necks. A caldron of boiling oil is the attribute of SS. John and Felicitas; of boiling lead, of St. Fausta. Red-hot ploughshares are the symbol that marks St. Cunegundes. The rock from which he was pushed into the sea is associated with St. Pantaleon; while others bear red-hot stones, are covered with burning charcoal, are pierced with the sword, are tormented in every conceivable way that the malice of their persecutors could suggest. It is impossible here to mention a tithe of the saints who make their appearance in art and are recorded in legend.

fig. 74

It was speedily felt by all who were interested in maintaining the pagan rites that the new sect of the followers of the despised Nazarene could not be bent, and must therefore be broken. It claimed an exclusive allegiance, and its progress meant the downfall of all other systems of faith. Politically too it was regarded with disfavour; not only therefore did the bloodthirsty Nero fulminate against its followers, and strive to crush the rising Church, but even the just and generous Trajan saw in it a danger to the State that must be promptly dissipated. Against the

fig. 75

new creed were arrayed the mighty material force of the empire of Rome; the intellectual power of the keenest minds, who brought their solid learning and acute argument to bear against it; the social influence of the old rites, that had been the stay and guide of their followers in times of trouble, and no less associated with them in the days of national and individual rejoicing; the conservative force that resented the intrusion of a new cult; the aesthetic force of all that was grandest in architecture and sculpture; the spiritual power wielded over the minds of men by the older beliefs; and, less reputable than these six great opposing influences, but as potent as any, the bitter, selfish opposition of such men as the makers of the silver shrines of Diana, who saw their gains diminished. Against these seven potent influences the infant Church, strong in a mightier power, prevailed and triumphed, esteeming the reproach of Christ greater riches than all the fading treasures of earth.

Fantastic legends have grown around the names of some, and many have had their glory dimmed by the mistaken zeal of those who strove to honour them, and yet imputed to them, in all good faith, actions far removed from the Christ-like spirit, while not a few are wholly mythical; but above and beyond all the great fact the noble army of martyrs: and it is meet and right that the fearless saints of the living God, the Church triumphant, should ever be held in highest honour in the Church still militant on earth.

Chapter 8

We pass now to a consideration of the various
symbols of sovereignty and authority, spiritual
and temporal. Of these the crown is naturally the
first that occurs to us. It is sometimes introduced
as an attribute of earthly sovereignty; at others,
as a celestial reward and proof of victory won. In
the arms of the see of St. Alban's, for instance,
we find, see fig. 76, a sword surmounted by a
crown: the first, a symbol of death of the great
British proto-martyr; the second, the reward of
his constancy to the faith. In Crivelli's picture in
the National Gallery of "the Madonna in Ecstasy,"
two angels are seen supporting a crown over her
head, and many other such-like renderings may
be met with.

fig. 76

The first mention of a royal crown is where the
Amalekites bring Saul's golden diadem to David.
Tarquin, B.C. 616, was the first Roman sovereign
who assumed it, and the earliest English crown
was that of king Alfred, A.D. 872. The tiara or
triple crown of the popes was originally a plain
high cap, much like those in which the Doges of
Venice are so often represented in old pictures
and medals. It was first introduced by Pope
Damasus II. in 1048. It is doubtful when the first
coronet was added, but the second was placed by
Pope Boniface VIII. in 1295, and the third by
Pope Benedict XII., about 1334. It has been held
that the three crowns refer to the Trinity, though
that could evidently not have been the original
idea, or they would not have been added one
after the other with an intervening interval in
each case of many years. Others affirm that they
denoted the threefold royalty of the pope: one
being the symbol of the temporal power over the
Roman states, another the spiritual over the souls
of men, and the third assumed as ruler over all
the kings and potentates of Christendom. A third
explanation is, that the three crowns are the
lordship claimed by the papacy over heaven and
earth and purgatory.

The arms of St. Edmund were three golden
crowns on a shield of azure; thus referred to by
Lydgate,—*"In which of gold ben notable*

crownys thre, The first tokne in cronycle men may fynde, Granted unto him for royal dignite, And the second for his virginyte, For martyr-dom the thridde in his suffring."

While the crown is an emblem ordinarily of power, the wreath is a symbol of victory.—*"Now are our brows bound with victorious wreaths."—King Richard II.*

It is ordinarily of the bay or sweet laurel, as in fig. 2, though the myrtle, olive, and other plants also appear. On the magnificent gold medallion of Constantius II., Constantine I. is represented standing between his two sons, while a hand from heaven crowns him with a wreath; and on many coins of ancient, mediaeval, and modern date the laureated head of the victorious ruler is a marked feature.

The wreath expressive of triumph won is one of the commonest of symbols in the catacombs.

The mitre, the symbol of authority of the Jewish high priest, is also the attribute of bishops and archbishops. Cardinals anciently wore them; but at the Council of Lyons, in the year 1245, they were appointed the scarlet hats that are so familiar to us all. As an ecclesiastical emblem we find the mitre introduced in the arms of the sees of Carlisle (fig. 77), Norwich (fig. 78), etc. In Il Moretto's picture of St. Bernardino, at the feet of the saint are three mitres, inscribed with the names Urbino, Siena, and Ferrara, the bishoprics of which he is said to have refused.

The sword as the symbol of authority and power, or, in an evil sense, of bloodshed and wrong, is freely introduced. Four symbolic swords are used at the coronation of a British sovereign. (1) The sword of state, a large, two-handed weapon, having a gorgeous scabbard of crimson velvet, decorated in gold with the port-cullis, harp, rose, thistle, and other heraldic symbols. (2) The curtana, or pointless sword of mercy. (3) The sword of spiritual justice. (4) The sword of justice of the temporality. In the very interesting series of figures of the prince-bishops of Wurzburg, in the cathedral church of that city,

the crozier, the symbol of their spiritual office, is held in one hand, while in the other is the sword of their temporal power.

The resurrection banner of triumph over death is freely met with in old pictures representing the risen Lord. It is of pure white, very long in proportion to its width, and having a red cross upon it. It may be seen very well in Fra Angelico's beautiful picture in the National Gallery of the Christ surrounded in glory by saints and angels. A banner is also borne as an attribute, often in conjunction with other symbols, by various saints. Thus St. Victorinus bears a banner and globe; St. Julian a banner and palm; St. Ursus, a banner and sword. Every one is familiar too with the importance of the flag in a secular sense as the emblem of the country, and of the deeds of heroism that its folds waving amidst the battle smoke have inspired.

The sceptre is a more ancient emblem of royal dignity than the crown itself. Homer makes it the only cognisance of the Greek kings, and the historian Justin declares that the ancient kings of Rome used no other ensign of royalty. The Greek poets describe the gods as having sceptres to indicate their empire, and declare that an oath taken on the sceptre was the most solemn that could be sworn. In Jacob's prediction of the Messiah we find the sceptre specifically mentioned as the emblem of regal power: "The sceptre shall not depart from Judah, nor a lawgiver from between his feet, until Shiloh come." Justin tells us that among the Romans the sceptre was originally a spear; but the sceptres described by Homer were simply big walking-staves, designed to show that the monarchs ruled by acknowledged right, and not by force. Le Gendre tells us that in the earlier days of the French kings the sceptre was a golden rod, crooked at one end, and of the height of the king himself. At the coronation of an English soverign the sceptre is placed in the king's right hand; and in his left, during the ceremony of investiture, he takes the virge or rod, which is carried before

Tarquin the Elder was the first who assumed the sceptre amongst the Romans, about 468 B.C.

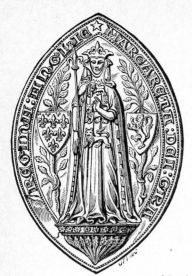

fig. 79

him in the concluding procession. The distinction between the sceptre and the rod is that the former is surmounted by a cross and the latter by a dome. This distinction is of very ancient date, as we find that it was observed in the ceremonial of the coronation of Richard I. A very good illustration of a sceptre may be seen in fig. 79, the seal of Margaret, queen of Edward I. The lions embroidered upon her dress are the heraldic symbols of her consort's kingdom; the fleur-de-lys, those of her father's realm.

The rod, or staff, or wand of office is one of the most familiar of symbols; and its use stretches in an unbroken line from the Pharaohs of Egypt in the childhood of the world, to the baton of the field marshal and the signs of office of the parish beadle, the cathedral verger, or Gold-stick in Waiting of the present day. The Israelites were familiar, during their residence in Egypt, with the notion that the rod was the emblem or cognisance of dignity. Hence we find Moses striking the rock at Meribah with his rod; and when the revolt of Korah rendered it necessary to affirm beyond doubt the high priesthood of Aaron, the signal miracle performed was the blossoming of this symbol of his authority. The memory of this was perpetuated amongst the Jews, not only by the preservation of the rod, but by the introduction of a device of budding almond flowers upon the shekels of Jerusalem.

"The Lord spake unto Moses, saying, Speak unto the children of Israel, and take of every one of them a rod according to the house of their fathers, of all their princes according to the house of their fathers twelve rods: write thou every man's name upon his rod. And thou shalt write Aaron's name upon the rod of Levi: for one rod shall be for the head of the house of their fathers. And thou shalt lay them up in the tabernacle of the congregation before the testimony, where I will meet with you. And it shall come to pass, that the man's rod, whom I shall choose, shall blossom: and I will make to cease from Me the murmurings of the children of Israel, and every one of their princes gave him a rod apiece, for each prince one, according to their fathers' houses, even twelve rods: and the rod of Aaron was among their rods. And Moses laid up the rods before the Lord in the tabernacle of witness. And it came to pass, that on the morrow Moses went into the tabernacle of witness; and, behold, the rod of Aaron for the house of Levi was budded, and brought forth buds, and bloomed blossoms, and yielded almonds. And Moses brought out all the rods from before the Lord unto all the children of Israel: and they looked, and took every man his rod."

In fig. 80 we have an illustration of the Jewish shekel. In the centre is the budding rod of Aaron, and the inscription, Jerusalem the Holy. In fig. 81 we have the reverse, having in the centre the pot of manna, and around it the words, Shekel of Israel. The date of this coin is about 450 B.C.

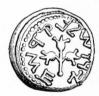

fig. 80

In Christian art the bearer of a budding staff may be, not Aaron, but St. Joseph of Arimathaea or St. Ethelreda.

Near Glastonbury Abbey stands an old hawthorn that has been the subject of many legends, the current belief however being that it sprang from the staff of St. Joseph, who, it is asserted, was the first preacher of Christianity to Britain, and who, to convince the benighted islanders of his mission, thrust his staff into the ground, when it at once budded and blossomed. The tree

fig. 81

has ever since flowered, not only at its proper season, but also at each Christmas, the anniversary of its miraculous origin.

In the earliest examples of Christian art, as in the catacombs or in the Museum of the Lateran our Saviour is often depicted as bearing a wand, and employing it in the working of various miracles, as in the turning of the water into wine, the raising of Lazarus, and other instances of the exertion of Divine authority.

The error of confusing the pastoral staff or crook with the crozier is one constantly made. The two things are perfectly distinct, and should be carefully discriminated. The pastoral staff belongs officially to all cardinals, archbishops, and bishops, and was also in mediaeval times assigned by courtesy to certain abbots and abbesses. It is borne in the left hand, thus leaving the right free to perform the necessary functions of ceremonial and worship. The crozier, a cross or crucifix on a staff, is never carried by the higher ecclesiastics, but is borne immediately before them, to indicate and emphasise their office and dignity. In England the pastoral staff was in use from a very early period: the pontifical of Dunstan (A.D. 957–988) gives the form of service for its benediction; while the Venerable Bede, in his treatise "De Vii Ordinibus," dwells on its symbolic significance. In the form for the consecration of a bishop in the first Prayer-book of Edward VI., the archbishop puts into his hand the pastoral staff, saying, "Be to the flock of Christ a shepherd, not a wolf; feed them, devour them not; hold up the weak, heal the sick, bind together the broken, bring again the outcasts, seek the lost."

The carving in the head of the crook is religious or symbolic in character. Several of these pastoral staves may be seen in the Victoria and Albert Museum. In one of them the subject within the volute is the crowning of the Virgin by Christ, in another the Annunciation, in another St. Michael and the dragon, and so forth. Numerous beautiful examples may be seen in monumental effigies

and ecclesiastical seals. Scores of the actual crooks were destroyed at the Reformation, partly because they were held to be popish, but probably more especially because, being often richly gilt and adorned with precious stones, the appeal to the cupidity of the king's underlings proved altogether irresistible.

The orb, mound, or globe is a symbol of sovereignty, and is born in the left hand. It was assumed as a cognisance by the emperor Augustus, and was sometimes termed the apple; in all cases it was regarded as the symbol of far-reaching dominion. The surmounting cross was added to the globe by Constantine, the first Christian emperor. Suidas, describing the statue of the emperor Justinian, says: "In his left hand he held a globe, in which a cross was fixed, which showed that by faith in the cross he was emperor of the earth. For the globe denotes the earth, which is of like form, and the cross denotes faith, because God in the flesh was nailed to it." The globe and cross were first introduced as ensigns of authority in Western Europe by Pope Benedict VIII. Almost all the English kings, from Edward the Confessor, have the globe in their left hand on their coinages or great seals, and it seems also to have been frequently so placed when sovereigns lay in state after their decease. In the picture by Rubens, "Henry IV. entrusting the Symbol of his Power to Mary de Medici," the symbol is the globe, which he places in her hands.

As the orb signifies far-reaching dominion, we naturally find it associated in early art with the Deity. In Giotto's "Christ adored by Angels," we see over all the eternal Father, bearing the globe in His hand; and we may see the same treatment again in the "Adoration of the Magi" by Fra Angelico, and in many other instances of early work. We have examples of this in figs. 82 and 83. The first of these is a gem dating from the sixth century, the letters on either side of the head clearly indicating, apart from the cruciferous nimbus, that the second Person of the Trinity is

fig. 82

149

fig. 83

fig. 84

represented; while in the second illustration (fig. 83) we see above the sitting Christ the eternal Father, and in each case bearing the orb. Fig. 26 is another example that may be referred to.

Many other symbols of authority will doubtless occur to our readers; the fasces carried by the Roman lictors, the caduceus of Mercury, the trident of Neptune, the thunderbolts of Jupiter. The Pharaohs of ancient history again, and the popes of mediaeval and modern days, had gorgeous feather fans borne before and around them; while not merely the cooling fan, but the sheltering umbrella becomes in hot countries a sign of distinction. In the wall paintings of Egypt and the carvings of Nineveh and Persepolis, the monarch has the sunshade held over him; and one of the most honourable titles of the king of Siam was Lord of the Twenty-four Umbrellas. On the coinage of Herod Agrippa I. we find as a device an umbrella.

As we see in fig. 84, a coin struck by Nero, A.D. 66. The eagle thereon is a symbol of imperial Rome, and the palm branch, of victory.

The flabellum had its origin in the Eastern Church, and was of distinctly practical use, cooling and refreshing the celebrant, and driving away the flies and other insect plagues of the sultry East from the eucharistic elements. With the spread of ritual came also the flabellum or muscarium, though in the less sunny lands of the North and West it ceased to be of any practical value. As its original employment was one of the duties of the deacon, it became a symbol of the diaconate, and in the early service books full directions were given at the ordination of a deacon as to the fit use of the muscarium then bestowed. The flabellum, though often of feathers, was also made of vellum, linen, and other materials of the kind, and we may sometimes find it a richly decorated disk of brass or silver. In an ancient Greek fresco we have a representation of the Saviour preaching, while an angel holds a circular flabellum of metal over His head, as a protection against the sun. Several examples of its use in the Western Church may readily be cited. We see an illustration of it, for example, in the "Book of Kells," an Irish manu-

script of the sixth century, and the "muscatorium de pennis pavonium" figures in the inventories of York, Salisbury, and other cathedrals. It has been held that the use of the peacock feathers symbolised the countless eyes, not of men only, but of good and evil spirits, watching the actions of the pontiff or other ecclesiastical dignitary, and reminding him thereby of the urgent need for holy watchfulness in return; but we may well consider such an explanation a laboured afterthought, and see in the splendour of the feathers a sufficient reason for their use at a time when men gave freely of their best for the service of the sanctuary.

The ring is another very characteristic emblem of power, as investiture by its means was the most ancient form of conferring dignity: it was by this ceremony that Pharaoh created Joseph his viceroy over Egypt. "Thou shalt be over my house, and according unto thy word shall all my people be ruled: only on the throne will I be greater than thou. And Pharaoh said unto Joseph, See, I have set thee over all the land of Egypt. And Pharaoh took off his ring from his hand, and put it upon Joseph's hand, and arrayed him in vestures of fine linen, and put a gold chain about his neck."

The ring appears to have been employed originally as a signet; as, for instance, when the prophet was cast into the den of lions, and a big stone was rolled to the mouth of the den, the king sealed it with his own signet and with the signet of his lords. Sir Gardner Wilkinson, in his "Manners and Customs of the Ancient Egyptians," refers to one bearing the name of a king who was reigning about 1,400 B.C. The device is a scorpion. Many excellent examples may be seen in the British Museum.

In mediaeval days a jewelled ring was part of the necessary adornment of the higher ecclesiastics, and it was ordinarily buried with them. In the old romance of "Sir Degrevant," we are told that at the marriage of the hero there were *"Archbishops with rings, More than fifteen."*

and in another fourteenth century tale, "King Athelstan," the king exclaims to an offending cleric, *"Lay down thy cross and thy staff, Thy mitre, and thy ring, that I to thee gaff, Out of my land thou flee."*

The prayer for the blessing of the ring ran as follows: "O Creator and preserver of mankind, Author of Spiritual grace and Giver of everlasting Salvation, send Thy blessing upon this ring, that whosoever shall walk distinguished by this sacred sign of faith may be the protection of Thy heavenly power attain everlasting life, through Jesus Christ our Lord. Amen." The bishop wore a ring as representative of the heavenly Bridegroom, and guardian of the Church.

The grand ceremony of wedding the Adriatic by casting therein a ring will be familiar to all who have studied Venetian history. The next thing we need refer to is the famous "fisherman's ring" of the pope. It is a signet of steel used for the marking of the official documents issued from the papal court. A new one is made for every pope, though all are based on a very ancient original, representing St. Peter in his boat drawing his net to the surface. The classic form of the boat and oar shows a direct derivation from an antique original.

Rings were used too for the purposes of divination, as amulets to protect the wearer from all harm, and as symbols of affection. These latter, the posy rings as they were termed by our ancestors, had ordinarily an inscription upon their inner surface; such as, "United hearts death only parts"; "A faithful wife preserveth life"; "As God decreed so we agreed."

It is said that king Edward the Confessor was met by a venerable old man, who asked alms of him; and the charitable monarch, being at the moment destitute of money, gave the suppliant his ring. Soon afterwards two English pilgrims, who had lost their way, were met, at the approach of night, by this same old man, who led them into a magnificent city with golden streets, the New Jerusalem, the visible existence of which

was a popular article of faith in the Middle Ages. The old man entertained them hospitably and gave them lodgings for the night. In the morning he informed them that he was St. John the Evangelist, of whom it was believed by many of the ancient Fathers that he was appointed to tarry on earth until the second coming of the Lord Christ. St. John told the pilgrims that it was to him in person that their king had given the ring, and he sent it back by them to him, with a promise that Divine grace should encircle every British sovereign who was invested with this ring at his coronation. The sacred ring was long preserved at the shrine of St. Edward, and only brought out at the time of a coronation. It deserves to be remarked that legends of the appearance from time to time of St. John continued to be held so late as the reign of Henry VIII.

Should we see in Christian art a figure holding out a ring, the statue or painting is probably meant for St. Edward the king and confessor; while SS. Theodosius and Gregory have as attribute a large iron ring round their bodies. St. Pelagia, the penitent, has the ground before her strewn with jewels and ornaments, the vanities of earth that she has cast from her.

Gold, as one of the two noble metals, has always been held in symbolic honour. It is a favourite emblem in Scripture of faith triumphant in adversity and suffering, while its brightness and value make it equally appropriate as a symbol of majesty and honour.

"They shall be tried as the gold in the fire" (2 Esdras xvi. 73); "When He hath tried me, I shall come forth as gold" (Job xxiii. 10); "The trial of your faith, being much more precious than of gold which perisheth" (1 Pet. i. 7); "I counsel thee to buy of Me gold tried in the fire, that thou mayest be rich" (Rev. iii. 18).

Gold, frankincense, and myrrh were the three symbolic gifts brought by the wise men of the east to the Babe of Bethlehem. *"Eastern sages at His cradle, Made oblations rich and rare; See them give, in deep devotion, Gold and frankincense and myrrh. Sacred gifts of mystic meaning: Incense doth their God disclose, Gold the King of kings proclaimeth, Myrrh His sepulchre foreshows."*

According to an ancient legend, this choice of gifts was to ascertain whether the mysterious

stranger that they were going to worship was a king or a prophet or God Himself. If he were a king, he would select the gold; if he were a poor man, he would choose the myrrh; but if God, He would take the incense. As both God and man, the King of kings veiled in humanity, He accepted from them all three of their gifts. *"An Age shall bring about the Day, When Lord of Lords shall lodge in clay; Three kings from east him to adore, Shall come with incense, myrre, and ore."*

Other ancient writers assigned the gold to the race of Shem, the myrrh for Ham, and the incense for Japhet. *"Then entered in those Wise men three, Full reverently upon their knee, And offered there, in His Presence, Their gold and myrrh and frankincense."*

The various precious stones have been endued with symbolic meaning and application. A notable example of this was the breastplate of judgment borne by Aaron when he entered the holy place. This breastplate had twelve precious stones, one for each tribe of Israel. The first row was a sardius, topaz, and carbuncle; the second an emerald, a sapphire, and a diamond; the third, a ligure, an agate, and an amethyst; the fourth, a beryl, an onyx, and a jasper; and on each stone was engraved the name of the tribe it symbolized.

The episcopal rings of mediaeval days were jewelled; and the stones usually chosen for such rings were ruby, emerald, or crystal. The choice had significance, as indeed almost all else had that entered at all into the ritual of the Roman Catholic Church: ruby being indicative of burning zeal, emerald of tranquil peace, crystal of simplicity and purity. In like manner the diamond indicated invulnerable constancy; the sapphire, hope; the amethyst, humility; the onyx, sincerity.

A hundred years or so ago it was the custom in England to use the stones in such a way in a ring that the initials of their names might spell out some little love message, some political catchword, or the name of the donor or the recipient.

St. Peter dictating the Gospel to St. Mark. Ivory, probably South Italian. 11th century. Victoria and Albert Museum.

Thus, if we place, one after another, round a ring or bracelet a ruby, emerald, garnet, amethyst, ruby, and a diamond, we get the word REGARD.

The onyx was held to be a sure talisman of victory over one's enemies. Our word diamond is a corruption of adamant, and this in turn is derived from the Greek word for invincible; not, as has been generally supposed, on account of its excessive hardness, but from the ancient belief in the inability of the gods to resist the prayer of any suppliant who carried one with him. "He who carries the diamond upon him, it gives him hardness and manhood, and it keeps the limbs of his body whole. It gives him victory over his enemies in court and in war, if his cause be just; and it keeps him that bears it in good wit, and it keeps him from strife and riot, from sorrows and from enchantments, and from fantasies and illusions of evil spirits. And if any cursed witch or enchanter would bewitch him that bears it, all that sorrow and mischance shall turn to the offender, through virtue of that stone; and also no wild beast dare assail the man who bears it on him. It makes a man stronger and firmer against his enemies: heals him that is lunatic, and those whom the fiend pursues or torments. And if venom be brought in presence of the diamond, anon it begins to grow moist." Thus says Sir John Maundeville, writing in the year 1356; but as, even in those ages of faith, some people evidently raised doubts, he adds: "Nevertheless it happens often that the good diamond loses its virtues by sin, and for incontinence of him that bears it, and then it is of little value." Any critic therefore who cavilled might be delicately reminded that there were undoubtedly occasions when the diamond refused to exercise its beneficent power, and that a little self-amendment might well take the place of adverse criticism.

We have of course modernised the language. The original English is excessively quaint, and almost unreadable in places.

The amethyst was held to possess the power of preserving wine-drinkers from the natural result of their over-indulgence; while the agate made its wearer proof against deadly serpents, and the emerald strengthened the sight and the memory.

The chrysolite could drive away evil spirits, while the onyx dispelled grief. Coral was held to keep off storm and thunder.

It is possible that the pagan belief in the efficacy of certain stones, such as the diamond, the jasper, the topaz, the sapphire, and the opal, to win from the gods a favourable answer to prayer, and, in the case of other stones, to ward from threatening dangers, may have not been altogether without influence when Christianity superseded the worship of the gods of paganism. The great wealth of jewellery expended on shrines, crucifixes, vestments, and pictures may have been partly the result of belief in its efficacy as well as a gift of faith and homage to the glory of God and the enhanced honour of the saints. A decree of Pope Innocent III., in the twelfth century, ordained that henceforth the sapphire should always be the stone used in the rings whereby the bishops at their investiture were wedded to the Church. When sacrifices were offered, and responses sought from Phoebus, it was thought that he was better pleased, and that it was easier to get one's request granted, if the sapphire were exhibited, since it was a sign of concord, and therefore in the Middle Ages it was held to keep a man safe from fraud, fear, or envy.

The mediaeval writers attributed to each gem a special influence over each month, and also assigned a precious stone to each of the twelve apostles.

Amongst the treasures prepared by David for the glorious temple that he would fain have built for the worship of Jehovah we find "onyx stones, and stones to be set, glistering stones, and of divers colours, and all manner of precious stones." These are repeatedly introduced in the picturesque eastern imagery of the Bible as the symbols of prosperity and magnificence: "O thou afflicted, tossed with tempest, and not comforted, behold, I will lay thy stones with fair colours, and lay thy foundations with sapphires. And I will make thy windows of agates, and thy gates of carbuncles, and all thy borders of pleasant stones."

Isa. liv. 11, 12.

158

The Book of Job again gives us many interesting references; but the most beautiful Biblical use of these gems is the attempt, the hopeless but magnificent attempt, to picture to mortal eyes something of the grandeur of the Paradise of God, with its walls of jasper, founded in sapphire and emerald and chrysolite, its gates of pearl, and streets of pure gold like unto clear glass. The writer could but put together all that seemed to him most splendid and radiant. He failed where it was impossible to succeed, since no material imagery that the heart of man can conceive can picture to our yet blinded eyes the ineffable grandeur and glory of that heavenly city, or give even a suggestion of the dazzling splendour of the New Jerusalem.

fig. 85

Chapter 9

We proceed now to a consideration of the various animal forms that have been employed symbolically in art. These are not very numerous; but one of them, the lamb, as a symbol of Christ, the great Lamb of the sacrifice, is one of the most freely met with of all symbolic representations. Its occurrence ranges from almost the earliest days of Christianity, throughout all the intervening centuries, down to the present time.

The sacrificial lamb is repeatedly referred to in the Old Testament; and the prophets, looking beyond the material rites of the Mosaic law, saw clearly in that sacrifice the future Messiah. John too, the great forerunner, announced the Christ to his followers as "the Lamb of God." It is therefore very natural that we should find it as one of the earliest symbols. *"An hevenly signe, a token off most vertu, To declare how that humylite Above alle vertues pleseth most Jesu. Off Adamys synne was wasshe away the rust Be vertu only off thys lambys blood."*—LYDGATE.

It soon became so favourite a form that we presently find some little danger of idolatry creeping in. In the sixth century it was placed with crown and nimbus on the cross; and in the year 692 a council of the Church was forced to decree that it should not henceforth be thus substituted for the human form. In the catacombs, on the sarcophagus of Junius Bassus, a lamb is represented as changing water into wine, raising the dead Lazarus, and performing other acts that clearly indicate that the animal form is but a symbol of the Christ. The early examples have no nimbus; but later on this is frequently added, being generally cruciferous or inclosing the sacred monogram. In other instances the lamb has the palm branch of victory.

In the church of St. Bavon, Ghent, may be seen a picture by Van Eyck of the "Adoration of the Lamb," where an actual lamb stands upon an altar, and is surrounded by worshipping angels and saints. We give in fig. 85 an illustration of this work.

In some of the early mosaics we see a lamb and

on either side of it six sheep, a symbol of Christ and His apostles. This may be very well noticed in the great mosaic in the apsis of St. Cosmo Damian in Rome, executed about the year 526. At other times a variable number of sheep is introduced; in which case it is to be understood that they are symbols of the Church, the general body of believers.

In mediaeval art the lamb is associated with St. John the Baptist and SS. Agnes, Regina, Genevieve, Catherine, and Joanna; and in the form of the Agnus Dei, the symbol of Christ appears in numberless examples on embroideries, painted on wall surfaces or in missals, or sculptured on the tympana, capitals, or fonts. It ordinarily bears a cross of very slender proportions, to which a banner is frequently attached.

On the door of the church of St. Pudentiana at Rome, for instance, is a medallion containing the Agnus Dei, together with the inscription: "Dead or living I am but one; I am at once the Shepherd and the Lamb." On the celebrated Syon cope at the Victoria and Albert Museum, London, amongst other devices, we see the Agnus Dei embroidered. In the Westminster inventory of 1540, we find "A nother albe haveyng wrought a egle, a gryffen, a holly lambe, and a lyon, with dyvers other beasts."

Louis IX. of France (St. Louis), who reigned from 1226 to 1270, caused the "agnel d'or" to be struck. This coin bore on one side the Agnus Dei, with the inscription, "Agnus Dei, qui tollis peccata mundi, miserere nobis," and on the other, "XPC vincit XPC regnat XPC imperat." This coin was imitated by Edward III., and, when the sacred significance of the symbol was forgotten, was popularly called the mouton d'or.

Countless myriads of people the wide world over, who in many cases know or care nothing of symbolism, or regard it as quite a feature of the past, Sunday after Sunday raise the prayer to heaven, "O Lamb of God, that takest away the sins of the world, have mercy upon us."

The Lamb of the Apocalypse, with the seven horns and seven eyes that indicate the seven gifts of the Holy Spirit is occasionally met with in mediaeval art; but the poetic imagery of the Book of the Revelation does not readily lend itself to material representation, and of this "the Lamb that is in the midst of the throne" is but one instance of many that might be referred to. No painter or sculptor can reduce these images to form; the mere effort results in grotesque impossibilities that are only preserved from irreverence by the honesty and good faith of those who attempted them. The title of the Lamb is applied to Christ twenty-nine times in the Revelation, and any one turning to these passages will at once realize how natural it is that the Agnus Dei should be one of the most cherished of symbols. Earthly sorrow finds consolation, and the great burden of humanity and the mystery of life is irradiated with Divine light, in the touching words, "For the Lamb which is in the midst of the throne shall feed them, and shall lead them unto living fountains of waters: and God shall wipe away all tears from their eyes"; while, the sorrows of earth over for evermore, we listen in another passage to the great triumph song of the redeemed, as the thrilling anthem rises from the innumerable host, "Worthy is the Lamb that was slain to receive power, and riches, and wisdom, and strength, and honour and glory, and blessing!"

St. John the Baptist is often represented in art as bearing a lamb. He may be thus seen in a picture by Murillo in the National Gallery, where he is painted as a child caressing a pet lamb, the type of the mediatorial and sacrificial work of Christ. The standard is lying on the ground beside them. On St. John's Day in Venice a little fellow is selected to impersonate the great forerunner of the Messiah by appearing with a sheep's skin tied round his otherwise naked body, and attended by a lamb. Such customs are survivals from the Middle Ages, when, as in the Passion plays, it was endeavoured to appeal to the senses, and to render the scenes and characters

of the Bible or the traditions of the Church in as realistic a manner as possible.

We pass now to a consideration of the use of the lion in religious art. We find it under several modifications of meaning, and it often becomes necessary to study the surroundings before we are able to appreciate the motive that may have led to its introduction. It is, for instance, sometimes used as a symbol of Christ, the Lord of life; at other times as a symbol of the prince of darkness. In the former case it illustrates such texts as "the Lion of the tribe of Judah has conquered"; in the latter it fitly personifies the lost angel fallen from his high estate, who "walketh about as a roaring lion, seeking whom he may devour." It is often introduced too in a general way as an emblem of strength, majesty, courage, and fortitude; or as the attribute of some especial saint; or, again, from its connexion with some particular historic event recorded in the Bible.

In a quaint old manuscript of the 12th century. "The Book of Beasts," written by Philip de Thaun, we find a curious literary exemplification of the association of the lion with the second Person of the Trinity. As the tone of thought of that period naturally influenced the missal painter, the stone-carver, and all who were in any way concerned in art, we may very legitimately quote the passage. "The lion," writes our old author, "in many ways rules over many beasts, therefore is the lion king. He has a frightful face, the neck great and hairy; he has the breast before square, hardy, and pugnacious; his shape behind is slender, his tail of large fashion, and he has flat legs, and haired down to the feet; he has the feet large and cloven, the claws long and curved. When he is hungry or ill-disposed he devours animals without discrimination, as he does the ass which resists and brays. Now hear, without doubt, the significance of this. The lion signifies the Son of Mary. He is king of all people without any gainsay. He is powerful by nature over every creature, and fierce in appearance, and with fierce

look he will appear to the Jews when he shall judge them, because they made themselves guilty when they hanged him on the cross, and therefore they have merited to have no king over them. The square breast shows strength of the Deity. The shape which he has behind, of very slender make, shows humanity, which he had with the Deity. By the foot, which is cloven, is demonstrance of God, who will clasp the world and hold it in his fist." We need not follow our old authority any further in his laboured mysticism; the passage given will sufficiently indicate the association in the Middle Ages of the lion with Christ.

It was an ancient belief that the lion cubs were born dead, but were brought to life three days after their birth by the roaring of the lion; and it was very easy to transfer this belief into a natural symbol of the resurrection of Christ.

The use of the lion as an emblem of strength, majesty, and fortitude naturally arises from many passages in the Scriptures. Samson asks, "What is stronger than a lion?" Job speaks of "the voice of the fierce lion." Any good concordance will supply an ample number of illustrative texts for the use of the lion as an emblem of the qualities we have named.

The lion was believed by the mediaeval writers on natural—or perhaps we should rather say unnatural history—to always sleep with its eyes open, an idea that they in turn borrowed from more ancient authors in lieu of investigating for themselves. Hence the idea of watchfulness was superadded to the other qualities ascribed to the lion. This idea probably had some influence in the selection of the twelve flanking lions of Solomon's throne. The lion is not unfrequently found in early Christian churches, and especially those under Lombard influence, as a sentinel at the doors, as the base to pillars, or at the foot of the pulpits.

The lion, again, as the attribute of some particular person, may freely be met with. The most notable example of this is seen, as we have

fig. 86

already noted, in its association with St. Mark. Fig. 86, from some ancient stained glass in the Victoria and Albert Museum, is a good illustration of this special application of the lion. In mediaeval art it is also largely associated with St. Jerome. In sculpture or painting the animal is ordinarily represented at his side. A well known example of this, fig. 87, familiar to most readers, from photographs and engravings, is the "Last Communion of St. Jerome," by Domenichino. The aged saint has been brought by loving hands to the altar, the ministering priest hands him the wafer, and attendant angels hover near to convey his soul to heaven. At his side crouches a full-grown lion.

In the National Gallery many good examples may be seen. The friendship between the saint and the lion began by a little kindly surgery on the part of St. Jerome, and in a picture by Cosimo Tura the lion is seen in the background limping with a thorn in one of his paws towards the kneeling saint. In a picture by Cosimo Rosselli St. Jerome turns to meet the lion and is taking him by the paw, while an attendant monk runs away towards the monastery, at the door of which are several

fig. 87

167

wondering and admiring monks. It is a delicate point of discrimination that the artist has given St. Jerome a nimbus, while the weak brother who flees faithlessly and abandons his companion has no such distinction. In the "St. Jerome in his Study," attributed to Giovanni Bellini, the "St. Jerome in the Desert," by Bono Ferrarese, and in "The Virgin, the Child, attended by St. Jerome and St. Domenick," of Filippino Lippi, the lion is in each case conspicuously introduced.

In mediaeval art the lion is introduced also in representations of several other saints. It is placed by the sides or at the feet of SS. Prisca, Euphemia, Natalia, Thecla, and Adrian. With St. Gerasimus it is represented as carrying a basket in its mouth. It fawns in the amphitheatre on St. Germanicus. It is represented as devouring SS. Silvanus, Agapetus, and Ignatius, as digging the grave of St. Mary of Egypt, and in the den with St. Pontianus. The student who desires full information on the various legends involved will do well to refer either to Butler's "Lives of the Saints," Newman's "Lives of the English Saints," and to Faber's "Lives of the Saints and Servants of God." The first runs to twelve volumes, the second to fourteen, while the last needs forty-two to do the subject justice.

On the tombs of ecclesiastics, the effigy has frequently a lion at the feet, significative of trampling upon the evil one. Sometimes it is a dragon instead. In either case it is suggested doubtless by the text, "Thou shalt tread upon the lion and adder, the young lion and the dragon shalt thou trample under foot."

We may, in conclusion, find the lion represented in illuminations, stone-carving, etc., in a way that is not symbolic at all, but historic. Several such examples will readily occur to the mind of the reader. We need only instance representations of Daniel in the lions' den. Even here such treatments may very often be considered as in part symbolic since the particular example we have instanced occurs frequently in the catacombs, and there can be no doubt that,

The figures at the feet of monumental effigies are in their intention at times incomprehensible, though we may ordinarily interpret their meaning. They will generally fall into one of three classes. The first of these includes all spiritual enemies to be trodden under foot; and these are symbolized by dragons, serpents, basilisks, and all such creatures, mythical or real, as bear evil significance. The second great class comprises all forms used with heraldic intent, or that are allusive in character to the name or vocation of the person with whom they are associated; such as the two hares at the feet of Bishop Harewell, on his tomb in Wells Cathedral. The third class comprises emblems of courage, strength, fidelity, and attachment. Dogs are frequently thus introduced: that they were often pets may be seen from the collars and bells attached to them; on the brass of Sir Bryan Stapleton the dog's name "Jakke" is inscribed on the collar.

beyond the illustration of a Bible incident, there was the recognition also of the general deliverance from evil of those who trusted in the God of Daniel.

The stag in Christian art is the emblem of solitude and purity of life. It is the attribute of SS. Hubert, Eustachius, Aidan, Felix, Julian, and Ida. When associated with the two former of these, it bears a cross between its antlers, in allusion to legends that are generally well known, and somewhat foreign to our present purpose to detail here. It was also taken as an emblem of religious aspiration, probably from the passage in the Psalms, commencing "Like as the hart panteth after the waterbrooks." The form appears very commonly in the sculptures and wall paintings in the catacombs of Rome and elsewhere in early Christian art. In the old belief that the stag was "a great enemy to all kinds of serpents, which he labours to destroy when he finds any, though he be afraid of almost all other creatures," it became in the days of exaggerated symbolism a still more popular emblem, its supposed ruthless antipathy to the serpent rendering it not inaptly a symbol of the Christian fighting against evil.

The ox was emblematic of patience and strength, and in the writings of some of the early Fathers it is accepted as a symbol of Christ the true sacrifice; secondarily of prophets, apostles and saints slain for the sake of Christ; and in the third place, of all who patiently bear the yoke, and labour in silence for the good of others. It is the well known evangelistic symbol attributed to St. Luke, and is also associated with SS. Leonard, Sylvester, Medard, Julietta, and Blandina.

The ox is, together with the ass, almost invariably introduced in representations of the Nativity, partly as natural accessories when the scene is treated historically, and more ordinarily as representatives of the homage due to God from all the creatures of His hand. St. Bernard dwells upon this idea and apart from this there is a very ancient tradition that an ox and ass were

actually present at the birth of our Saviour. Besides this, the two animals were regarded as being symbolic respectively of the Jews and of the Gentiles.

SS. Germanus and Philibert have the ass as an attribute, and it kneels before the consecrated wafer borne by St. Anthony of Padua. It is a firm belief with many ignorant people that the conspicuous lines that form a cross on the back of the animal are a memorial of our Saviour's ride on the creature into Jerusalem, and that in remembrance of that event the whole race have ever since borne this badge of honour. *"The mother of the eternall Sonne A Mayd shall be: Salvation Shall bring the world: yet far from Pride, Though King He on an asse shall ride."*

In an example of French glass of the sixteenth century we see that the angel who is sounding the trumpet of the last judgment, at whose dread summons the earth is yielding up her dead, is represented as riding on an elephant that tramples a man underfoot; while on a seal in private hands we see the device of St. Peter bearing the usual keys, and riding upon an elephant too. The invincible might of the creature may probably have in each instance led to its introduction. In the latter case it may represent the Church under the guidance of St. Peter going forth to conquer. The elephant was long regarded as the emblem of the kingly rank from a belief that he could not bow his knees, an idea that is met with from time to time in the old writers.

In Christian art the horse appears as the symbol of three saints, Anastasius, Hippolytus, and Quirinus. In any representations of those saints that approach the pictorial, they are depicted as being dragged and torn by wild horses. The horse is sometimes regarded as an emblem of courage and generosity. In the Roman catacombs it ordinarily denotes the swiftness of life. Sometimes the palm branch of victory is placed over its head.

SS. Martin, Maurice, Victor, and George are generally represented on horseback. The latter as

"The Adoration of the Magi" from the
Sforza Book of Hours (Flemish
Miniatures and Borders: 1519-1521).
British Museum.

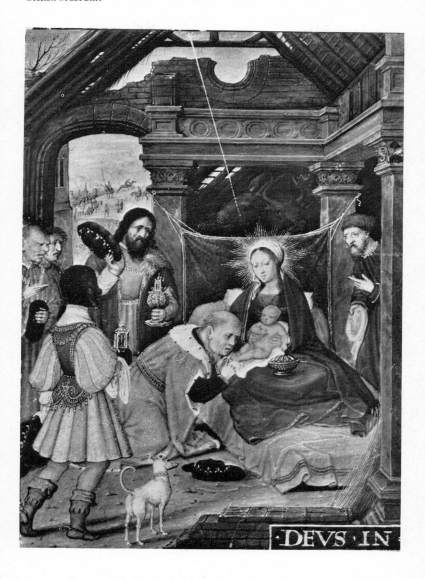

the patron saint of England will be familiar enough to all; for, to quote the Golden Legend, "the blyssyd and holy martyr Saynt George is patron of this Realme of Englande," and he is represented freely on our coinage and elsewhere.

The mythical unicorn was regarded as a symbol of purity and strength, and is figured in the catacombs. From its supposed love of solitude it was also a symbol of the monastic life. It is associated too with St. Justina. In my book "Mythland" I have gone at very considerable length into the legendary, heraldic, and religious references to the creature; and to this I would refer those of our readers who care to follow out an old belief through its various phases.

While we in England naturally regard the bear as a creature only to be seen in zoological gardens, it was in earlier days, as it still is, on the Continent a common animal enough, and the hermits in their caves and woodland solitudes had abundant opportunities of making its acquaintance. Hence in Christian art we find the bear associated with SS. Maximinus, Blandina, Florentius, Corbinian, and perhaps more especially with St. Gall. In this latter case the bear is generally represented as carrying a log of wood. On the seal of the monastery of St. Gall in Switzerland the saint is represented sitting on a throne, and offering a small loaf of bread to a bear, who stands on his hind legs and receives the gift in his two frontpaws. The same device is found on the seal of the town of St. Gallen on a document dated 1300. According to the accepted legend it appears that, as St. Gall was praying in the wilderness on the spot where the famous monastery called after him was afterwards erected, he saw a bear come from the forest and devour the fragments that remained of his frugal supper. He at once called the beast before him, and commanded him as compensation for his lost meal to fetch some wood for his fire. The bear retired to the forest and shortly emerged with an enormous log, which he cast upon the embers, whereupon the saint in kindly good

nature went to his small store, gave the bear a whole loaf from his scanty supply, and dismissed him in peace.

Probably one great reason why the dog, "the friend of man," as we call him, is so seldom introduced in religious art is that it is an animal that is but rarely mentioned in the Bible and when referred to at all is seldom named in anything but an evil sense. The only indication of their possessing any value is in a passage in Job, where the dogs of the flock are referred to, though even here the reference is somewhat contemptuous. Elsewhere the children of Israel are told not to bring the price of a dog into the house of the Lord for any vow. The thankless people of God are compared by Isaiah to dumb dogs, elsewhere to greedy dogs; and in the last chapter of the whole Bible we read that dogs, sorcerers, murderers, and idolaters shall be excluded from the paradise of God. It will be naturally objected to this latter passage that it cannot be taken in any literal sense; but if the animal be introduced in a symbolic sense, it only strengthens our assertion that all the associations connected with the dog in the Bible are unfavourable to its introduction in any art under religious influence. If the reader will take the trouble to look up some of the passages, and there are over thirty of them where the animal is expressly named, he will find that the statement is fully borne out by the facts. The dog even to the present day throughout the East occupies a very inferior position. He is tolerated as a public scavenger, but he calls no man master, and, prowling as he does with his fellows in large packs, goes far to become a public nuisance. In mediaeval art he is generally intended as a symbol of fidelity. He is placed at the feet of SS. Bernard, Wendelin, Sira, and Roch; while St. Parthenius is represented as slaying a mad dog by the sign of the cross.

The pig is intended in a good sense as the symbol of St. Anthony; in an evil sense, as one of the forms in which Satan has from time to time

appeared. St. Anthony was said to have been originally a swineherd, and is therefore ordinarily represented as accompanied by a hog; and pigs were in some cases dedicated to him. In Pisano's picture in the National Gallery of "St. Anthony and St. George," the two saints confront each other, and at the feet of one is the pig, and of the other is the vanquished dragon. Amongst the figures carved in Henry the Seventh's Chapel at Westminster will be found St. Anthony, a bearded figure in frock and scapular, and at his side a gaunt pig is standing.

The use of the pig in an evil sense has probably been a good deal influenced by the Biblical story of the possession of the herd of swine by the evil spirits cast out from the demoniacs, and by its being included amongst the unclean beasts forbidden to the chosen people. Such texts again as that in Proverbs, "As a jewel of gold in a swine's snout, so is a fair woman which is without discretion," or that in Matthew against casting pearls before swine, show a tendency towards depreciation of the animal.

"Gregory relateth in a dialogue in his third book that when a certain church of the Arians having been restored to the Orthodox was being consecrated, and reliques of St. Sebastian and the

See Matt. viii. 28 et seq.; Mark v. 2 et seq., Luke viii. 27 et seq.

See Lev. xi. 7; Isa. lxv. 4, lxvi. 3 and 17.

174

Whalebone panel of the Franks Casket with scenes of the Adoration of the Magi and Wayland the smith, surrounded by runic inscription. Anglo-Saxon c.700 A.D. British Museum.

blessed Agatha had been conveyed thither the people there assembled of a sudden perceived a swine to be running to and fro among their feet: the which regaining the doors of the Church could be seen of none, and moved all to marvel. Which sign the Lord showed for this cause, that it might be manifest to all that the unclean inhabitant had gone forth from that place. But in the following night a great noise was made on the roof of the same church, as if some one were running confusedly about. The second night the uproar was much greater. On the third night also so vast a noise was heard as if the whole church had been overthrown from its foundations, but it immediately ceased, and no further inquietude of the old Enemy hath appeared in it." *Durandus.*

The goat, wolf, fox, and ape were ordinarily employed by the old writers and sculptors in an evil sense as symbols of lust, cruelty and fraud. St. Anthony, for instance, is represented as tempted by Satan in the form of a goat.

"The Wolfe indeede signifieth craft, subtiltie, greedinesse of mind, inordinate desire of that which appertaineth to another, to some discord and sedition: for it is saide how that the Wolfe procureth all other beasts to fight and contend. He seeketh to devour the sheepe, that beast

175

which of all other is the most hurtlesse and simple and void of guile, thirsting continually after their blood: yea, nature hath implanted so inveterate a hatred atweene the wolfe and the sheepe, that being dead, yet in the secret operation of Nature appeareth there a sufficient trial of their discording natures, so that the enmitie betweene them seemeth not to dye with their bodies: for if there be put vpon a harpe, or any such like instrument, strings made of the intrailles of a sheepe, and amongst them but only one made of the intrailles of a wolfe, be the musician never so cunning in his skil yet can he not reconcile them to an vnity and concord of sounds, so discording always is that string of the wolfe. It may well likewise denote the seditious persons, of which sort if there be but one in a whole commonwealth yet he is able to disturb the quiet concord and agreement of many thousands of good subjects, even as one string of that beast is able to confound the harmony of many other well tuned strings."

In Scandinavian mythology the wolf is the bringer of victory, and amongst the Romans, from its association with Romulus and Remus, it was held in honour; but the extract I have just given from Ferne, a mediaeval writer on heraldry, very fairly reflects the feeling of the Middle Ages, and helps to account for its evil repute.

Though every allusion to the wolf in the Bible is of an unfavourable nature, the creature is often in the legendary history of the saints represented in a favourable light, doubtless with the idea of making the miracle still more miraculous. He is in the Bible the "grievous wolf," "the ravening wolf," the "fierce evening wolf"; while to St. Vedast he brings a goose in his mouth, and to St. Mark a ram's skin (in each case, we fear, making the saint a receiver of stolen goods). He guards the dead body of St. Carpophorus and that of our own St. Edmund until they receive fit interment and the last rites of the Church.

We often in the Middle Ages find bitter and satirical evidences of the feud between the

various orders of clergy and the itinerant friars, leading to such representations as a fox preaching to geese, an ass's head beneath the cowl, a monkey at prayers, a fox with the mitre and staff of the bishop. These illustrations, whatever may be lacking of grace, or frequently even of decorum, are often pungent and graphic in the extreme, and remain as curious records in our old churches of this strong antagonism. The following title from a book written by one of our bishops, but secretly printed under an assumed name at Zurich in 1543, is a good literary illustration of the opporbrious use of the fox in theological controversy: "YET A COURSE AT THE ROMYSHE FOXE', A DYSCLOSYNGE OR OPENING OF THE MANNE OF SYNNE, Contayned in the lat Declaratyon of the Popes old Faythe, made by Edmonde Bonner, Byshopp of London. Whereby Wyllyam Tolwyn was than newlye professed at Paules Crosse openlye into Antichristes Romyshe Relygyon agayne by a newe Solempne Othe of obedyence, notwyth-stadnge the Othe made to hys Prynce afore to the contrarye."

While the predatory disposition and crafty policy of the fox rendered the creature an apt emblem where such features had, with more or less charity, to be satirised, the monkey and ape were rather the symbols of indecorum and of unseemly levity; though in a fourteenth century window in the north aisle of the nave of York Minster we find them (very exceptionally) introduced in an entirely different spirit, playing on musical instruments as a part of the great choir of creation: "Praise the Lord from the earth, ye dragons and all deeps: . . . beasts, and all cattle; creeping things, and flying fowl." "Praise Him with the sound of the trumpet: praise Him with the psaltery and harp. . . . Let everything that hath breath praise the Lord."

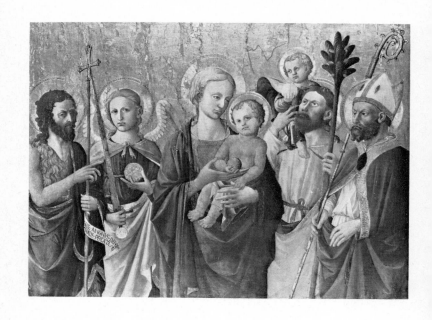

"Madonna and Saints" by Domenico
Di Michelino 1417-1491.

Chapter 10

Amongst bird forms the dove, the symbol of the
Holy Spirit, is most freely met with in art. Such
distinct Bible references as that in Matthew iii.
16, where upon the baptism of Christ "the Spirit
of God descending like a dove," or in the words
of St. Luke, "the Holy Ghost descended in
bodily shape like a dove," are an ample warrant
and justification of the symbol. See figs. 26, 56,
69, 85, 88, 89. Doves of carved wood are
frequently found on font covers in our old
English parish churches, and probably in former
days no font would have been considered duly
complete without such a symbol of the
sacramental rite, and of the presence of the Holy
Spirit in it. The symbol is one of the few that
have fully retained their place and meaning
throughout the centuries down to the present
day, and it is as intelligible to us now as to the
Christians in the earliest ages of the Church. The
three scenes in which the figure most freely
occurs are in representations of the baptism of
Christ, of the annunciation of the Virgin, and of
the creation of the world, though we also see it

fig. 88

fig. 89

introduced hovering over the heads of the saints of God as the inspirer of noble thoughts, or at times resting on their shoulders. In the picture by Borgognone of the "Coronation of the Virgin" all the persons of the Trinity are present; and here, as elsewhere, when any event which concerns all the Persons of the Godhead is represented, the Holy Spirit, with but few exceptions, is in the form of a dove.

Examples are so numerous that it seems scarcely worth while to particularize at any length. As three typical examples however we may mention the "Baptism of Christ," by Francesca, in the National Gallery; the "Annunciation," in the same collection, by Crivelli; and the "St. Peter of Alcantara," by Zurbaran (fig. 89). In the last example the dove is hovering over the saint, while in a statue at Chartres Cathedral of Pope Gregory the Great the dove is on his shoulder, holding commune with him, and inspiring holy thoughts.

Sometimes in old work (as in fig. 90) we find a ring of seven doves surrounding a figure; but the significance is the same, the reference is still to the Holy Spirit, though in this case the sevenfold gifts of the Spirit are more especially emphasised.

fig. 90

In Isaiah xi. 2 we have in the Authorized Version but six of these Divine gifts mentioned: "The spirit of wisdom and understanding, the spirit of counsel and might, the spirit of knowledge and of the fear of the Lord"; but in the Vulgate rendering of this passage we have "Sapientia, Intellectus, Consilium, Fortitudo, Scientia, Pietas, Timor."

Authority is the attribute of God the Father; and as ruler of all things He bears the orb, the symbol of universal sway. Love is the attribute of God the Son; hence as Redeemer of the children of men He bears the cross of Calvary. Knowledge is the special attribute of God the Holy Spirit; hence He bears the book, the symbol of intelligence and reason. He is the instructor of the ignorant, the illuminator of the blind, the Spirit of truth to abide with man for ever. The

Spirit of wisdom reveals God to man; the spirit of understanding teaches us about Him; the Spirit of counsel teaches us to distinguish good from evil; the Spirit of strength enables us fearlessly to struggle for the right; the Spirit of knowledge guides into the way of peace; the Spirit of godliness gives us love; the Spirit of fear teaches us humility, and the reverence due to the great King.

In a more general sense, the dove becomes the symbol of all believers. Such a text as "be ye harmless as doves" would naturally suggest the idea. Doves are generally employed in the Bible as the symbols of guilelessness, gentleness, innocence, and faithfulness. David, in the midst of his troubles, dreams of a haven of peace, and sighs for the wings of a dove, that he might flee away from earthly turmoil to celestial rest. Other passages will be found in the Canticles, Isaiah, Jeremiah, Ezekiel, Hosea, Nahum, and elsewhere. Doves as emblems of believers figure largely in the catacombs of Rome, and throughout early Christian art. As emblems of conjugal affection sometimes two are placed together.

On the martyrdom of St. Polycarp the legend tells us that his blood extinguished the flames that surrounded him, and that from the ashes arose a white dove which flew heavenward out of sight. In representations of St. Celestin and St. Cunibert the dove is whispering in their ear the heavenly message; to St. Albert it brings the eucharistic elements; to St. Agnes, virgin bride of heaven, a ring; to St. Remigius, a cruse of oil.

The dove with the olive branch in its mouth points to its association with the receding waters of the Deluge, and is thus an emblem of restoration to prosperity and peace.

The pelican, though without Biblical authority, and only having its symbolic meaning based upon an error in natural history, is perhaps, next to the dove, the most familiar of bird symbols.

The pelican is in an especial manner a Christian symbol, an emblem of the Redeemer of mankind; and I know of no instance of its use with any

symbolic meaning in pre-Christian times. The bird has at the tip of its long bill a crimson spot, and this gave rise to the belief amongst the older naturalists that the pelican, while really pruning its feathers, was feeding its young with its own blood. It is the symbol therefore of loving sacrifice. Hence Dante calls the Saviour "nostro pelicano." In the black-letter "Bibliotheca Biblia" we read that "the Pelicane, whose sons are nursed with bloude, stabbeth deep her breast, self-murtheresse through fondnesse to hir broode." Shakesperian students again will recall the lines in "Hamlet": *"To his good friends thus wide I'll ope my arms, And, like the kind, life-rend'ring pelican, Refresh them with my blood."* While in the "Giaour" of Byron we find allusion to *"The desert bird whose beak unlocks her bosom's stream, To still her famished nestlings' scream."*

In the inventory of the goods of Westminster Abbey of the year 1540 we find mention of a "Crosse Staff of Syluer Gylt withe the Salutacon Pelycan," the latter the symbol and type of the coming Messiah (Luke i. 42).

In the "Account of the Antient Rites and Monuments of the Monastic Church of Durham," as they existed before the suppression, written in 1593, we read: "At the north end of the high altar there was a goodly fine letteron of brass, with a great pelican on the height of it, finely gilt, billing her blood out of her breast to feed her young ones, and her wings spread abroad, whereon lay the book. Also there was, lower down in the choir, another letteron of brass, with an eagle on the height of it, and her wings spread abroad, whereupon the monks laid their books." The first of these was for the epistle and gospel, the second for the lessons.

In the year 1649 an enthusiastic admirer of Charles I., and an evident believer in the idea that he shed his blood for his people, wrote a book on that king, entitling him "The Princely Pelican."

A variation in the mediaeval pelican legend may occasionally be met with where instead of the young being nourished by the blood of the bird, their dead bodies are restored by it to life. Whichever reading we accept has equally valuable symbolic meaning, though the generally accepted version is the more pleasing. The alternative

reading—I quote from Bossewell's "Armorie of Honour"—is as follows: "The pellicane feruently loueth her young byrdes. Yet when thei ben haughtie, and beginne to waxe hote, they smite her in the face and wounde her, and she smiteth them and slaeth them. And after three daies she mourneth for them, and then striking herself in the side till the bloode runne out, she sparpleth it upon their bodyes, and by vertue thereof they quicken againe."

We find the same idea again in the "Armorie of Birds" of Skelton: *"Then sayd the Pellycane: When my Byrdts be slayne, With my Bloude I them revyve. Scripture doth record, The same dyd our Lord, And rose from deth to lyve."*

Though all belief in the phoenix has been for some centuries exploded, that mythic fowl was firmly believed in by the ancients; Pliny, Ovid, and many other writers giving full details of its mysterious existence. As I have in my book "Mythland" fully gone into the whole subject, I forbear to do so afresh, contenting myself here with just explaining that the ancient belief was that the phoenix, after living a thousand years or so, committed itself to the flames that burst at the fanning of its wings from the funeral pyre of costly spices that it had itself constructed, and that from its ashes a new pheonix arose to life. Tertullian, one of the early writers of the Christian Church, in all good faith accepts it as a most marked and evident symbol of the resurrection and of eternity. The phoenix is represented in some of the earliest Christian mosaics in the churches of Rome, and often has a star-shaped nimbus.

The powerful heavenward flight of the eagle, fixing its gaze upon the sun, has made it a very natural symbol in Christian art of the Ascension, while it is still more widely employed and far more commonly recognised as the symbol of St. John. SS. Medard and Bertulph are represented in art as sheltering beneath an eagle with outstretched wings; and St. Servatius, sleeping in the hot sunlight, is shaded and fanned by the pinions of an eagle that hovers over him.

184

The peacock, like the dove, is a very favourite
form in Byzantine art; though now-a-days thought
of rather as an emblem of vanity or pride, it was
in earlier days regarded as a symbol of the
Resurrection. Hence it is generally represented as
standing upon a small ball or globe, the glorified
spirit rising above all mundane cares. Many good
examples of it may be seen in the mosaics of
Ravenna and Venice. (Fig. 91 is from an early
Christian monument at Athens.)

fig. 91

The peacock was regarded as an emblem of the
Resurrection, from the yearly changing and
renewal of its brilliant feathers, and from an old
belief in the incorruptibility of its flesh.

The cock is another very ancient symbol. If
associated with any representation of the denial
of Christ by St. Peter, it signifies repentance,
since the crowing of this bird awoke the time-
serving apostle to a sense of the depth to which
he had fallen. At other times it is employed as a
symbol of vigilance. In the "Mystical Mirrour of
the Church," by Hugo de Sancto Victore, we
learn that "the cock representeth the preacher.
For the cock in the deep watches of the night
divideth the hours thereof with his song, and
arouseth the sleepers. He foretelleth the
approach of day, but first he stirreth up himself
to crow by the striking of his wings. Behold ye
these things mystically, for not one of them is
there without meaning. The sleepers be the
children of this world, lying in sins. The cock is
the company of preachers, which do preach
sharply, do stir up the sleepers to cast away the
works of darkness, which also do foretell the
coming of the light, when they preach of the Day
of Judgment and of future glory. But wisely
before they preach unto others do they rouse
themselves by virtue from the sleep of sin and do
chasten their bodies."

The swan figures but rarely in Christian art. It is
represented by the side of St. Hugh, St. Ludger,
and St. Cuthbert. We find a curious passage in
Foxe's "Book of Martyrs," wherein, speaking of
the martyrdom of Huss, he tells us that he said,
"You are now going to burn a goose (the name

of Huss signifying a goose in the Bohemian language), but in a century you will have a swan, whom you can neither roast nor boil." Foxe goes on to say that "if this were spoken in prophecy he must have meant Martin Luther, who shone about one hundred years after, and who had a swan for his arms, whether suggested by this circumstance or of family descent and heraldry is not known."

A mediaeval moralist says that "swans are looked upon as symbols of hypocrites, because they have fine wings, and yet can scarce raise themselves from the earth, so that they are of no use to them; besides the feathers of a swan are white to perfection, but their flesh is very black, as are the hypocrites, appearing outwardly virtuous, and being inwardly very wicked."

In religious art the owl is associated with the idea of mourning and desolation. "The owle betokeneth alwaies some heavie newes, and is most execrable and accursed. He keepeth ever in the deserts, and is the verie monster of the night, neither crying nor singing out cleare, but uttering a certaine heavie grone of dolefull moning. Therefore if he be seene within citties or otherwise abroad in any place it is not good, but prognosticateth some fearfull misfortune." We see the same idea again in Shakespeare: "Out on ye owls! Nothing but songs of death!" and other well-known passage in Macbeth will readily occur to readers.

In some cases no doubt the Christian symbolism was a deliberate reaction from the pagan. Thus the owl, as the bird of Athene, was held in especial esteem by the Athenians, who claimed that the goddess as the patron and founder of their city, and stamped her emblem on their coinage. Hence therefore, the early Christians would feel an objection to the introduction of the bird. The raven again, the standard of the Norsemen, and amongst the classic nations a bird dedicated to the sun-god Apollo, was, like the magpie, held in later days to be a symbol of ill fortune. When these birds therefore are introduced

in Christian art, they ordinarily reflect the prevalent idea; thus in some manuscripts they are represented as perching in the tree from whence Eve gathers the forbidden fruit. The association of the raven with the story of the subsiding Deluge has also made it an emblem of wandering and unrest. It is connected with the legendary history of some few saints; it is placed at the feet of St. Benedict, it bears a ring in its mouth to St. Ida, brings a letter to St. Oswald, and guards the body of the sainted martyr Vincent.

The hen and chickens, as an emblem of God's providence, are sometimes met with in old sculptures on ecclesiastical buildings. Their introduction evidently springs from that passage in the Bible that shows us the infinitely tender Redeemer mourning over the guilty city of Jerusalem, and declaring that, had its inhabitants so willed it, God's good providence would have been to them a shield and sure defence, an effectual succour, even as the hen gathers her young beneath her wings, and guards them from every harm.

Many other animal forms might have been referred to, the spotless ermine and the stork, the emblem of filial piety, until in descending scale we reached the ant, the emblem of industry, and the bee, the symbol of busy forethought; but it is scarcely desirable, in pity to the reader, to make an exhaustive catalogue, so we pass now to a consideration of some few of the plants that have had symbolic meaning attached to them in Christian art.

The vine as a symbol of Christ, based upon His own words, "I am the Vine;" has at all times been freely employed. Often, as on the tomb of the empress Constantia, the sister of Constantine, it is the sole symbol of the Christian faith. In the early Christian mosaics (as in fig. 92) the vine plays a conspicuous part; and we see in these early works how persistently, in the well nigh exclusive use of such symbols as the vine and the Good Shepherd, the mind of the Church then dwelt almost solely on the risen Lord.

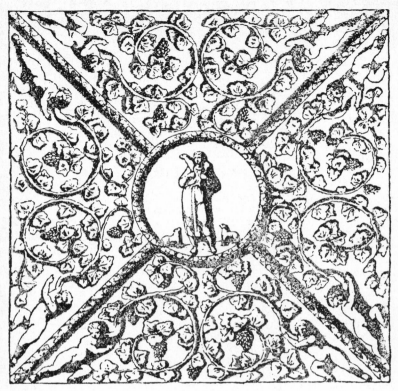

fig. 92

The vine is several times employed in the Old Testament as a symbol of the chosen people: "A vine Thou didst bring out of Egypt. Thou castedst out the nations, and plantedst it. Thou preparedst the ground for it; and it spreads its roots and filled the land. The mountains were covered with its shade, and with its tendrils the lofty cedars."

Sometimes it is used in a general sense as expressive of temporal blessing, as in the benediction of Jacob by Isaac. "God give thee of the dew of heaven, the fatness of the earth, and plenty of corn and wine"; or later on as an emblem of the joyous, festive innocence of the Christian life. It is also found as one of the symbols of the Eucharist.

The palm, the symbol of victory, is one of the earliest of Christian symbols, and commemorates, times without number, in the catacombs the triumph of the martyrs for the faith. In the darkness of these subterranean vaults, to the survivors it bore testimony of conflict past and death vanquished, as in fig. 94, while in the light of heaven we see it recognised and honoured as a testimony for evermore of victory won, where the great army of the faithful unto death, out of every nation and kindred and people, stand before the eternal throne, clothed in spotless white and bearing the palms of victory in their hands.

fig. 93

In the "Peter Martyr" of Titian, the saint looks up to heaven in expectation of speedy death, while hovering overhead a cherub bears a palm branch; and in the "Massacre of the Innocents," by Guido Reni, in the clouds above the scene of violence and bloodshed two cherubs bear large bundles of the palm branches in their arms.

FL. IOVINA . QVAE . VIXIT .
ANNIS . TRIBVS : D . XXXII . DEPOS
NEOFITA . IN PACE . XI . KAL . OCTOB

fig. 94

fig. 95

fig. 96

We may see this very well illustrated in figs. 95, 96, 97, representing coins struck by the Romans on the defeat of the Jews and the destruction of Jerusalem.
In fig. 95 we see two captives at the foot of the symbolic palm; and fig. 96 is very similar, except that the place of one of the captives is taken by a Roman soldier. In fig. 97 a winged figure of Victory inscribes the SPQR on the shield, in token of the subjugation of Judaea by the armies of Rome. Fig. 98 gives the obverse of this coin, and shows us the laurel-crowned head of the conqueror, the emperor Vespasian.

It was an ancient belief that the palm tree would always grow erect, no matter how it might be weighted or pulled aside, hence it was a favourite emblem in the Middle Ages of triumph over adversity. Mary Queen of Scots adopted it for instance, in this sense; and on the frontispiece of the "Eikon Basilike" we see, amongst many other emblems, a palm tree standing erect, with two heavy weights attached to it, and the legend, "Crescit sub pondere virtus," and the "Explanation of the Embleme": *"Though clogged with weights of miseries, Palm-like depressed I higher rise."*

The palm is also associated with the triumphant entry of Christ into Jerusalem, commemorated thereafter as Palm Sunday. It was the special emblem of Judaea.

The white lily, from its association in art with the Virgin Mary, is one of the commonest of floral symbols. The fragrance, purity of colour, and beauty of the flower render it a most appropriate emblem. Abundant examples of the association of this flower with the Virgin mother may be found in the National Gallery and elsewhere, so that it is almost needless to particularize special instances. In Roman Catholic countries the snowdrop is, from a similar motive, dedicated to the Virgin Mary; and on the festival of the Annunciation in March, when white lilies are not procurable, her altars are decked with it.

The passion flower is freely used in modern work to symbolise, as its name implies, the passion of our Lord. It is a good illustration of that exaggerated symbolism that one so often encounters, in that straining after analogy that sees a wealth of meaning in the most natural and ordinary of arrangements. The ten members composing the perianth of the flower, we are told, represent the apostles, Peter being absent because he deceived his Master, and Judas because he betrayed Him. The rays within the flowers are the nimbus or glory. The ovary is supposed to resemble a hammer, while the three styles with their rounded heads are the nails, the

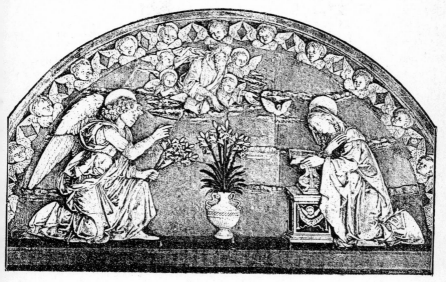

fig. 99

five stamens being five wounds. Though the
passion flower is now not uncommon,
readers will remember that it was introduced
from abroad; hence it does not occur in early
English art in our cathedrals, illuminations, or
elsewhere.

The immortal amaranth has a literary rather
than an artistic existence. Clement of Alexandria
refers to it as the "amaranthus flos, symbolum
immortalitatis." The name is derived from two
Greek words, signifying not withering. The
passage in our New Testament, "a crown of glory
that fadeth not away" is in the original Greek
"the amaranthine crown of glory."

The rose is only twice referred to in the Bible,
and the commentators are generally agreed that
the plant so called has been wrongly named. One
reference will be found in the Song of Solomon,
"I am the rose of Sharon, and the lily of the
valleys"; while the second is in Isaiah, where we

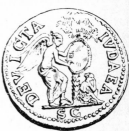

fig. 97

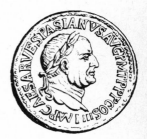

fig. 98

read that when the kingdom of righteousness shall be established on earth, the desert shall rejoice and blossom as the rose.

Though the rose was known in Syria, and one species, the damask, takes its name from Damascus, the word translated rose in the Bible indicates a bulbous-rooted plant. The plant intended was probably the narcissus, a flower that is abundant throughout Syria.

Amongst the various flowers consecrated to the Virgin by our forefathers, the rose occupies a conspicuous position, and amongst the numerous titles bestowed upon her we find that of Santa Maria della Rosa. This title therefore is given to several pictures in various continental collections, in which a rose is placed either in her hand or in that of her Divine Son. We may see a good example of the introduction of this flower, together with the white lily, in one of the pictures of the Virgin and Child, by Benozzo Gozzoli, in the National Gallery. The Virgin is hailed in some books of devotion the Rosa Caeli, the Rose of Heaven or the Mystic Rose.

The rose figures again in the legendary history of St. Dorothea, who suffered martyrdom under the government of Fabricius, and who converted afterwards one Theophilus to the Christian faith by sending him some roses from Paradise. It is also associated with SS. Casilda, Elizabeth of Portugal, Rose of Viterbo, Rose of Lima, Rosalia, Victoria, Angelus, Francis and several others.

The olive has been celebrated from the earliest ages. It must have been known before the flood, as the dove returned to Noah in the ark with a leaf of it in her mouth. There can be little doubt of this incident having been the origin of the recognition of the plant as the emblem of peace and good-will. It is frequently mentioned in the Scriptures. Jacob, for instance, poured the oil of olive on the memorial pillar that he set up in Bethel, and the Promised Land was to be "a land of wheat, and barley, and vines, and fig trees, and pomegranates; a land of oil olive, and honey." The holy anointing oil of the Temple was olive

Full-page miniature of the Madonna and Child executed in East Anglian style early in the 14th century. British Museum.

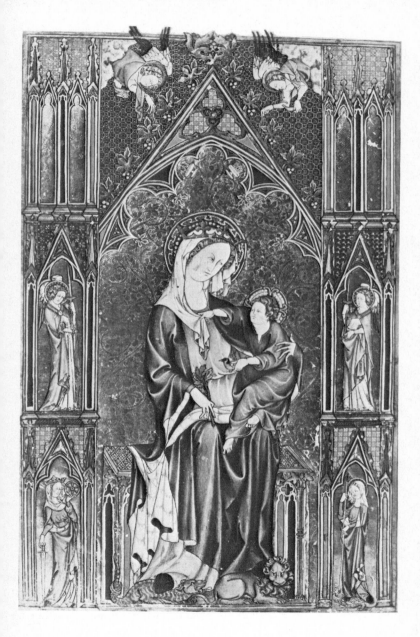

oil, scented with myrrh, cinnamon, sweet calamus, and cassia.

As sacred history made the olive emblematic of peace, so from its great value to man has it been also considered the sign and expression of plenty. As a symbol in one or other of these senses we thus find it on the coins of those countries where the plant is not a native. Our own Britannia, for instance, holds in her hand the olive branch of peace and good-will on some of the coinage of previous reigns.

In Christian art the old illuminators and glass-painters often represented the genealogy of Christ under the form of a tree, the tree of Jesse, in allusion to that text in Isaiah where it states that "there shall come forth a rod out of the stem of Jesse, and a branch shall grow out of his roots." Jesse is represented as recumbent, and the tree springs from his loins, spreading into luxuriant foliage and bearing on its numerous branches the various royal and other personages who are mentioned in the first chapter of St. Matthew's Gospel. The name of each is usually inscribed on a label in close proximity to the figure, and crowning all, at the summit of the tree is the Virgin Mary in an aureole, bearing in her arms the Divine Son. Sometimes, though more rarely, the tree terminates in a cross bearing the dying Christ. The tree of Jesse first appears as a device in the twelfth century, and in the thirteenth and fourteenth centuries becomes exceedingly popular, occurring in stained glass, mural paintings, illuminated manuscripts, sculpture, wood carving, and embroidery. The foliage is often that of the vine, the symbol of spiritual fruitfulness, and allusive to Him who said, "I am the Vine, ye are the branches."

The Celtic priesthood regarded the yew as an emblem of immortality, and therefore planted it in their sacred groves. It has been conjectured that the early Christian churches were of set purpose erected on the sites of the old heathen shrines as a more distinctive token of the supplanting of the old creed by the new, and that in

"A cope of blewe velvett rychely embrothered with a Jesse, the ymages of the Jesse beyng garnysshed with perle."—Inventory, Westminster Abbey, A.D. 1540. In inventory of St. Paul's A.D. 1245, we find a "Jesse quam dedit Rex," and a red cope "bene breudata Jesse."

that case some of the magnificent yew trees seen in many country churchyards may be relics of a yet older faith. In Brady's "Clavis Calendaria" we read that "amongst our superstitious forefathers the palm tree or its substitutes, box or yew, were solemnly blessed on Palm Sunday and some of their branches burnt to ashes and used on Ash Wednesday in the following year, while others were gathered and distributed amongst the pious, who bore them in procession." Caxton in 1483 also shows that the yew was a substitute in these northern regions for the palm; for he says in his book on the Church festivals, "but for that we have none olyve, therefore we take yew instead of palm ovyve."

Many of the ancient and mediaeval beliefs in various branches of natural history affected theologians and artists, and gave rise to symbols that lived for awhile; but when the false ideas upon which they were based were corrected (though the myth of the pelican is a marked instance to the contrary), the symbols in most cases lost their force, and were discarded.

It is manifest that we have but referred to some few of the more common vegetable forms. In some cases, as in the apples presented to a king for the restoration of his sight by St. Malachy, a plant may only once appear in Christian symbolism. It is impossible to extend our remarks to such a length as would include all these exceptional cases. In other legends "flowers" alone are mentioned, without any attempt at distinction of species, while many well-known references, such as the withering grass, the fading flower, the purging hyssop, the parable of the wheat and the tares, and the illustration of the grain sown in the earth as a symbol of the resurrection of the dead, are very familiar to us, but scarcely appear in art representation, and are therefore somewhat outside the limits of this work.

St. Mark, an illuminated page from The Lindisfarne Gospels, written and illuminated about A.D. 700, probably in the monastery on Lindesfarne or Holy Island off the Northumberland coast. British Museum.

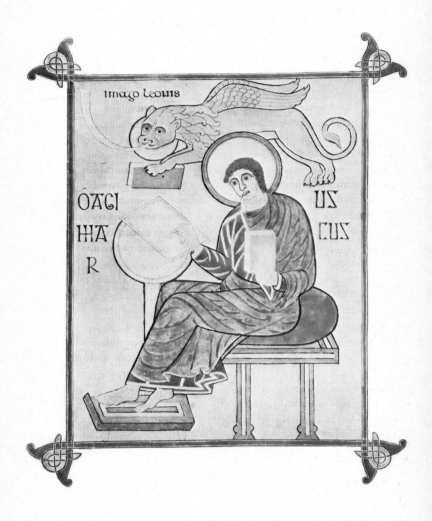

Chapter 11

The multitudinous forms of the earth have supplied us with numerous illustrations of the symbolic use. We turn now to the great water depths, and find in sea and river further examples of emblematic forms, and to the firmament of heaven in search of the lessons taught by the revolving seasons and the starry host.

Men have naturally, in earlier days, given the greater attention to the more distinctive and prominent forms. Thus while the lamb, the lion, wolf, horse, fox, eagle, and many other animal forms are introduced, the list of symbolic plants is a much shorter one. This is still more marked when we pass to marine creatures, where one or two conventional types do duty for all the finny denizens of the deep, while the scallop shell sums up its conchology.

It is as an emblem of our Lord that the fish is most abundantly met with in Christian art. St. Augustine and Tertullian both refer to the fish as an emblem of Christ, and Clement of Alexandria enumerates the fish, the anchor, the ship, dove, lyre, and fisherman, as fitting objects to be employed by the Christians on their seals and lamps. When it was discovered that the letters in the Greek word for a fish are the initials of "Jesus Christ, the Son of God, the Saviour," the symbol at once sprang into use. Though the fish symbol arose from the Greek word, the Greek Church never adopted it. It is found in the Latin communion alone. In fig. 100 the Church, in the form of a ship, is borne by Christ amidst the storm and stress of life. It is somewhat curious that such a symbol should have held its ground so long, since it sprang merely from a verbal, or rather a literal coincidence, and that too of a somewhat forced nature. It had nothing of the poetical feeling of that beautiful symbol, the Lamb, nor did it express, like the lion, anything of the royal majesty of the great King of kings. The form was based on no allusion in any text, and the difference and distance between the cold-blooded and apathetic creature of the waters and the Creator, the Lord of all, who

fig. 100

suffered so freely for the sheep of His pasture, is something infinitely great, and would, we should have thought, have led men earlier to feel how unworthy the symbol was of One so infinitely tender, One so immeasurably exalted.

The fish was sometimes applied secondarily as a symbol of believers, and we find the early Fathers of the Church writing of their flocks as *pisciculi*, since they cast off the former life and became new creatures as they emerged from the waters of baptism. Tertullian says, "We are born in water like the fish"; and Clement speaks of Christ as "drawing fish out of the waters of sin." It is one of the earliest symbols employed, being freely found on the sepulchral slabs in the catacombs of Rome, often alone, but sometimes with the wreath or crown, the emblem of triumph won through Christ, as in fig. 101; sometimes with the anchor, as in fig 102, the emblem of a sure and certain hope of the Resurrection. The name piscina, given to the baptismal font, is derived from the Latin word for a fish.

Jonah, as a type of the Resurrection, is freely introduced in early art, and the big fish, his attribute, is always associated with him in these representations. Fig. 103, a gem of the fourth century, is a very quaint illustration of this. As is common in much archaic art, several independent incidents are grouped together into one composition, in defiance of the possibilities.

fig. 101

fig. 102

Thus in the present example we get the prophet three times over: we see him sitting beneath his sheltering gourd, tossed to the great sea-monster, and, finally, preaching repentance to the men of Nineveh.

The fish is introduced in the legends of many saints, and may be seen duly figured in art. To St. Congall a fish is brought by an angel, and to St. Walter by a bird. Associated with St. Mauritius we have a fish with a key in its mouth. St. Zeno has one hanging from his crozier. The corpse of St. Chrysogomus is borne up in the water by their aid, and St. Anthony of Padua is represented as preaching to a congregation of fish.

The dolphin is often introduced in art as a symbol of maritime power, but it finds no place in Christian symbolism.

fig. 103

fig. 104

The scallop shell (fig. 104) is more particularly associated in religious art with St. James the Greater. In representations of the saint the shell is either held in the hand or fastened on the hat, cloak, or wallet. St. Felix, a less widely known preacher of the faith, though, like St. James, one of the noble army of martyrs for that faith, is represented as laid upon a bed of shells.

Every pilgrimage had its special symbol, which sign the pilgrim on his return wore conspicuously, that all might know that he had accomplished that particular pilgrimage. That for the Holy Land was the cross; and it had this distinction above all others, that it was worn as a special sign directly the vow to visit the sacred land was made. Some even branded it with a hot iron upon their breasts in their enthusiasm, until a rubic was inserted in the "Officium Peregrinorum" forbidding the practice. When the pilgrim had fulfilled his vow and had visited the Holy Land, he was entitled to wear the palm, and was hence termed a palmer. The pilgramage to Rome, the centre of the religion and civilization of the West, was held in next highest esteem. Many shrines were there visited, each indicated by a special sign; the chief of these were the figures of St. Peter and St. Paul, the cross-keys, and the vernicle or kerchief of St. Veronica. Hence we find that the pardoner in Chaucer, "a vernicle hadde he served in his cappe," for "he strait was comen from the court of Rome." The great Canterbury pilgrimage had as its sign the ampulla, or flask suspended round the neck, while that for Compostella was the escallop shell.

In the description of a pilgrim in "Piers Ploughman's Vision," we read that he had *"An hundred of ampulles: on his hat seten Signes of Synay and shells of Galice, And many a crouche on his cloke, and keys of Rome, And the vernicle beofe, for men sholde knowe And se bi his signes whom he sought hadde. Then folk prayed hym first fro whence he came? From Synay he seide, and from our Lordes Sepulcre: In Bethlem and in Babiloyne I have ben in bothe:*

In Armonye and Alesaundre, in many other places Ye may see by my signes, that sitten in my hat, That I have walked ful wide in weet and in drye, And sought good seintes for my soules helthe."

Another interesting reference to this custom of going on pilgramage may be found in the "Canterbury Tales" of Chaucer: *"And thries hadde sche ben to Jerusalem; Sche hadde passed many a straunge streem; At Rome sche hadde ben, and at Boloyne, In Galice at Seynt Jame, and at Coloyne."* The pilgramage to the Holy Land naturally took the highest rank. Why Rome too was visited calls for no explanation. "At Boloyne" a notable image of the Virgin was preserved, while at Cologne were to be seen the bones, real or reputed, of Gaspar, Melchior, and Balthazar, the Wise Men of the East.

The city of Compostella became in the eighth century one of the great centres of attractive force to the pilgrims, from a legend that the body of St. James had been discovered there; and in the ninth century the Galilaean fisherman was transformed into the patron saint of Spain, and led her chivalry, we are told, against the Moorish infidels. At the battle of Clavigo, A.D. 844, in which sixty thousand Moors were slain, St. James was said to have appeared on a white horse, the housings charged with scallops, and led the Christian host to victory. Thenceforth enthusiasm for so potent a champion of the faith rapidly grew, and, as in the case of St. Thomas of Canterbury, national feeling and religious fervour combined to pay due honour to his shrine. *"The poor with scrip, the rich with purse, They took their chance for better for worse, From many a foreign land; With a scallop-shell in the hat for badge, And a pilgrim staff in hand."*

While the foregoing extract from Southey introduces the literal facts of the pilgrim's journey to the shrine of the saint, the following passage from Raleigh deals rather with the broader view of pilgrimage; though we still find the scallop selected as a notable symbol of the

pilgrim's equipment. *"Give me my scallop-shell of quiet, My staff of faith to walk upon, My scrip of joy, immortal diet, My bottle of salvation, My gown of glory, hope's time gage, And thus I'll make my pilgrimage."*

The crocodile has been accepted as a symbol of dissimulation, from an old belief that this reptile sheds tears to attract the sympathy of passers by, in order that it may bring them within reach of its formidable jaws and devour them. Though the crocodile has occasionally been introduced in art in this sense, the symbol has, on the whole, had a literary rather than artistic application. Thus in Shakespeare, 2 King Henry VI. iii. 1, we find the lines: *"As the mournful crocodile With sorrow snares relenting passengers."* While Quarles writes: *"Oh what a crocodilian world is this, Composed of treacheries and ensnaring wiles! She clothes destruction in a formal kiss, And lodges death in her deceitful smiles: She hugs the soul she hates; and there does prove The veriest tyrant, where she vows to love; And is a serpent most, when most she seems a dove."*

Lelia, in "The Captain" of Beaumont and Fletcher, exclaims: *"No, I would sooner trust a crocodile When he sheds tears, for he kills suddenly, And ends our cares at once."*

Water, though sometimes associated in a bad sense with the idea of an overwhelming flood of evil and of swift destruction, is ordinarily a symbol of cleansing and regeneration or of refreshment. "I will take you from among the heathen, and gather you out of all countries, and will bring you into your own land. Then will I sprinkle clean water upon you, and ye shall be clean." "As cold waters to a thirsty soul, so is good news from a far country." Biblical examples could however be given in scores, and any one with but little search will readily see excellent illustrations of the symbolic use in both the good and evil sense.

In the Middle Ages, at the consecration of a church, evil spirits were exorcised by the use of water, wine, salt and ashes. "These," to quote

Durandus, "be four things which expel the Enemy. The first is the outpouring of tears, which is denoted by the water; the second is the exaltation of the soul, which is denoted by the wine; the third is natural discretion, which is the salt; the fourth a profound humility, which is signified by the ashes. Therefore not one of these ingredients ought to be wanting, because the Church is neither sanctified nor released from sins without the union of these qualities.

Salt, in the Divine language, is often a symbol of wisdom: "Let your speech be savoured with salt." Christ too said to His disciples, "Have salt in yourselves, and have peace one with another." And again, "Ye are the salt of the earth: but if the salt have lost its savour, wherewith shall it be salted?" In the second part of "King Henry IV.," Shakespeare writes: "Some smack of age in you, some relish of the saltness of time."

One of the most constantly recurring symbols in the catacombs, mosaics, etc., of the primitive Church, was a representation of a rock from which four rivers proceed. Some little doubt arises as to its significance. Ambrose, Bede, and other authorities tell us that these streams represent the writings of the four evangelists, flowing forth to fertilize and enrich the world; others see in them the four rivers of Eden, while others again think them the four great councils of the early Church.

The rock is primarily a symbol of Christ. "They drank of that spiritual Rock that followed them, and that Rock was Christ." It is often used in the Old Testament as a symbol of Stability and of the Divine protection, the place of refuge in the day of trouble. "Unto Thee will I cry, O Lord, my rock." Thou art my rock and my fortress." "In God is my salvation and my glory: the rock of my strength, and my refuge is in God." The reader will readily recall the parable of the house that was established immovably upon the rock, and there is perhaps no more popular composition in the whole Christian hymnody that that of Toplady which commences, "Rock of

ages cleft for me." The rock is, secondarily, a symbol of the Church, an idea naturally flowing from the words of the Saviour: "Thou art Peter, and upon this rock I will build My Church." It is, finally, a general emblem of steadfastness. Thus in the frontispiece of the "Eikon Basilike," we see amongst other forms of symbolic meaning a raging sea having a rock rising from the midst, with the words added, "immota triumphans." The sky is black with rolling clouds, and on either side of the rock we see dark faces amidst the storm blowing vehemently against it. Beneath are the lines—"*As the unmoved Rock outbraves The boistrous Winds and raging Waves: So triumph I and shine more bright In sad Affliction's Darksom night.*"

The ship riding in safety amidst the storms was a very frequent and favourite image of the Church in the earlier days of Christianity. The mast is generally in the form of a cross, and is surmounted by the dove or the monogram. St. Clement of Alexandria and other early writers dwell frequently upon this symbol, and Tertullian says that the church, using the word in its more restricted sense as a place of assembly for worship, must be oblong in form, and expressly declares that it thus better symbolises a ship.

The Church of Christ, as a ship, is often found on early gems (as in fig. 100) lamps, and other objects, and is freely depicted (as in fig. 105), on the walls of the catacombs. Instead of a masted

REFRICERIVS QVI VIXIT
ANNOS PL. M. VI. MENS VIIII B
V. °QVESCET. IN PACE

fig. 105

fig. 106

vessel, it is often (see fig. 106) the ark of Noah, a form of perhaps additional significance, as it would appear to promise future protection and deliverance to the Church by a reminder of the past mercy of God to His faithful followers in the midst of a world of abounding wickedness. In many cases the ship is merely introduced in a lower symbolic sense, as an emblem of maritime power, as in fig. 107, where we see the prow of an antique galley and the trident of Neptune. St. Jude is represented with a ship, or sails, or an oar in his hand. St. Raymond in a boat hoists his cloak for a sail.

fig. 107

The anchor, often, as in fig. 108, terminating in a cross, is primarily the symbol of steadfastness and hope: "a strong consolation, which hope we have as an anchor of the soul, both sure and steadfast."

It is, secondarily, associated with St. Clement as the instrument of his martyrdom, he being bound to an anchor and cast in the sea. The antique form of anchor may be very well seen in fig. 109.

In the legends of the saints we find St. Bertulph changing water into wine; St. Gummarus drawing it from a rock; SS. Rufina and Secundus, thrown into the sea, float miraculously on the surface; while SS. Nazarius, Celsus, Aldegondes, and Birinus walk in safety over the waves.

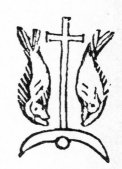

fig. 108

The beneficent sun, the source of light and heat, has naturally been accepted as a symbol of the "Sun of righteousness," the Dayspring from on high, to give light to them that sit in darkness. The ancient Egyptians depicted the providence of God as a radiant sun, with wide, outstretching wings; while our English word Sunday remains as a reminder of the sun-worship of our ancestors.

fig. 109

The sun and the moon are often introduced together in representations of the crucifixion, as symbolic of the great powers of nature adoring the Lord of the universe; or veiled and eclipsed in the darkness that was over all from the sixth to the ninth hour, when the earth did quake and the rocks were rent, and all nature shuddered at the

fig. 110

deed enacted. Though the face often represented in sun and moon is sufficiently, though involuntarily, grotesque, it bears record to the belief, current in the Middle Ages, that each was the home of an archangel, who was in turn the leader of thousands of the angelic host. Thus the sun was the abode of Michael, and the moon of Gabriel. Mercury, in like manner, was the abode of Raphael, Venus of Anael, Mars of Samael, Jupiter of Zadkiel, and Saturn of Cassiel. The illustration, fig. 110, is taken from the "Dialogus Creaturarum," A.D. 1480.

The crescent moon was the symbol of Byzantium. When Philip, the father of Alexander, was besieging the city in the fourth century before the Christian era, the sudden appearance of the moon betrayed the details of the intended assault; and the citizens, grateful for their deliverance, erected a statue to Diana, and took the crescent moon, her symbol, as their device.

When the Turks took the city in the fifteenth century, they found the device still in use, and in turn adopted it, and it remains to this day the symbol of the city and of the Turkish sway.

The starry host of heaven is often introduced as an emblem of the universe; and in times when men believed in the stellar influences, the presence of the stars had a deeper meaning than now appears, as they would represent to them a watching, guarding, and guiding Providence. The Virgin Mary is often depicted with a number of stars around and above her, and SS. Dominic, Humbert, Athanasia, Bruno, and Swidbert have a star on head or breast. Richard I., on his great seal, placed a star over a crescent in token of his victories over the Saracens, and as a symbol of the triumph of Christianity over Muhammadanism.

The star is one of the less common symbols of Christ. It owes its origin to the text in the Apocalypse, "I am the root and offspring of David, and the bright and morning Star"; which in turn is a fulfilment of the prophecy of Balaam, "There shall come a Star out of Jacob, and a Sceptre shall rise out of Israel."

The star is associated again with Christ at the Nativity and Epiphany (see figs. 1 and 65), the star of the East being always a feature in representations of that event. A false Messiah, a century afterwards, in the reign of Hadrian, called himself Bar-Cocheba, the Son of a Star, and caused a star to be stamped upon the coinage that he issued.

"Frontal for the day of ye Ephphanye of whyte wyth starrys." —Inventory, Westminster Abbey, A.D. 1540.

During mediaeval times we very frequently find representations of the seasons, or of the months, or of the signs of the zodiac. The introduction of the several employments of the months often had mystical significance, showing too that all labour is honourable, and teaching at the same time that the God of grace is God also of nature.

These representations are especially common in the early Norman doorways, though we have no examples in England that will at all compare with some of the examples met with on the Continent. In the great west doorway of St.

Mark's at Venice, for instance, we get the signs of the zodiac carved with great life and spirit; and then emblematic figures of the months,—an old man in fur coat and hood warming himself before a blazing fire, a man with a sheep on his shoulders, a mower amidst the long grass, a reaper in the harvest-field, and many others; and in the centre, hallowing all, a grand figure of Christ seated in a firmament of stars. At Modena, Verona, Lucca, Sens, Rheims, Amiens, Saint Denis, Chartres, other excellent illustrations may be found. We also find these figures on paving tiles, fonts, capitals, and stained glass. Very good Renaissance examples may be seen in twelve large circular medallions of enamelled terra cotta, preserved in the Victoria and Albert Museum, and attributed to Luca della Robbia. They are painted in blue, the subjects being representations of the agricultural operations symbolic of each month, and in each case the appropriate zodiacal sign is introduced.

In conclusion, we have to deal with some few geometrical forms and arrangements that have defied classification and incorporation in any of the preceding chapters.

Conspicuous amongst these forms is the equilateral triangle, fig. 111, the simple yet most effective symbol of the Trinity in unity. It occurs very rarely in the early Church, but later it became commonly employed, and is still in use. St. Angilbert, contemporary with Charlemagne, had the abbey of St. Riquier built in the form of a triangle, and devoted three hundred monks to its service, expressly stating that this was so done in honour of the adorable Trinity. On the coins of Edward I., the monarch's head, full-faced, is placed within an equilateral triangle, in some cases the apex being upwards, above the crown, and in others below the beard. The idea of its use was no doubt symbolic, and expressive of the king enjoying the Divine protection and surrounded by Divine grace.

The octagon, as we have seen in our remarks upon numbers, was symbolic of regeneration, an

fig. 111

old writer affirming that as the whole creation was complete in seven periods of time, the number next following may well be significative of the new creation. We give the theory for what it is worth, and the reader will doubtless concur in deciding that its value is not very great. However defective the theory, the use of the octagon in actual practice was very marked. We note that in the ancient examples given by the Cambridge Camden Society, in a pamphlet drawn up for church builders, the Norman fonts that are octagonal only number fifteen, while those of all other shapes amount together to forty-three. In the Early English period the octagonal examples are nineteen, while the others amount to thirty; but in the Decorated or fourteenth century period, the fonts of octagonal form that are given are twenty-four in number, and there is only one of any other form; while in the next period, the Perpendicular, the numbers are respectively fifty-seven and two.

The pentalpha, pentacle, or pentangle, is a five-pointed star. If we mark off on the circumference of a circle five equal divisions, and join each point in succession, we shall form a pentagon; but if we join instead every other point, the result will be a pentalpha. The crossing of the lines suggests five A's, hence the name. It was formerly considered the symbol of health, and within the five points we sometimes find the five letters SALVS. It is sometimes termed the pentacle of Solomon, and when it is delineated on the body of a man, it is pretended that it points out the five places wherein the Saviour was wounded, and that therefore all evil spirits flee from it. It was held to be a magic talisman against the powers of witchcraft, and in many ways a sign of great power. The pentalpha may be seen in the eastern window of the south aisle at Westminster Abbey. It was at one time used by the Greek Christians in lieu of the cross at the beginning of inscriptions, and the Jews also employed it. It is said to have had its origin in the secret rites and doctrines of the Pythagoreans.

From its association with witchcraft and demonology it is also sometimes called the Fuga Daemonorum.

The simple equilateral triangle is sometimes superseded by a symbol of like significance, composed of three equal and interlacing circles. This came into use first in the thirteenth century, and its appropriateness, no less than its greater beauty, soon gave it firm hold. The three equal circles symbolise the equality of the three Persons in the Trinity, the binding together into one figure the essential unity, while the circular form signifies a never-beginning, never-ending eternity.

The form known as the fylfot is frequently introduced on the vestments of the Greek Church, and is found also somewhat more sparingly in the West, both in ecclesiastical and heraldic work. It was most commonly employed amongst the Western peoples in the thirteenth and fourteenth centuries, and many examples of it may be seen on monuments, brasses, and so forth. Amongst the various mediaeval textile fabrics we find one called stauracin, a material taking its name from the Greek word for a cross, and so called from its being figured over with the form of the cross, the design being sometimes of the simplest character, and in other examples of very elaborate enrichment of detail. This was also known as gammadion. In the Greek alphabet the capital letter Gamma consists of two lines at right angles to each other, like an English letter L, and many of the mystical writers of earlier days have seen in this form a symbol of Christ as the corner-stone. On this idea as a basis the mediaeval designers combined these L-like forms into many more or less decorative arrangements. Four of them placed with their four angles towards each other creat the form of the Greek cross; at other times they were so arranged as to form the letter H; or, placed with their angles outwards, a square is produced.

By far the most ancient and most common form, fashioned out of the repetition of the

Z Ш T I K Ш Z O T I K H

Vitalis Vitalia

fig. 112

DOMITIA. IVLIANETI FILIE IN PACE
QVE BIXIT. ANNIſ III. MEſIſ. X. ORAſ
XEX. NOTIſ DEFVNTA Eſ T IDVS
MAZAſ

fig. 113

Gamma, is that known as the fylfot. This may be
found even in the catacombs, as in the examples
figs. 112 and 113; and from its resemblance to
two rough S's or Z's crossing each other—S and Z
in old work being often interchangeable—it has
been conjectured that it was probably the cross
represented as *signum*, the sign, *i.e.*, of faith in
the Crucified.

In the use of the fylfot the early Christians
merely adopted and diverted to their own
purpose a symbol centuries older than the
Christian era, a symbol of early Aryan origin,
found abundantly in Indian and Chinese art, and
spreading westward, long before the dawn of
Christianity, to Greece and Asia. The subject is
beset with difficulties, and many theories have
been propounded in attempted elucidation, one
being that it represents a revolving wheel, and
symbolises the great sun god; while another is
that it stands for the lightning wielded by the
omnipotent Deity, whether this Deity be the
Manu, Buddha, or Brahma of the East, or the
Thor or Zeus of the West. The fylfot is abundantly
found on the terra-cotta objects dug up by Dr.
Schliemann at Troy, and conjectured to date
from 1000 to 1500 B.C.; and the Greek fret or
key pattern is frequently seen in combination
with the fylfot, or is itself a fuller and more
decorative development of the form. The subject
is one of immense interest, but its consideration

211

lies entirely beyond the limits we have imposed upon our work. Any one caring to pursue the subject at greater length will find an excellent paper upon it in *Archaeologia*, vol. xlviii., and it has also been dealt with by Dr. Schliemann, Max Müller, Fergusson, Ludwig Müller, Waring, and many other writers of authority and learning.

The letter Y is sometimes used symbolically. It is sometimes called the Y of Pythagoras, because that philosopher called it the emblem of human life. The foot of the letter represents infancy, but a time comes to all as their life goes on when two paths open out before them, one leading to good, the other to evil. A very good example of this symbolic use may be seen in the frame of a mirror of Italian workmanship of the sixteenth century in the Victoria and Albert Musuem. At the branching of the Y are placed two figures, one the recording angel, the other a human skeleton. An acanthus scroll is interwoven throughout, and within this are various animals, on the one side those symbolic of the virtues, and on the other those representing the vices of human nature. Each animal is accompanied by a golden letter, the one series spelling out the word BONUM, the other MALUM.

The triquetra, made by the interlacing of three portions of circles, is used in Christian art as a symbol of the Trinity. It may be frequently met with on Celtic crosses. On the cross at Margam in Glamorganshire it is placed above the figures of the saints that stand on either side of the shaft, and at Llanfrynach it occurs in association with the figure of a dove. On a cross at Calf of Man the triquetra appears on the dress of the crucified Saviour, and on the breasts of the evangelists in a sixth century manuscript in the library of Trinity College, Dublin. Numerous examples may be found figured in Stuart's "Sculptured Stones of Scotland," in Westwood's "Lapidarium Walliae," and in Cumming's "Runic Remains of the Isle of Man."

In conclusion, I venture to express the hope that these pages, the writing of which has been so

enjoyable a task to myself, may not prove altogether without interest and profit to others. The study is one of the greatest value, and the fault is that of the exponent and not of the subject if I have failed to transfer some idea of this form my own convictions to the mind of the reader.

Therefore "now pray I," in the quaint and honest language of Chaucer, "to hem that harkene thys tretyse or rede, that yf ther be onything that liketh him, that thereof they hank HIM of whom proceedeth al wit and goodnes, and yf ther be onything that displease hem, I pray hem also that they arrete it to the defaulte of myn unkonnyng and not to my will, that would have seyde better yf I had knowing."

Christ healing the blind from a vellum manuscript. British Museum.

በይቤልዖ፡እግዚ፡እ፡ከ
መ፡ይትከሠታ፡አዕይን
ት፡ነቀወእምሐርዖ፡ለእ
ዝ፡እ፡ኢ፡የኩከ፡መ፡መሐ
መ፡እግዚ፡እ፡ኢ፡የኩ፡ክ፡

ወገሠሃ፡መ፡ወለከፍ፡መ፡
እዕይን፡ቲ፡ሆ፡መ፡ቀወደ፡ቢ
ሎ፡መ፡በከ፡መ፡ሃይ፡ማና
ትከ፡መ፡ወእ፡ሚ፡ኖ፡ች፡ከ፡መ፡
ይኩ፡ን፡ከ፡መ፡ቀወ፡በ፡ጊ፡ዚ፡ሃ፡

ነጸሩ፡ሰቤሃ፡ወተ፡ከሠ፡ተ፡፡
እዕይን፡ቲ፡ሆ፡መ፡ወር፡ኤ
ዮ፡ሰቤሃ፡ወ፡ተ፡ለ፡ወ፡ዖ፡፡

213

Pen and ink drawing of St. Christopher carrying the Christ-Child. From a Psalter of Westminster Abbey, late 12th century. British Museum.

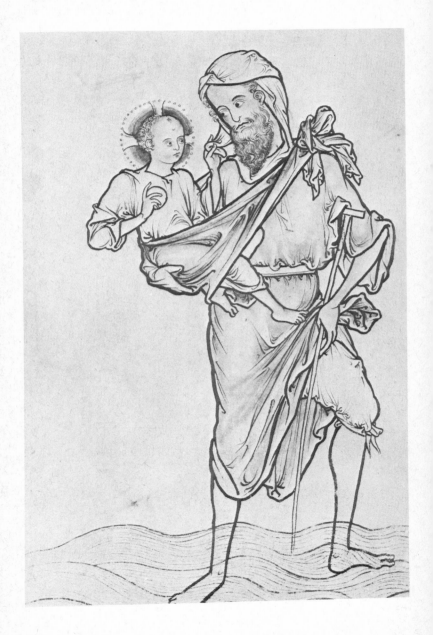

Appendix

A.

The Magi in art and literature are ordinarily three. Gaspar an old man with a long grey beard and venerable aspect; Melchior, a man of the prime of life, and always given a short beard; and the third Balthazar, a young, beardless man, often depicted as a negro, and having the thick lips and curly hair of that race. The scene of the Nativity is in the East always shown as a grotto or cave, while in the West it is a poor stable. The following extracts from old carols indicate this very clearly, art and popular belief reacting always upon each other. *"In Bethlehem, in Jewry, This blessed Babe was born, And laid within a manger, Upon this blessed morn; The which His mother, Mary, Did nothing take in scorn."*
"And when they came to Bethlehem, Where our dear Saviour lay, They found Him in a manger, Where oxen feed on hay; His mother Mary kneeling down, Unto the Lord did pray."
"Onward then the Angels sped, the shepherds onward went, God was in His manger bed, in worship low they bent. In the morning, see ye mind, my masters one and all, At the Altar Him to find who lay within the stall." "Then were they constrained in a stable to lie, Where horses and asses they used for to tie: Their lodgings so simple they took it no scorn, But against the next morning our Saviour was born."
"Good Christian men, rejoice With heart and soul and voice; Give ye heed to what we say: News! News! Jesus Christ is born to-day: And He is in the manger now. Christ is born to-day!"

B.

St. Christopher was of heathen birth and parentage, and the old chronicles tell us that he was twelve cubits high, "a right grete" stature indeed. He was ambitious to dedicate his strength to the service of the mightiest monarch on earth,

215

and after considerable quest he arrived at the court of a sovereign who seemed to meet the requirement, and he therefore entered his service, and was gladly accepted.

One day however a strolling minstrel arrived at the court and sang a lay in which the name of Satan was referred to, and the king, being a good Christian, crossed himself and muttered something at each repetition of the name. The puzzled and observant heathen asked the monarch for an explanation; but the prince evaded the question for some time, and finally confessed that it was to protect himself from the power of the evil spirit. Christopher exclaimed: "Then am I deceived in hope, for I had thought that I had found the greatest lord in the world; but this devil of whom you speak and whom you fear is mightier than yourself. I go then to seek him and to become his vassal."

Having left his first master, as he wandered over a great and savage wilderness he encountered one who demanded of him the cause of his travels, and, being told the object, the stranger assured him that he need seek no further, as the object of his quest stood before him; and he at once welcomed Christopher into his service. One day, as they were riding along together, Satan espied a road-side cross some little distance ahead, and at once turned out of the track into the thorny wilderness, and only returned to the high road when well past the cross. Christopher was much puzzled, and asked his lord why this curious wooden object had so affected him. The devil, like his former master, would have evaded the question, but at length admitted that Christ, an old enemy of his, had vanquished him by its means, and that whenever he saw a cross he fled. Then answered Christopher, "This Christ then is a mightier than thyself; I go to seek Him as my king."

After a lengthened search, "whan he had demanded where he shold fynd Crist, atte last he came to a grete desert to an hermyte that dwelled there, and this hermyte preched to hym of Jhesu

Crist, and enformed hym in the fayth dylygently, and sayd to hym, 'Thys kyng whom thou desirest to serve requyres the seruyse that thou must faste oft.' " But Christopher replied, fasting not being at all to his taste, "Requyre of me somme other thynge, and I shall doo it, for that whiche thou askest I cannot." Whereupon the hermit replied, "Thenne must thou wake and make many prayers." Then answered Christopher, "I wot not what this is; I can doo no such thynge." The indulgent friar, unwilling to lose the services of one so willing, yet so very unconventional, taking a glance at the brawny limbs of the giant, thought of yet another acceptable form of service, and replied, "Know you a certain river in whych manye perish?" On the disciple's affirmative reply, the hermit bad him, "by cause he was noble and hye of stature and strong in the membris," to dwell by the foaming torrent and carry all comers across. This being a kind of service very much more to Christopher's taste, he willingly accepted his instructions, and having built himself a hut on the bank, bore over all who came that way.

One night as he was sleeping he heard the cry of a little child, "Come out, good sir, and bear me over the stream"; so he at once ran out, but in the darkness saw no one, and concluded that it was a dream. A second time the same thing happened; but as he decided that the sounds were a device of his late master to annoy and frighten him, he composed himself to sleep again. Scarcely had he closed his eyes than he heard himself again called; so hurrying again to the water's edge he found a little child "whiche prayed hym goodly to bere him over the water." So Christopher lifted him on to his shoulder, and bore him into the stream. As he plunged into the foaming current the water rose ever higher and higher, and the child "heavyer and heavyer," until Christopher began to fear for his life. On at last reaching the opposite bank, he exclaimed, "Childe, thou hast put me in grete peryl; thou wayest alle most as I had had all the world upon

me, I myght bere no greater burden." The child
answered, "Chrystofre, merueyle thee nothynge,
for thou hast born Hym that created and made
alle the world upon thy shoulders. I am Jhu
Cryste, the king whom thou servuest in thys
werke, and bycause that thou knowe that I saye
to thee truth, sette thy staf in the earthe by thy
hous, and thou shalt see to morne that it shalle
bear flowres and fruyte, and anon he vanysshed
from his eyen." Christopher obeyed the
command, and on the morrow found that the
promised miracle had been fulfilled.

Full of joy at the Divine recognition, he
hastened to the city of Lycia to serve his new
Master more fully; but on arrival there he was
met by the practical difficulty of being wholly
unable to speak the language of the people, so he
fell on his knees in the market and besought the
gift of tongues, a petition that was immediately
answered. He then hurried to the place where the
martyrs for Christ were imprisoned, and brought
them much comfort. The pagan judge, greatly
incensed at this, struck him in the face, where-
upon Christopher said, "If I were not Chrysten I
shold anon auenge me of myn injurye." Plunging
his staff anew into the earth, he prayed that the
miracle might be repeated, and on the rod
bursting into blossom eight thousand men of the
city immediately became Christians.

The king of that country, greatly alarmed at
this startling event, sent a party of knights to
arrest this disturber of the ancient faith; but
when they found him on his knees praying to his
God, and realized moreover what kind of
reception so very doughty a champion of the
faith might have in store for them, they thought
discretion preferable to valour, and parleyed with
him as to their instructions from the king.
Christopher, learning their business, "commanded
them that they shold bynde his hondes behynde
his backe, and lede hym so bounden to theyr
kyng." The king when he beheld him fainted
with fear, but seems to have got over his
apprehension when he saw that he was tightly

bound. Christopher replied, on being asked who he was, that originally his name was Reprobus, but that he had been baptized into the Christian faith, and was now named Christopher. The king told him that he was a great fool for bearing the name of a crucified malefactor, and added: "Yf thou wilt now doo sacrefyze to the goddes I shall geue to thee grete geftes and grete honours, but yf not I shall destroye thee by grete paynes and torments. But for alle thys he wold in no wyse do sacrefyse, wherefoe he was sent into pryson."

The king commanded Christopher to be thrashed with red hot rods and a ring of glowing iron to be placed upon his head. He was bound too on an iron chair under which a fierce fire of pitch and bitumen was kindled, so that his seat presently melted "like waxe" in the intensity of the heat, the only result being that when the chains by which he was bound melted from him the saint "yssued out wythout ony hurte."

The monarch, full of rage and fury, then gave orders that he should be fastened to a tree and shot by the royal bodyguard of archers; but all the arrows missed their aim, though one of them, on glancing from the tree, smote the king and blinded him. St. Christopher on seeing this exclaimed, with the Christian spirit that he had exhibited all through the proceedings, "I shal die thys mornynge, tempre a little clay withe my bloude and anoynt thy wounde, and strayhtwaye thou shalt be healed." Though the flame and the skill of his marksmen had alike failed, the king commanded that the saint should be beheaded; and the saint, having made "hys oryson," died at the hands of the executioner. The king, impressed with the fulfilment of the first part of the saint's prophecy, was eager to put the rest to the proof; and on following the instructions given, his sight was immediately restored. This softened his heart, so that he too became a convert to the faith, and with all the fervour of a new convert published a decree that whosoever should fail to worship the God of Saint Christopher should be put to death.

C.

No attempt at a description of the various symbols introduced in art could be at all complete without reference to that great storehouse of early examples, the catacombs of Rome, excavations which it is conjectured contain some seven million graves, and having a combined length altogether of some five hundred miles. These burial places were in use for some three centuries, the earlies dated inscription being A.D. 72, the latest A.D. 410. They were also places of refuge during the fierceness of persecution, and later on were used as places of worship when a deepening superstition led to adoration of the relics of the first martyrs of the faith. The passages are some seven or eight feet high and about three feet wide, and their sides are lined with the slabs that cover the resting places of the members of the early Church.

After their abandonment in the year 410, bodies were so often abstracted from them as relics that Pope Paul III., about the year 1220, transferred many others. The catacombs after this date appear to have been absolutely forgotten, until a vinedresser in 1478 accidentally dug into one of these subterranean passages.

The investigations of Padre Marchi and the two De Rossi, his pupils and companions, are full of interest, and their books on the subject may well be consulted: "I Monumenti delle arti Christiane primitive nella Metropoli del Christianèsuno," the "Inscriptiones Christianae," and the "Roma Sotteranea." The soil is a tufa that is readily worked, and yet of sufficient rocky solidity to bear excavation. It was at first though when they were re-discovered that the catacombs had been the common burial places of both heathens and Christians, as may pagan inscriptions were discovered; but in by far the greater number of cases these slabs were found either sideways, upside down, or with their heathen inscriptions on the inner face, showing that the Christians often used old slabs without troubling to remove

a former inscription. At the same time there are several examples that cannot be thus explained away. The letters D.M: or D.M.S. occur some forty times amongst the fifteen or twenty thousand inscriptions that have been recorded. On heathen monuments these letters occur abundantly, and they then signify *Dis manibus* or *Dis manibus sacrum*, and it has been very reasonably surmised that the Christians, finding useful slabs thus marked, were glad to employ them, and in doing so gave an altered significance to these letters, as for instance *Deo Maximo* or *Deo Maximo Salvatori*.

Nothing could often be ruder or less artistic than the Christian symbols on the early monuments; but they are most valuable as expressing contemporary beliefs, and what later forms gain in grace they may lose in sincerity.

The most favourite subject on these slabs after the various symbols or inscriptions is the raising of Lazarus, in itself a symbol of faith in Jesus and the resurrection of the dead. Other very common Bible subjects are the three children in the fiery furnace, Daniel in the den of lions, and the story of Jonah; but by far the commonest symbol is that of Christ as the Good Shepherd.

D.

The Christian Museum of the Lateran. One of the most interesting of the unrivalled collections of art treasures of the Eternal City. The objects are chiefly casts from the reliefs on ancient sarcophagi, paintings copied from the originals in the catacombs, and inscriptions. In the catacombs the originals have to be sought in far-reaching subterranean galleries, and examined as well as may be by the light of flickering lamps; but in this museum the choicest examples are collected together, and, thanks, to the admirable descriptive catalogue, made much more instructive and intelligible. Nevertheless no collection of casts,

however instructive, well arranged, or excellently lighted, can for a moment compare in interest with the study of the original slabs still in the position where these memorials of the saints of God were placed centuries ago by the loving hands of the brethren of the early Church.

Index

223